ART SCENE

Chicago 2000

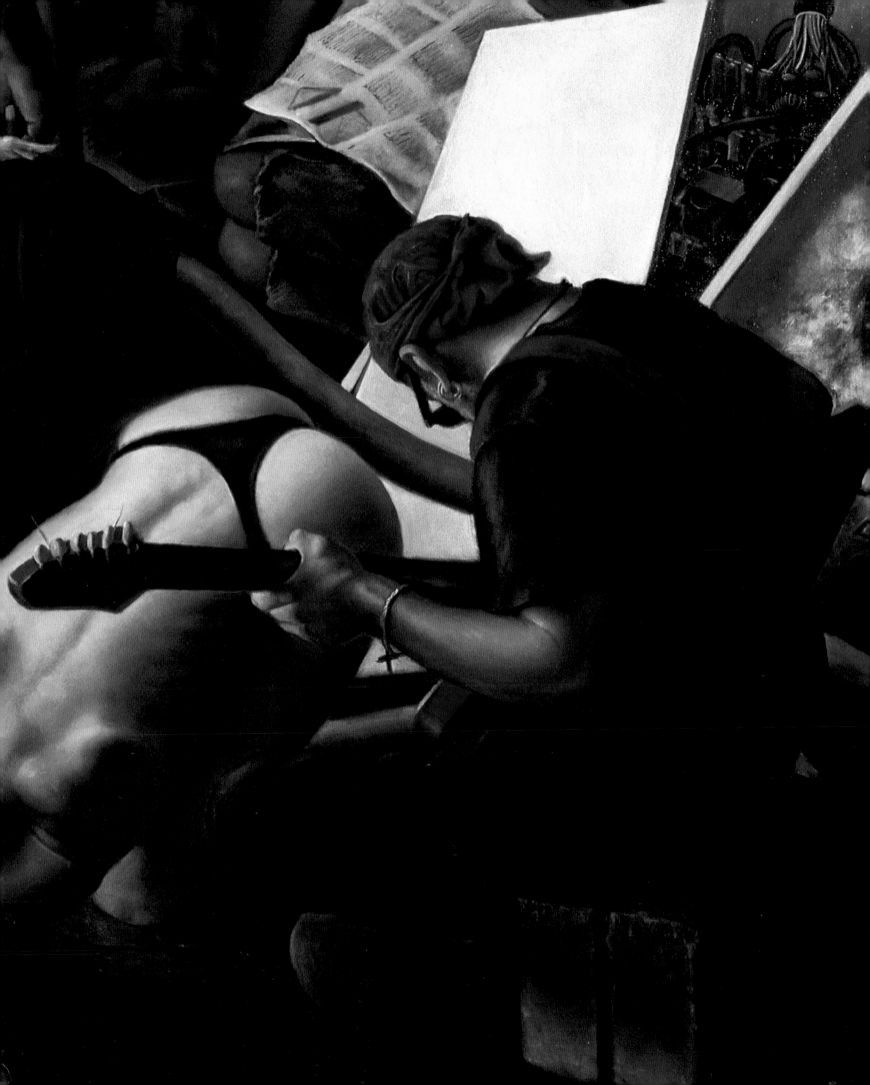

ART SCENE

Chicago 2000

Ivy Sundell

CROW WOODS PUBLISHING

FOR Tom

Published by: Crow Woods Publishing
 Post Office Box 7049
 Evanston, IL 60204
 crowwoods1@netscape.net
 http://sites.netscape.net/crowwoods1/

Printed in China.

Publisher's - Cataloging-in-Publication Data
Sundell, Ivy.
 Art scene: Chicago 2000 / Ivy Sundell.
 p. cm.
 ISBN 0-9665871-6-2 (pbk.) ISBN 0-9665871-7-0 (hc.)
 1. Artists—Illinois—Chicago. 2. Art, American—Illinois—Chicago. 3. Art, Modern—21st
century—Illinois—Chicago. I. Title.
 N6535 2000
 709'.2'2

Library of Congress Catalog Card Number: 00-090161

FRONTISPIECE:
Bruno A. Surdo
Re-emergence of Venus (No. 169, detail)

PAGE 6:
Pala Townsend
Yellow Diver II (No. 181, detail)

PAGE 8:
Herbert Murrie
Father and Son (No. 117, detail)

PAGE 12:
Maureen Warren
Six Fledgling Crows (No. 193, detail)

PAGE 15:
Andrew Sterrett Conklin
Artist and Model III (No. 24, detail)

Contents

7 **Foreword**

9 **Introduction**

10 **Acknowledgments**

13 **Jurors**

15 **Artists**

158 **Directory of Artists**

Foreword

Ever since my previous book, *The Chicago Art Scene,* was published, I have noticed many articles lamenting the lack of art coverage in this vibrant art community. On the other hand, the Cows on Parade™ public art project in 1999 was so successful that it brought tourists and local residents alike to the scene and is inspirational of many cow art projects in the area. In my daughters' school, for example, the children have drawn cows and have painted mini-sized cows for the recent school auction. Also in 1999 three local museums—The Smart Museum at the University of Chicago, The Mary and Leigh Block Museum at Northwestern University and the DuSable Museum of African American History expanded their art exhibition space. There were even talks of starting a museum devoted to Chicago area art. So amidst all these efforts to keep Chicago in the forefront of the art world, I decided to add my contribution and create a second book on Chicago contemporary artists.

Some people have noted that *The Chicago Art Scene* does not provide a complete picture of the art scene, namely that photography, three-dimensional art, and performing arts are excluded. While I could have expanded this book to cover every aspect of art in the community, I feel that a focused book would allow a more expansive coverage of this one aspect of art. An attempt to cover all aspects of art would mean relegating each aspect to a more limited section of the book, thus creating the opposite effect. Since my purpose for this book is not to encompass the complete art scene, but rather to help readers appreciate the artists' visions and understand how their background influences their work, the scope of this book remained the same as my previous one.

As in my previous book, I endeavored to showcase good Chicago-area artists, rather than necessarily established artists. My initial strategy of recruiting was to advertise in local newspapers and the Chicago Artists' Coalition newsletter along with contacting various galleries and art leagues. Eventually a greater portion of my time was spent calling individual artists recommended by other artists. This latter strategy was much more effective since the artists recommended by others are those actively producing and exhibiting art in the area. The result is a very strong follow-up to my first book and I hope the readers will enjoy it even more than the first book.

Introduction

The primary objective of this book is to help the art viewing public better appreciate individual artist's work. This is achieved through an emphasis on each artist's statement of intent and a narrative biography highlighting his or her career. And what can be more effective than to demonstrate this relationship by showcasing contemporary artists— artists whom you can converse with and who can tell you about their visions? While this book only covers seventy-one two-dimensional visual artists living in the Chicago area, this approach can be applied to other artists not featured in this book, whether they be visual or performing artists or artists living outside of the area.

Considerable effort was spent in making each artist statement an eye-opener for the reader. A statement may directly discuss the artist's vision, or it may address the evolution of the artist's career, or it may detail the techniques of the artist's work or the uniqueness of his or her style. In any event it attempts to draw the reader in on a more personal level so that the reader can share that artist's world.

The biography has a dual function of giving the reader a sense of the artist's achievements and listing some of the venues that the artist has used in the recent past. The purpose of the latter is to allow the reader who is interested in a particular artist's work to look out for upcoming events at those venues. One may be able to meet that artist at the next opening reception, or one may find other artists' work at those venues to be of interest.

The artwork featured in this book was selected to represent the strongest and most recent of the artist's work. Having said that, there are also many exceptions to the rule. Perhaps the primary reason for an exception is to match the artwork to the statement of intent. In many cases, too, the artists were asked to write an updated or more specific statement for the work they submitted. Another reason for the exception is the desire to show variety and versatility in an artist's work. Work completed five or more years earlier is featured in a few cases; and work that covers more than one medium or subject matter is showcased in another handful of cases. Regardless of the artwork this book features, however, the featured artist is someone who is currently active in producing artwork.

Ten artists in this book were also featured in my previous book, *The Chicago Art Scene*. These artists had the burden of showing a different medium—as Jean Hirsch has done in submitting her watercolors rather than oils, or a different focus on the same body of work—as Takeshi Yamada has done in drawing attention to the retouching of his work, or simply a new statement expanding on concepts in their prior book's statement—as some of the other 'original artists' have done. The reader will be able to learn more about these artists even if they have read about them previously.

A directory of the featured artists is presented at the back of this book. The directory is intended to provide art viewers, art buyers and any other interested parties access to the artists. For artists who are represented by a local gallery, the telephone number, e-mail address and web site of that gallery may be listed. Artists represented by more than one gallery will have their primary local gallery listed in the Directory. Compared to two years ago, it is astonishing to see that so many of the artists are connected through the Internet. In publishing the e-mail addresses and web sites it is hoped that not only can the public have access to the artists, but the artists can be more accessible to each other.

Acknowledgments

In preparing this book, I had the advantage of learning from my earlier book, *The Chicago Art Scene*. A portion of that learning draws from mistakes I made then; more important is all that I learned from the artists featured in that book. The many book-signing events I staged with the featured artists and the exhibition hosted by Belloc Lowndes Fine Art in February 1999 brought me in closer touch with the artists and the venues they use for promoting their art. Certainly, having the support of many artists, art educators, art researchers, etc. help bring in the larger number of entrants. In fact, so many have offered their assistance that simply listing their names would fill many pages.

IN SEARCH OF JURORS

While many individuals suggested potential jurors for this book, the jurors were ultimately chosen from two particular lists. Jurek Polanski of artscope.net and James Mesplé both recommended many jurors who are respected in the Chicago area, and their advice were taken. I'm much indebted to them for helping me find such capable jurors.

IN SEARCH OF ARTISTS

The search for fine artists was as vigorous as before. Somehow the deadline for artists' submissions became my personal deadline to find as many talented artists as possible for the book. I handed out flyers at the 1999 Chicago Art Open and Jacqueline Moses, a featured artist from *The Chicago Art Scene*, also helped me hand out flyers at another art opening and spread the word to her friends.

Many leaders of art organizations included my search for artists in their bulletins or newsletters. I was special guest at the Chicago Society of Artists' holiday celebration and was given the opportunity to talk to the artists who belong to the oldest art organization in the U.S. Pat Galinski and Davida Schulman of Artists of Rogers Park very effectively ran an article I wrote on how the member artists used their contacts to learn about the opportunity to submit their work for my previous book and in the same issue printed the notice of my search. Margarete Gross at the Art Information area of Harold Washington Library sent a mailing out to artists prompting them to submit their work. Ron Manderschied and Patti Byer at the Northwestern University Settlement House again sent a mailing to their hand-selected artists on my behalf. Colette Cooper of the Wilmette Arts Guild also did a special mailing for me.

A dramatic increase in the number of artists represented by galleries in the Chicago area is probably the best gauge of the confidence the gallery owners had for this book. Over half the artists featured in this book are represented by the galleries I contacted. While most galleries simply passed the notice along to the Chicago-area artists they represent, the owners of Wood Street Gallery and David Leonardis Gallery submitted work on behalf of a number of their artists. I am grateful to all the art galleries, including those whose submissions were not selected, for their vote of confidence.

Lastly I want to thank the many artists who submitted their work and also passed the word to their artist friends, or provided me with lists of talented artists to contact. While the process of contacting list after list of artists was painstaking, the result made it all worthwhile.

I am also thankful for all the artists featured in this book—for their faith in this project and for their cooperation in providing more recent slides or writing a more specific statement to accompany their artwork.

PEER REVIEW
My peer reviewers are again Charlie Seminara, Thomas Sundell and Bunny Zaruba. I am grateful to them for their generosities with their time and for their advice. Charlie Seminara is an artist and graphics designer; Thomas Sundell is a writer and consultant; and Bunny Zaruba leads a design group at Xceed in Sausalito, California.

EQUIPMENT
Evanston Arts Council was again kind enough to lend me the slide carousels for jurying.

SPECIAL THANKS
This book is dedicated to my husband, Tom, for his constant help and support, and for broadening my vision for this book.

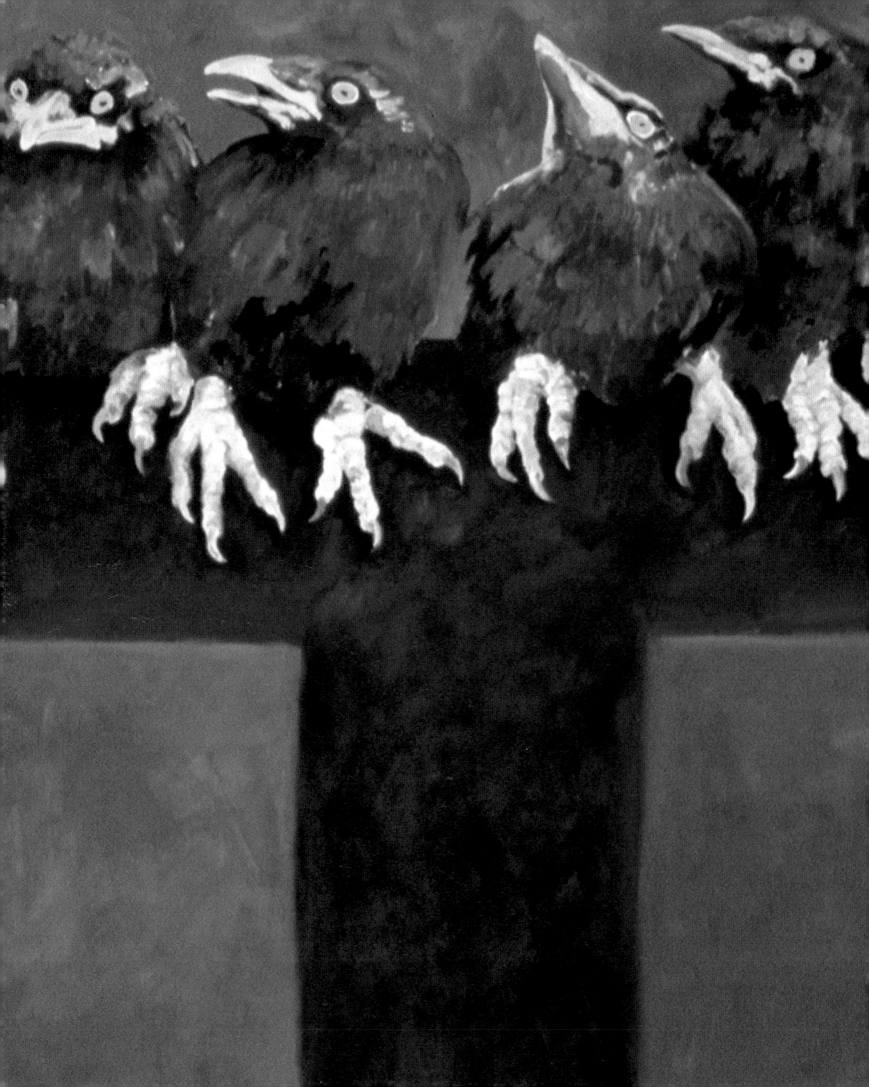

Jurors

Robert G. Donnelley

ON JURYING

"Again this year, the second year of the book, the selection was based primarily on the viewing of slides submitted by the artists. Discussion among the jurors was limited; the respective artists were not identified; the individual votes were kept confidential. To insure consistency, the jurors were asked to assess the artworks according to four specific criteria: originality, technique, composition, and emotional appeal. The evaluations were based on a rigorous point system.

A dramatic increase in the number of entrants demonstrates that the Chicago art scene is both vibrant and flourishing. The breadth of the artistic mediums, stylistic techniques, and subject matter was astonishing. In several cases, however, such diversity within the work of a particular artist complicated the assessment process. Nevertheless, I was impressed by the technical professionalism and originality of the artists who submitted their work for judgment."

BACKGROUND AND JURY EXPERIENCE

Donnelley serves as Director for Intuit: the Center for Outsider and Intuitive Art. In addition, he gives presentations on Native American history and is active in various committees. He was the Co-director and then Director of the Terra Museum of American Art, and Trustee of the Terra Foundation for the Arts from 1992 to 1994. During that time, he co-sponsored a partnership program for Art Education of Inner City Youth and a related exhibition titled *Reclamation and Transformation: Three Chicago Self-Taught Artists*. Before that, he worked with Katherine Kuh to develop and manage the art collection at First Chicago and later was chairman of the Art Committee.

Donnelley attended Art History courses at Northwestern, received his Master's degree in Art History from the University of Chicago, and is currently in Doctoral Program in Art History at University of Chicago.

Jennifer Robertson Norback

ON JURYING

"In the process of jurying, I became aware of the breadth of work being created in Chicago. As these artists are together due to their local residence and not due to stylistic or thematic affinity, the challenge for me was to develop criteria independent of my personal preferences of styles. While the formal jurying process required us to register four separate reactions in four separate criteria, I found my personal reaction to be driven by three elements. First I was sensitive to whether or not there was enough consistency among the works that I could make any judgement at all. Secondly I looked for work that avoided visual clichés. Lastly I looked for work that would continue to be interesting to look at over time. Looking at paintings is essentially a meditative experience and ideally I would have loved to have the opportunity to spend more time with each piece."

BACKGROUND AND JURY EXPERIENCE

Norback is Gallery Director at Hart Gallery and former Gallery Director at Lydon Fine Art, both located in Chicago. While at Lydon Fine Art she arranged the exhibits *Stephen McClymont*, *Mastering Silence*, *New Paintings from Paris*, and *Six Artists from Prague in Chicago*. She recently juried the exhibit *Harvesting the Urban Landscape:* *Recycling in Art* at Christopher Art Gallery, Prairie State College. She was the guest curator at Pi Gallery for their Around the Coyote exhibition in 1998.

Before that, Norback was curator at Galerie Cornette-Pajaran and Assistant Director at Galerie Toft in Paris. She received her Master's degree in Art History from University of Colorado-Boulder and received her Bachelor's degree in Art History and South Asian Studies from University of Wisconsin-Madison.

Charles Thurow

ON JURYING

"It always seems daunting when asked to jury a project such as this one. It is daunting because there are so many artists to review. It is daunting because one must evaluate them by looking at a few slides—never seeing the actual qualities of the work itself. And it is daunting because you know you are one of several judges with little or no chance to interact. As a consequence, one of us may cancel the other out without realizing it.

With this particular project, all those emotions were there but it was also fun. It was fun because it was a day of looking at very good art. It was fun because the amazing depth, variety and richness of the arts community of Chicago was palpable. We were looking at only one segment of the area's arts—its two-dimensional works. But it alone spoke of how much Chicago is a city of art and artists. It was also fun because of the certainty that the final product would be one of which we could be proud."

BACKGROUND AND JURY EXPERIENCE

Thurow has been Executive Director of the Hyde Park Art Center since 1998. He served on its Board from 1985 to 1994, including four years as Chair of its Exhibition Committee and three years as Board Chair. He curated a number of shows and chaired various fund raising and special projects.

Thurow has been active with Chicago's arts organizations, including being a member for eight years of the City of Chicago's Public Art Commission. He was Deputy Commissioner of the City of Chicago's Department of Planning and Development for twelve years. He has been responsible for a wide variety of projects within the City, but most recently he led the Commission on Chicago Landmarks.

Thurow holds advanced degrees from University of California, Berkeley and University of Wisconsin, Madison.

Author's Note on the Selection Process

PROCEDURE

The procedures that worked well in the jury process for *The Chicago Art Scene* (1998) were repeated. The jurors were again asked to rank the artists' work from 1 to 5 (1 being the least and 5 being the most) in the areas of originality, technique, composition and emotional appeal.

Since the selection of the artist does not necessarily follow that the particular work in the slide would be featured, the jurors were instructed to pay attention to the quality of the body of work as the whole. Artists with only one or two pieces of work within the same medium that is strong among the five submitted should be considered as such. Similarly artists who submitted slides of artwork in more than one medium but are not equally strong in all media are noted.

JURORS' DISCUSSIONS

Over twice the number of artists submitted slides for this book than for *The Chicago Art Scene,* causing the jurors to focus on nearly 1,400 slides in one exceedingly long day.

Although discussions among the jurors during the viewing were limited, the session was interspersed with occasional comments, from 'I really like this artists' work.' and 'That's too bad!' to the incredulous 'Are these done by the same artist?'

FINAL SELECTIONS

Of the 279 artists who submitted slides, the top ranking 71 were included in this book. It is comforting to note that in most cases the jurors agreed on the quality of the artists' work. The handful of artists who received the same ranking and were tie for inclusion in the book were selected based on the strength of their statements. True to the spirit of this book, for those few artists, their statements were used to determine the context of their work and the statements' ability to help the reader appreciate their art.

As I alluded to earlier, the final selection of artists is only the first step in the process. Since this book typically feature three pieces of artwork per artist, the artwork to be featured is carefully selected based on many factors. For some artists the work selected is their three strongest pieces. For some, it's the work that demonstrates the most flexibility in their style or technique. For many it's the work that most clearly supports their artist statement.

An effort was made to include the artist's more recent work. In some cases, though, the artist's older work showed more breadth or was more demonstrative of their statement of intent, and those older work was featured instead.

In breaking with tradition, this book features a few artists who work in more than one medium. While it may be shocking to see two distinct styles and media on the same two-page spread, at the same time it reflects the reality that some artists are versatile in a variety of styles and media.

Ultimately the artwork featured is a combination of all the factors mentioned above and the sense of what may enhance the reader's knowledge and appreciation of the artist's work.

Artists

PRESENTED IN ALPHABETICAL ORDER

Alex Abajian

"Starting with a sketch, the images in my paintings evolve into something more complex. I let the process of painting guide me, instinctively trusting and continually reinventing until I feel a sense of completeness. My inspiration comes from moments of solitude and day to day living."

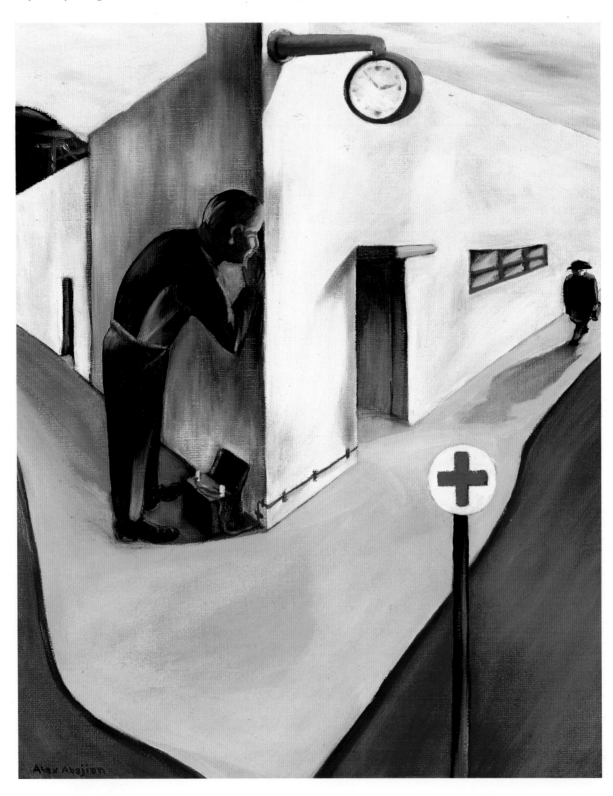

1. *The Living End*
 1998
 Oil on Linen
 10" x 8"

BIOGRAPHY

Abajian is a self-taught painter who works primarily with oils. His work has received many awards from shows, including the Old Orchard Fine Arts Show in Skokie, the Oak Brook Fine Arts Show, the Milwaukee Museum Lakefront Fine Arts Festival, the Beverly Art Center in Chicago (1999) and the Manhattan Arts International (2000).

In 1996 Columbia College choreographed a dance based on Abajian's paintings and entitled it *Interludes*. The dance was performed at the Athenaeum Theatre in Chicago. In 1997 one of his paintings was selected to appear on the cover of the Annual for Independent Publishers Group. Images of his work have also been published by Debut Records in Paris, the New Musical Express in London and Luna Music in Indianapolis.

In recent years Abajian has participated in the 57th Street Art Fair, Around the Coyote Arts Festival and the Chicago Art Open. He also exhibited his work at KMS Gallery in Philadelphia; the Cherry Creek Exhibition in Denver, Colorado; the Ann Arbor Fine Arts Exhibition in Michigan; and the St. Louis Art Exhibition in Missouri. In both 1999 and 2000 his work was exhibited at Gloria Jones Gallery in Chicago.

2. *Three Levels Down*
1998
Oil on Linen
12" x 9"

3. *4:35 A.M.*
1998
Oil on Linen
10" x 8"

Christopher T. Buoscio

"I have an interest in capturing the feeling of night. I am also interested in the approach of darkness and the changes that occur psychologically while viewing the onset of night.

My settings are usually places I am familiar with or ones that strike a chord with me.

I have always maintained that my work is less about a physical place but more about the effect that nightfall has on my perception of that place. I have moved toward focusing the content of the work on emotional responses.

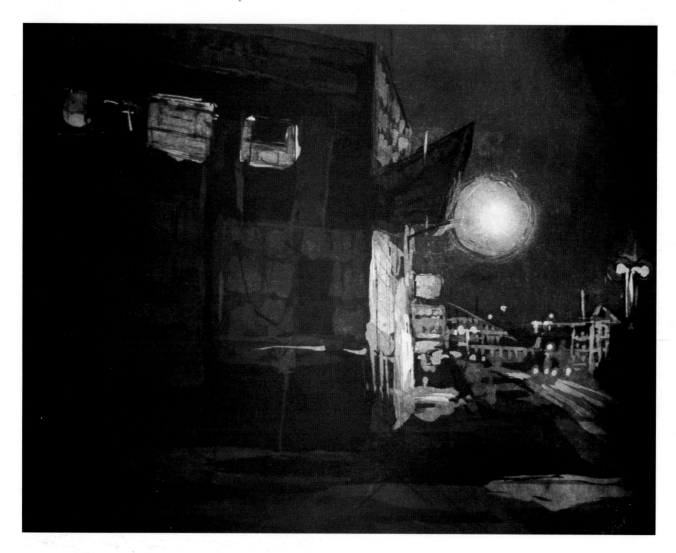

I have made an effort to quiet the work down, to make it less busy. I feel a true artist can speak simply yet universally. My admiration drifts towards artists whose economy of line speaks of their virtuosity.

At times, I feel a strong sense of history. My view is not solely about perceptions but recollections. I sense I am retracing my previous footprints and the paths of others.

The composition and framing in my work are influenced by film and photography. The stylistic choices in my work influenced by Film Noir are now giving way to a more subtle and personal viewpoint.

I consistently search for the evasive essence of what I do. My work has shown a consistent thematic arc; the progress is a growth, not a sporadic trying of things."

4. *Corner Street at Night*
1997
Etching on Tan Rives
BFK Paper
16" x 22"

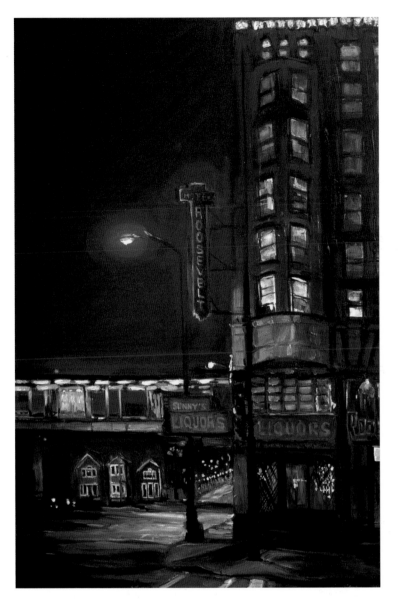

5. *Hotel Roosevelt at Night*
1999
Oil on Canvas
36" x 24"

BIOGRAPHY
Buoscio holds a Bachelor's degree in Fine Art from Illinois State University in Normal, and a Masters of Fine Arts in Printmaking from Ohio University. He has also studied at The School of the Art Institute in Chicago and attended a private workshop in Italian methods of intaglio and lithography at La Corte Della Miniera in Urbino, Italy.

Buoscio was a teaching associate for relief printmaking and drawing at Ohio University, and for painting and photography at Northern Indiana Arts Association. He has given presentations at art centers and universities.

Buoscio has had solo exhibitions at Cecelia Coker Bell Gallery in Hartsville, South Carolina, as well as Gallery 451 in Rockford, Illinois; Italian Cultural Center in Stone Park, Illinois; and Beverly Art Center, The Triangle Gallery of Old Town and Silver Cloud Supper Club in Chicago.

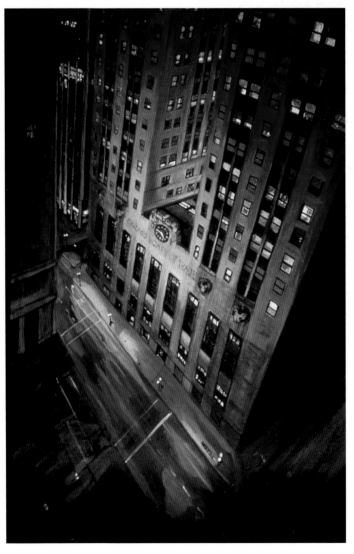

6. *Board of Trade*
1995
Oil on Canvas
72" x 48"

Buoscio has also exhibited at various local invitational and juried shows including the Annual Quad-State Juried Exhibition at Quincy Art Center, the Annual ARC Regional at ARC Gallery, *Big City* Invitational Exhibit at Las Manos Gallery, *Artwork 1998* and *Artwork 1999* at The School of The Art Institute, Union Street Invitational at Union Street Gallery as well as the 6th Mini Print International Exhibition in Binghamton, New York. He was awarded Outstanding Work at Artlink's 12th Annual National Print Competition in Fort Wayne, Indiana.

Buoscio is represented by Chicago Center for the Print and Raw Art Gallery in Chicago.

Pamela Callahan

"My paintings are studies in human nature and speak of my fascination with it, with all of our tendencies and struggles, and also with our attempts at peace. Painting is my attempt at making peace, making a connection with even the most deviant parts of myself and then maybe also with others in this world. I seek out the parts of ourselves and of our nature that elude us. I constantly seek for what is true about this living. I seek balance from opposites: knowing and not knowing, kindness and bitterness, uniqueness and universality, seeking out and letting go. I do this so that we may see ourselves and others with open eyes and hearts and minds.

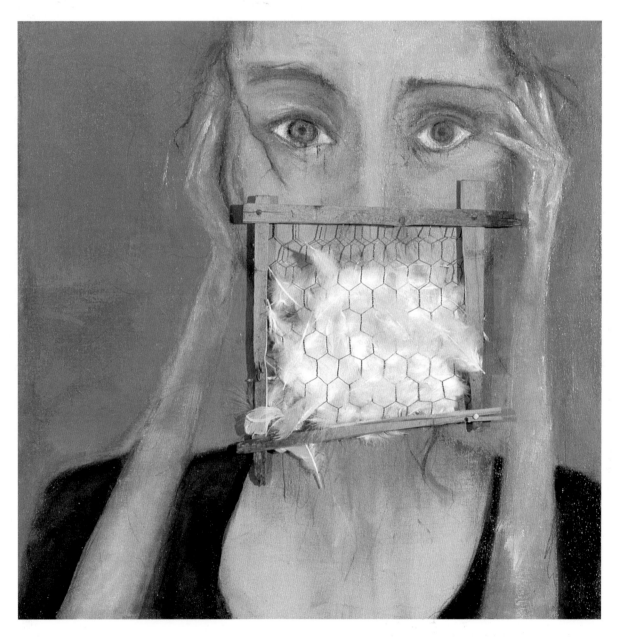

And even while I search for understanding, my hope is that these images encourage the relinquishing of this urgent need to comprehend all and everything. Instead they provide a place, an opportunity, to simply revel in, meditate on, or maybe even shake our heads at the wonder and strangeness of our experiences as human beings.

As for my approach to creating such images, I find that more and more, in addition to oil paint, I'm using materials at hand: wood, wire, string, leaves, wax, feathers and other treasures found on the street. Sometimes found objects tell a story somehow simpler and stronger than we humans are able."

7. *Coop*
1999
Oil and Mixed Media on Linen
28" x 28"

9. *Rise*
 1999
 Oil and Mixed Media
 on Linen
 66" x 44"

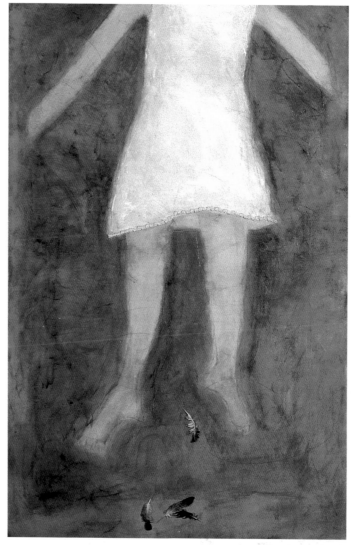

8. *Man at Peace*
 1998
 Oil and Mixed Media on Linen
 62" x 34"

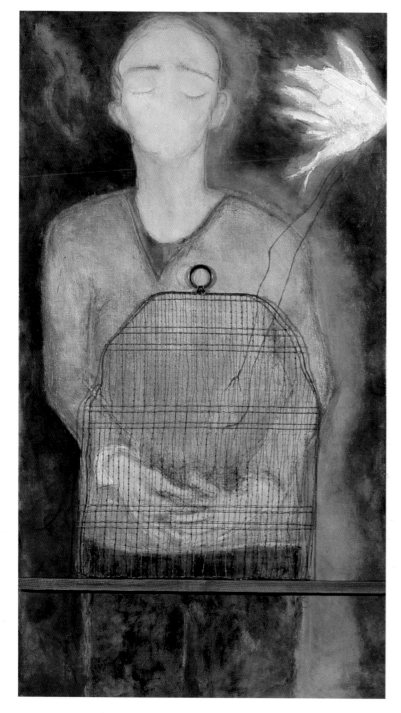

BIOGRAPHY

Callahan holds a Bachelor's degree in Studio Art from Lawrence University in Appleton, Wisconsin. She was curatorial assistant at Walker's Point Center for the Arts in Milwaukee, and has been the Gallery Director of Woman Made Gallery since 1997.

In recent years, Callahan has participated regularly in juried exhibitions, such as Around the Coyote Arts Festival, Chicago Art Open, and the Winter Juried Exhibition at Anderson Art Center in Kenosha, Wisconsin. Her work was also shown at Woman Made Gallery; the Leigh Yawkey Woodson Art Museum in Wausau, Wisconsin; and The Women's Center Gallery and the Toucan Gallery in Billings, Montana.

Steven Carrelli

"I focus on minutely perceived small forms from nature. Attention is lavished on the individual components of a landscape—a single leaf, a seed, a cluster of berries. Although the small works depict objects isolated from their 'natural' environment, the images are infused with a sense of a larger whole: the macrocosm implied through the microcosm.

I work in egg tempera on panel. My paintings are created using an exacting, time-consuming technique in which thin layers of paint are repeatedly overlaid onto the existing stratum. This repeated layering mirrors what is required of the viewer—a contemplative frame of mind."

10. *Pendulum*
1998
Egg Tempera on Panel
14¾" x 10¾"

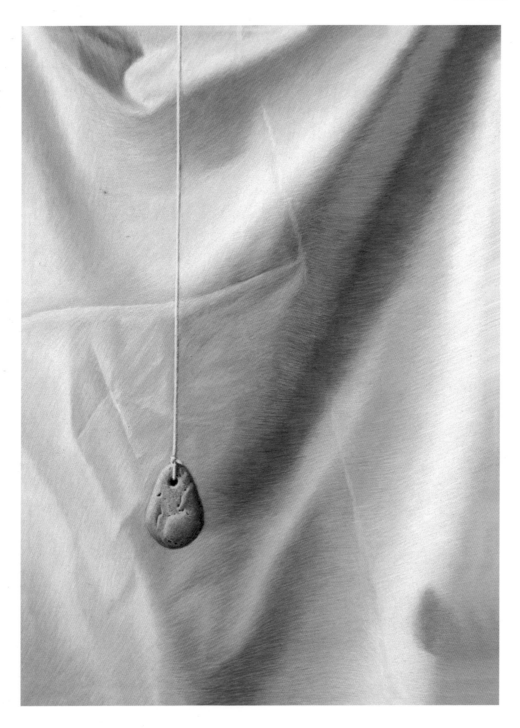

11. *Measure*
1994
Egg Tempera on Panel
2⅜" x 7⅞"

BIOGRAPHY

Carrelli received his Bachelor's degree in Studio Art from Wheaton College, and his Master of Fine Arts degree in Painting from Northwestern University in 1995. He has taught at The Muse Theater Company in Wheaton, Illinois; Northwestern University; Evanston Art Center; and Chicago Metropolitan Center and has lectured at a number of museums and colleges, including Midwest Museum of American Art in Elkhart, Indiana; Canton Art Institute in Ohio; Notre Dame University in Indiana; and Studio Art Centers International in Florence, Italy. He currently teaches drawing, painting and art history at DePaul University.

Carrelli has had recent solo exhibitions at Wood Street Gallery in Chicago and Notre Dame University in South Bend, Indiana. He has also exhibited at Suburban Fine Arts Center in Highland Park; Trinity Christian College in Palos Heights; Fourth Presbyterian Church in Chicago; Kendall College of Art and Gallery Arcadia in Grand Rapids, Michigan; and Susan Cummins Gallery in Mill Valley, California. He is represented by Wood Street Gallery in Chicago.

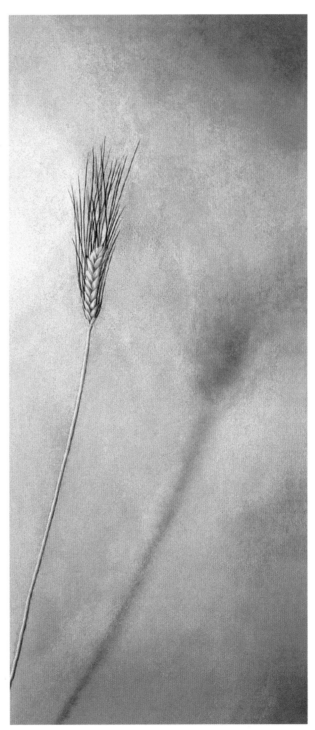

12. *Untitled (Wheat Stalk #2)*
from *Four Wheat Stalks*
1997
Egg Tempera on Panel
21" x 9"

M. Ivan Cherry

"Genre, specifically exploration of the domestic male have preoccupied me thematically. My paintings deal with clumsy father fingers, piles of laundry, ironing clothes, never-ending chores and all the other wonderfully monotonous happenings in the household. The spaces serve to define the figures and yet they confine them. The common objects relay meaning and are also enjoyed for their own particular objectivity. We are overwhelmed with a feeling of both anxiety and tedium, of responsibility and duty, and of the splendor of 'busting the seams' chaos. The paintings seem to spin out of control and yet there exists somewhere a focal point that anchors us to stability, even if that anchor is an ironing board. What holds it all together is the physical act of working through to find the meaning.

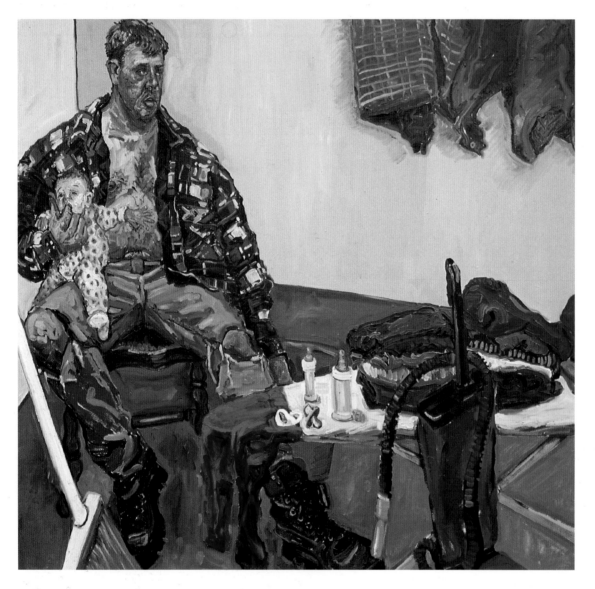

13. *Empty Bottles…Loads of Laundry*
1998
Oil on Canvas
64" x 70"

Most recently my observations have taken me into the bedroom. I have constructed my canvases to the exact dimensions of bed mattresses, hence the sizes are King, Queen, Full, Twin, etc. Before painting my figures I tend to lay in the patterns, prints and solids, having received much inspiration from fabric stores, linen stores, and clothing stores. I then lay my models horizontally before me and paint. In the end, however, the paintings are arranged in a vertical format. By doing so I alter our understanding of perception and skew our sense of reality. I have permanently suspended them from the rest or comfort that is so desired. This is not done for sardonic intent. Rather I use it as a convention to explore the possibilities of body language and what it can represent in the expression of both individuality and universal experiences."

BIOGRAPHY

Cherry was born in Arizona. He received his Bachelor of Fine Arts degree from Northern Arizona University in 1996 and his Master of Fine Arts degree from The School of the Art Institute of Chicago in 1998. He has been an art instructor at Evanston Art Center and in the Early College Program at The School of the Art Institute. He has also taught courses in Art Immersion and Art Appreciation at University of Chicago, The Graham School of General Studies.

Cherry has received many awards, including a full scholarship at The School of the Art Institute. His work was exhibited at an international juried competition at The Museum of Church History in Salt Lake City in 1997 and the First Annual Juried Competition on Portraiture at Elmhurst Art Museum. His work was also exhibited on several occasions at the Contemporary Art Workshop. In 2000, along with his solo exhibition at Northern Arizona University, he was invited there as guest lecturer and juror for a student exhibition.

14. (below)
Suspend
1999
Oil on Canvas
75" x 39" (Twin)

15. (below, right)
Bump
1999
Oil on Canvas
80" x 60" (Queen)

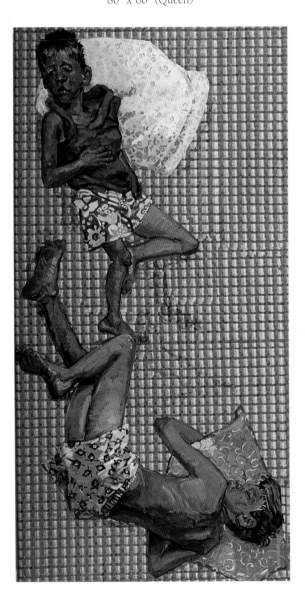

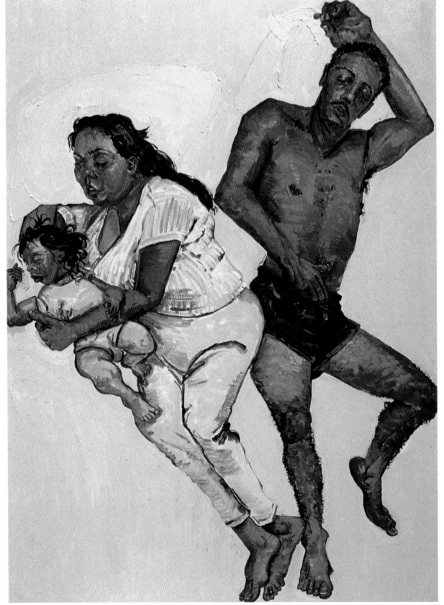

Rimas Ciurlionis

"In my work, I express the interaction and relationship of color, tone, line and form. I'm especially captivated by texture on a surface—smooth and rough, depression and elevation. By using these relationships, combining them, playing one off the other, I attempt to bring the work to an abstract, maximally concentrated conclusion. This intense process brings out my intuition and a sense of the interconnectedness of all things.

In my hands, a painting or work on a flat surface, be it canvas or wood panel, takes on a more sculptural image. Like a musical sound, it does not obligate. It only elicits or awakens in us an emotion, a mood, an idea, a memory. It can be an impulse which starts a wave that reaches out and touches our existence.

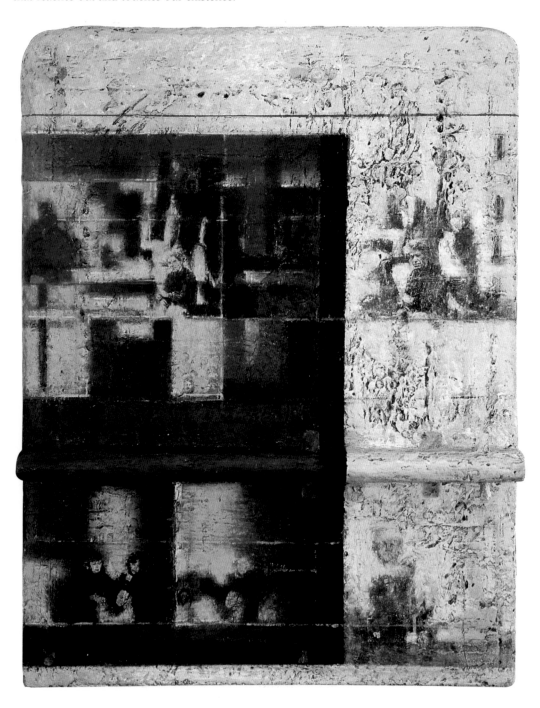

I use a combination of materials including marble dust, sawdust, paper pulp and acid-free glue to create the texture in my work. It is important that the surface on which the paint is applied be strong yet flexible. I also incorporate found objects from nature such as stones and driftwood in my work."

BIOGRAPHY
Ciurlionis was born in Kaunas, Lithuania. He studied painting and graphic design at the Stepas Zukas Art College and participated in numerous solo and group exhibitions throughout Lithuania. For eleven years after college, he was employed in the restoration of frescoes at the Pazaislis Monastery outside of Kaunas. In 1989, he was awarded an artist residency in Schwalenberg, Germany. While there, he had several exhibitions and was placed second in an art competition to commemorate the 800th year anniversary of the city of Lemgo.

16. *From Another Light*
1998
Oil on Particle Board
20" x 15½"

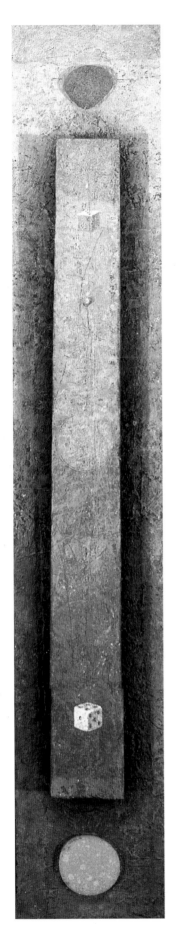

In 1992 Ciurlionis came to the United States and settled in Chicago. He has had recent solo exhibitions at Balzekas Museum of Lithuanian Culture and Collins Fine Art. His work has been shown in California at Gallery 224 in Laguna Beach, Linda Warren Fine Art in Los Angeles, and the Palm Springs Art Expo. His work is in numerous private collections both in the United States and abroad. He is currently working with Collins Fine Art in Chicago and with Linda Warren of mamisi.com based in Los Angeles.

Ciurlionis is a featured artist of *The Chicago Art Scene* by Ivy Sundell (1998).

17. *Table*
 1998
 Oil and Stone
 on Particle Board
 33⅛" x 6" x 2½"

18. *Doors*
 1998
 Oil and Stone on Particle Board
 12" x 7½"

Grace V. Cole

"With these new works I have wished to express a sense of trepidation for our world today and a feeling of hope for the new millennium. The objects, landscapes and figures in the oil paintings are used as metaphor. The ripe and decaying fruit, the serene and polluted landscapes, the reflective figures, all express mankind's struggle for growth and balance in existence. Light plays an important role in setting a mood.

Craft is a critical part of my work. My fascination with and admiration of the great masters have been my inspiration: Rembrandt for humanness, Titian for color and the contemporary artist, Odd Nerdrum, for atmosphere.

Art, as a record of human history, compels me to create works that will speak of our time—yet reflect a continuing period of change and expectations."

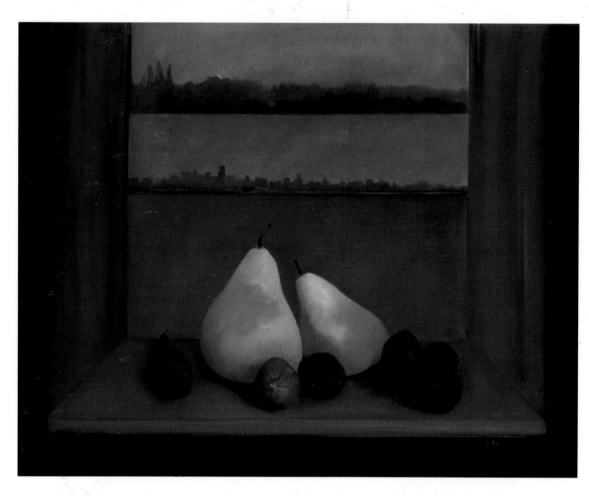

19. *Museum of...Idols*
2000
Oil on Linen
22" x 28" x 2"

BIOGRAPHY

Cole studied at The School of the Art Institute of Chicago, University of Chicago, and at École Albert du Fois Vihiers in France with Ted Seth Jacobs. She also had private apprenticeships in painting, drawing and sculpture. In 1994 she was given the Golden Apple Award in recognition of her exceptional teaching at Prairie State College in Chicago Heights. She now teaches privately in her studio.

Cole has had many solo and group exhibits. Her recent solo exhibits were held at The Arts Club in Washington D.C.; The Cliff Dwellers and The University Club in Chicago and Illini Gallery at University of Illinois, Chicago. Her group exhibits include University of

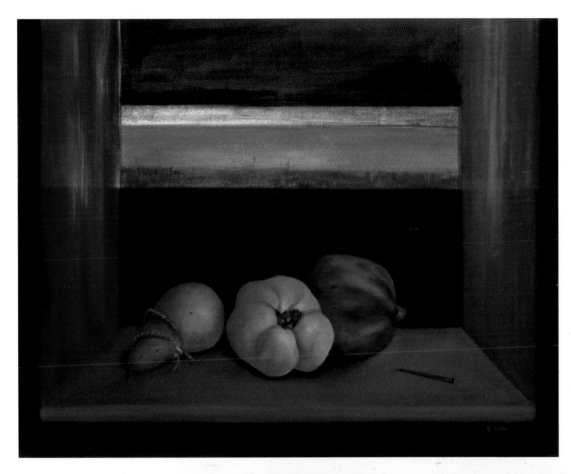

West Florida in Pensacola, Arts Council of South East Missouri in Cape Girardeau, University of Wisconsin in Oshkosh, Prairie State College in Chicago Heights, The Armory in New York City, and Art Chicago.

Cole's work is in many public and private collections in the United States, England and France. She is currently represented by Byron Roche Gallery in Chicago and Judith Racht Gallery in Harbert, Michigan.

Cole is one of the jurors for *The Chicago Art Scene* by Ivy Sundell (1998).

20. **Museum of…Compassion**
2000
Oil on Linen
22" x 28" x 2"

21. **Museum of…Passions**
2000
Oil on Linen
22" x 28" x 2"
Collection of John and Ladd Mengel

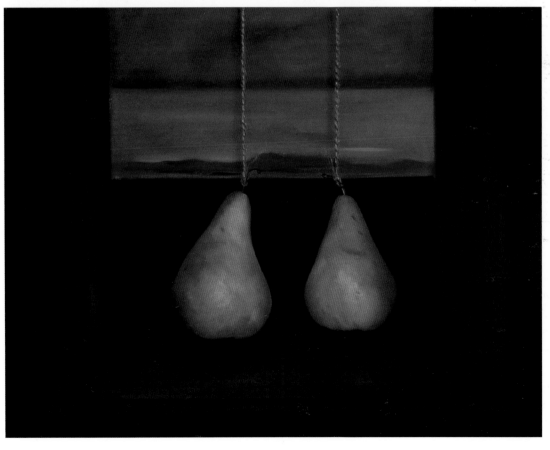

Andrew Sterrett Conklin

"My subject is human figure, depicted most often in pleasure-seeking activities. Some of my recent pictures include a painter and model, masked Venetian revelers, practicing musicians, and art students copying sculpture. Though I have been painting for 19 years and teaching for nine, I am still an avid student. My passion is for Dutch and Northern Italian Baroque painting.

My interest in drawing the figure began in childhood. I drew pictures of football players, race car drivers, pirates and astronauts on stationery my father brought home from his office.

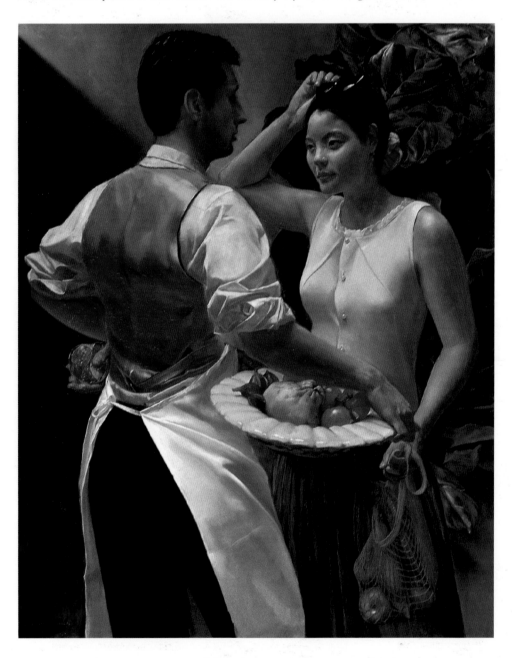

22. *Gourmet Garage*
1997
Oil on Linen
40" x 32"

I first encountered a nude model in art school, and my attempts at drawing from life were humbling. It became a personal challenge to achieve an accurate and lively representation of the figure on paper. Painting the figure, with its use of color, paint media and technique, was exponentially more demanding and intriguing. Producing a beautiful figure painting, I thought, was a goal that would take a lifetime to achieve.

At age 38, I believe I am painting at the peak of my technical proficiency, but I am only now able to express what I want with the medium. I look forward to producing paintings containing all the lessons I've learned, not only in the years of my training as an artist, but more importantly, in my experience of the world. I want to show others that this traditional art form can lift the spirit with its silent explication of the beauty, dignity and grace of the human being."

BIOGRAPHY

Conklin was born in Chicago. After graduating from the American Academy of Art in Chicago, he studied at the National Academy School in New York City. He also studied at the Art Students League of New York and with portraitist Aaron Shikler and painter and illustrator David Levine. Between 1989 and 1997, he has studied independently in Italy, Spain, Holland, Belgium, England and France.

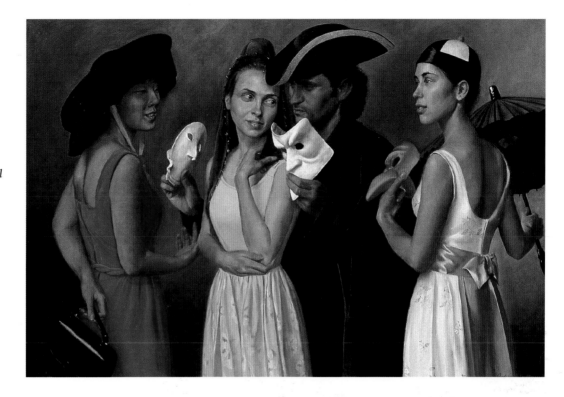

23. *Venetian Ball*
1999
Oil on Linen
38" x 56"

24. *Artist and Model III*
1999
Oil on Hemp
52" x 72"

Conklin has been an instructor at the New York Academy of Art since 1993 and was faculty member at its Graduate School of Figurative Art from 1995 to 1999. He has also taught at Parsons School of Design, National Academy School of Fine Arts and the American Academy of Art in Chicago. He is currently a lecturer at Harold Washington College in Chicago.

Conklin has exhibited his figurative paintings throughout the East Coast and has won a number of major awards. He has exhibited at the American Academy and Institute of Arts and Letters and the *Century Collectors' Show* in New York, and Fairfield University in Connecticut. Locally, he exhibited his work at Lyons Weir Gallery in 1999. He is a three-time recipient of the Elizabeth Greenshields Foundation Grant.

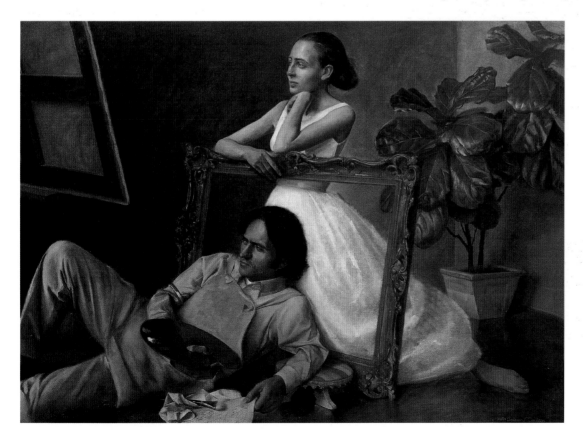

Conklin's work is found in numerous public and private collections. His subjects include two U.S. District Court judges, a governor of Rhode Island and a dean at Princeton University. His work was featured in *American Artist* magazine in December 1991 and January 1998, and in *The Artist's Magazine* in November 1994.

Dick Detzner

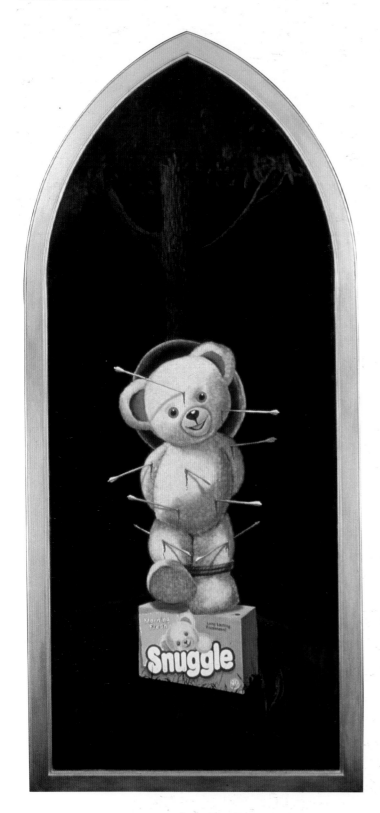

25. *St. Snugglebear*
1998
Oil on Panel
80" x 36"

REVERENCE AND SACRILEGE

"For the last year and a half, I have been examining those things which inspire reverence. By combining more traditional with less traditional symbols, cultures and mythologies, I try to get people to examine just where their reverence actually lies. Thus far, I've concentrated on the role played by corporate icons as tools for modern advertising. Many people may not realize that these advertising symbols affect more viscerally and with more immediacy than traditional religious stories. Advertising and religion are only two areas of culture which inspires devotion, but there are many others, such as sports, politics, music, art, literature and fashion. For many, including myself, this is an unconscious process—something people soak up through the culture they live in. I merely make it more conscious."

BIOGRAPHY

Detzner received his Bachelor of Fine Arts degree from University of Notre Dame and has studied at the American Academy of Art in Chicago.

In the last two years, he has had solo exhibits at The Boulevard, Yello Gallery, and Fred Burkhart Gallery in Chicago, and Center for the Study of Art & Architecture in Champaign, Illinois. He has also exhibited at Wood Street Gallery, Izzo's Artery, Cambium, and Lucky Horse Gallery in Chicago as well as at Gallery 84 in New York; Charlotte County Art Guild in Punta Gorda, Florida; and Yorkarts Gallery in York, Pennsylvania. In 1997, he received the Crescent Cardboard and Napa Valley Awards from the Kentucky Watercolor Society. Other awards include a grant for a painting residency at Vermont Studio Center and a grant from the City of Chicago Department of Cultural Affairs.

Detzner's work has been featured in *Art Calendar Magazine, Creativity Magazine,* and *Art & Performance Magazine.*

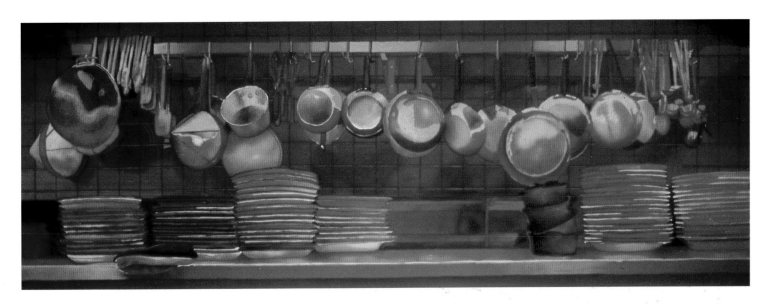

26. *Hot Pots*
 1999
 Watercolor
 28½" x 68"

"My latest series of watercolors deals with objects and utensils found in the kitchen, both residential and professional. They provide a variety of shapes and tones, often with a very musical feeling."

27. *Pastry Table*
 2000
 Watercolor
 27" x 20"

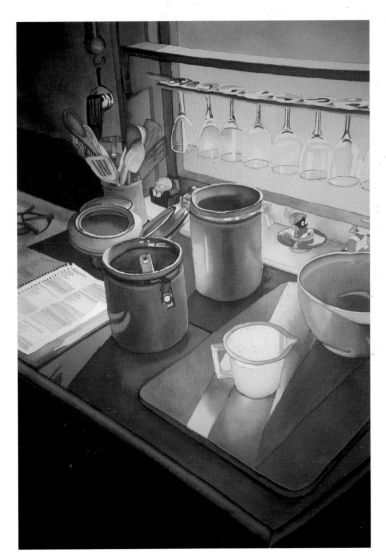

Dzine

"I do not usually write statements about my work…as I feel the work should speak for itself."

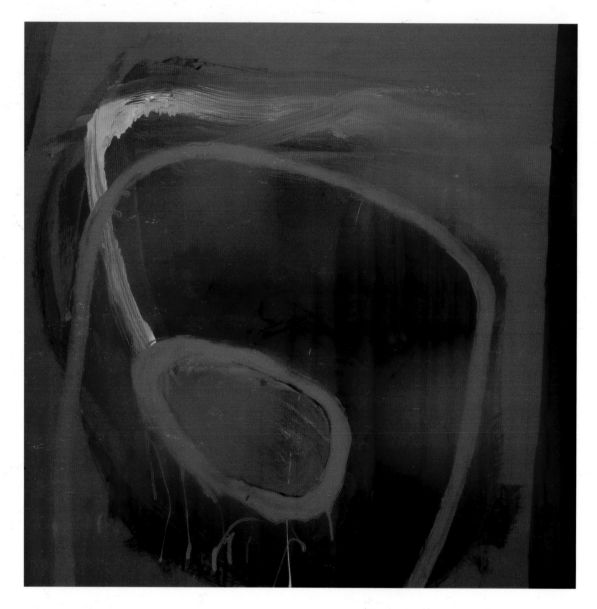

28. *The Other Side Part II*
1996-1999
Enamel and Envirotex on Canvas
31½" x 31½"

BIOGRAPHY

Dzine was born in Chicago as Carlos Dzine Rolon. He grew up in the southwest side of the city painting elevated rooftops and trains along the Chicago subway systems. At the age of twenty-nine, Dzine has exhibited his paintings, constructions and mural installations in galleries and museums in Paris, Italy, England, Spain, Portugal, Japan, Canada, New York, Los Angeles and his home town of Chicago.

In 1998 Dzine received a grant from the City of Chicago Department of Cultural Affairs' Chicago Artists International program for a four month residency in Nairobi, Kenya. While there he exhibited his paintings at the Maison-Française French Cultural Center, and worked with local artists to develop murals dealing with the awareness of the AIDS epidemic in the rural parts of Nairobi. His work has also been featured during the European Donostiako *Jazzaldia* jazz festival in San Sebastion, Spain.

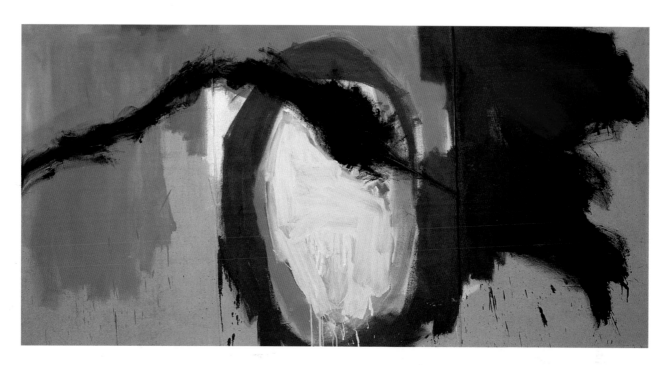

29. *Jin Ping Mei*
1998
Oil on Canvas
48" x 96"

Dzine is working on several projects for 2000. His work will be exhibited internationally with *Bossa Très...Jazz, when Japan meets Europe*, the latest release of the French Record Company Yellow Productions. He has created a series of twelve paintings which will serve as the main visuals for the double album and CD ROM which contains a limited edition full color catalog, and will participate on the tour in Paris, Japan, New York and London. He will also have solo exhibitions of his paintings and installations at the Union Gallery of University of Madison in Wisconsin; Cristinerose Gallery in New York; and Eastwick Gallery in Chicago.

Dzine is represented by Eastwick Gallery in Chicago and Laurence Taburiaux in Paris.

30. *Sucker Punch*
Detail
1999
10' x 30' site-specific
installation
CSPS/Legions Arts,
Cedar Rapids, Iowa

Curt Frankenstein

"One art teacher I admired told his students that if they want to be an artist, they have to develop a philosophy. Completely misunderstanding him, I rushed out and purchased Durand's *The Story of Philosophy*. Now, after many years, I realize I want to paint pictures that reflect a bit of the human condition—the illusions we all labor under, the paradoxes that life presents."

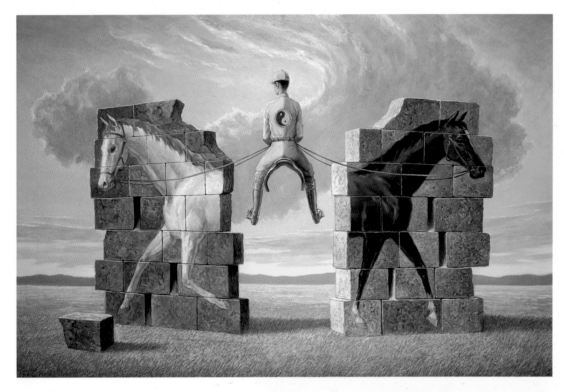

31. *The Yin-and-Yang Rider*
 1999
 Oil
 42" x 60"

"The Yin-and-Yang Rider shows man suspended between positive and negative forces. He can choose either way, nevertheless both halves constitute one whole nature."

32. *Victory of Spring*
 1999
 Oil
 36" x 48"

33. *The Juggler*
1996
Oil
54" x 36"

BIOGRAPHY

Frankenstein came to the Chicago area from Germany when he was 25. He attended the American Academy of Art, The School of the Art Institute of Chicago and the Otis Art Institute of Los Angeles. Subsequently he took courses in lithography under Max Kahn at the School of the Art Institute and in etching under Hedi Bak at Studio 22 in Chicago. He now resides in Wilmette where he has a studio and a printshop with his own etching press.

Frankenstein has been in many solo and juried group shows. Some of his local solo exhibitions were held at Illini Union, University of Chicago; American Bar Association Foundation; Wilmette Public Library; Illinois Institute of Technology; Chicago Cultural Center; and David Adler Cultural Center in Libertyville. In recent years he has participated in the Port Clinton Fine Arts Festival in Highland Park, Oakbrook Fine Arts Promenade, The Municipal Art League of Chicago and Baer Memorial Competition held at the Beverly Art Center. His exhibits in other states, at other colleges, universities and art fairs, and his awards from various competitions are innumerable.

Frankenstein's work was featured in various publications, including the Union League Club centenary art catalog, *One Hundred Years,* in 1987; and Louise Yochim's *Harvest of Freedom* in 1990. He is a member of The Print Consortium.

Harold Gregor

"Because twenty-first century issues and values will be different from those of the twentieth and nineteenth centuries, landscape painting today, to be of insightful consequences, needs to be as remote as possible from past artistic conventions and expectations. Landscape painting needs to be 'of our time' and perhaps even beyond our time; but at the same time it must not detach itself too far from nature. Landscape painting without an anchoring natural reference is not landscape painting but something else.

34. *Illinois Flatscape #61*
1997
Acrylic on Canvas
60" x 82"

I use three travel modes as a basis for painting the prairie scene: flying, driving and walking. This leads to three types of depiction: the Panorama which deals with problems of realistic depiction, the Flatscapes which offer color-modified and pattern-enhanced depiction, and the Trail paintings which concentrate on expressive depiction. Seen together the work makes manifest my attempt to embrace essential characteristics of the present day prairie scene, a scene too complex to be known from a single aspect.

In 1988 I painted my first panorama using a 1:8 format. A panorama requires a different spacial emphasis than does a 'window space' painting. Instead of focal points typical of window space, the panorama requires a 'roll-on' perspective which is realized by grouped areas. This arrangement matches the way most of us view the prairie farmland today—riding past it in an automobile, momentarily focusing on something, then drifting until another feature attracts our attention.

About six years ago, I began doing Trail paintings. These works fuse an exciting color array within a gesturally layered, overall format that is hoped to express the sparkling warmth that can be absorbed when walking the trail."

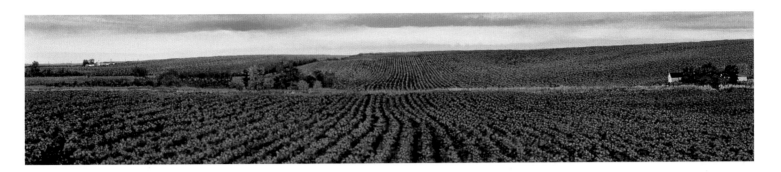

35. *Illinois Landscape #153*
1999
Oil, Acrylic on Canvas
18" x 90"

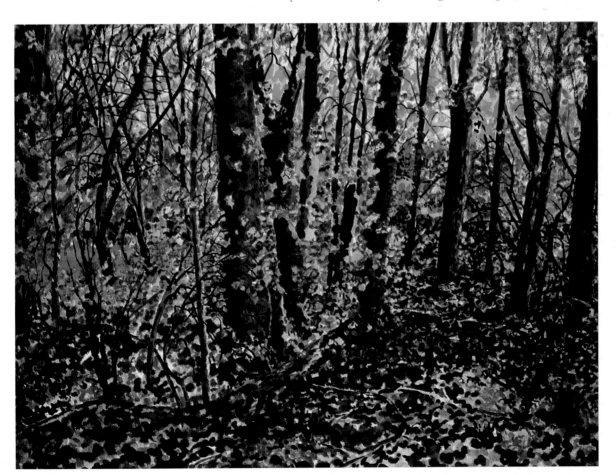

36. *Pink Edge Border*
1997
Watercolor, Crayon
18" x 24"

BIOGRAPHY

Gregor was born and raised in Detroit. He received his Bachelor's degree from Wayne State University and his Master's degree in ceramics and painting from Michigan State University. After spending two years in the Army and three years as a clay modeler with the Chrysler Corporation, he then completed his Ph.D. at Ohio State University in painting, aesthetics and art history. He has taught at San Diego State University and served as head of the art department at Chapman College in Orange, California. He has been teaching at Illinois State University in Normal since 1970.

In 1993 Gregor was awarded the Illinois Academy of Fine Arts Lifetime Achievement Award. He also received the Burlington-Northern Award for Outstanding College Teaching, and two awards from Illinois State University as Outstanding and Creative Researcher, among others.

Lakeview Museum of Arts and Science in Peoria held a retrospective traveling exhibit of his work in 1987. In 1993-1994, Rockford Art Museum also held a retrospective exhibition of his work. Gregor has had many solo exhibitions including those at Richard Gray Gallery and Nancy Lurie Gallery in Chicago, Tibor De Nagy Gallery and Sherry French Gallery in New York, Marvin Seline Gallery in Houston, and Iannetti-Lanzone Gallery in San Francisco.

Gregor is represented by Richard Gray Gallery in Chicago, MB Modern Gallery in New York, Gerald Peters Gallery in Santa Fe, Elliott Smith Contemporary Art Gallery in St. Louis and Tory Folliard Gallery in Milwaukee.

Pamela J. Hart

"I have always taken the subject matter for my paintings from nature. In my early paintings I worked in dark tones with leaves and settings based on the forest floor. For several years I worked on a series of fungus paintings, highlighting their delicate and beautiful undersides. I once spent a whole morning drawing the most healthy plant I had ever seen only to find out later it was Poison Ivy. The focus of my paintings have now shifted to landscapes and my style has shifted as well. While my early paintings were more detailed and almost photographic, presently my work has a lighter, more impressionistic style.

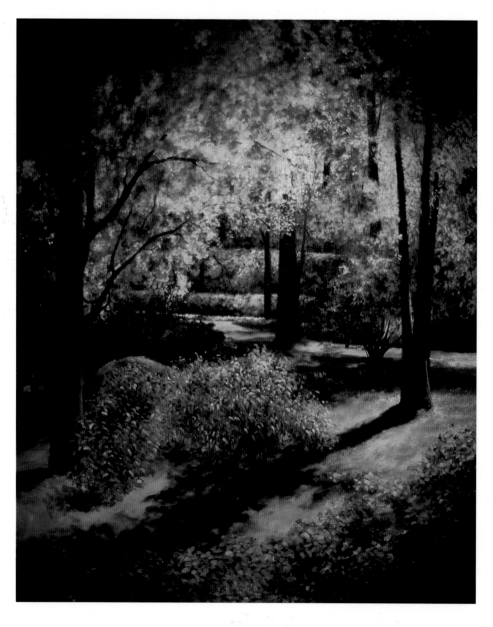

37. *Untitled*
 2000
 Oil on Canvas
 43" x 40" x 1¼"

"All of my paintings are 1¼ inches deep. I don't frame them. I wrap the canvas to the back and continue painting around the edges. I find this makes them appear more expansive."

My current work is a series of paintings from our local gems—Cantigny, Chicago Botanical Gardens and The Morton Arboretum. I call this series 'Pathways' because I am intrigued by the play of light and shadow on the paths and walkways of these settings—the light from dawn to dusk, and Spring to Winter. With my interest in gardening, it is not surprising that many of my paintings include periodic stands of flowers in full bloom."

BIOGRAPHY

Hart received her Bachelor's and Master's degrees from Ball State University. She has been painting with oils on canvas for over 25 years.

Hart has held solo exhibitions at Union League Club in Chicago, Cantigny Visitor Center and Schaffer Gallery in Wheaton, and Jefferson Hill Street Shops in Naperville. She has shown her work at various local invitational exhibits such as the Vicinity Show at Norris Gallery in St. Charles, and Aurora University's Annual Area Invitational. She has also exhibited at local art fairs and art league exhibitions such as the Oak Park Art League exhibition, Naperville Art League exhibition, Oak Brook Terrace Art Show, Danada Nature Show in Wheaton, Downers Grove Fine Art Festival, Glen Ellyn Festival of the Arts, Evanston Lake Shore Art Festival, Art in the Barn in Barrington, and many more. In 1999 she was a Finalist in the Alice and Arthur Baer Art Competition and Exhibition and in 2000 she won an Artistic Merit Award at the Women's Work Art Exhibition in Woodstock, Illinois.

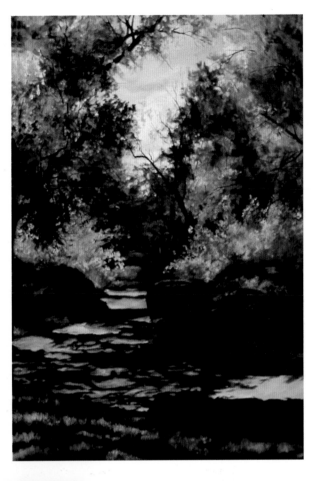

38. *Dark Shadows*
1997
Oil on Canvas
30" x 24" x 1¼"

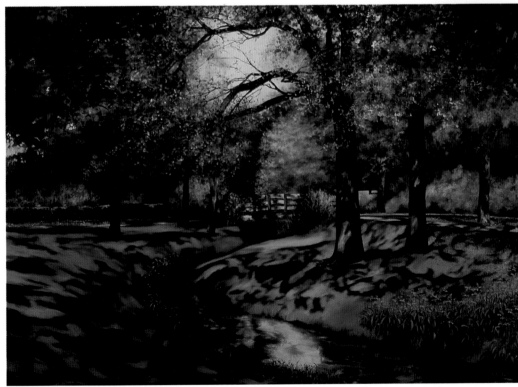

39. *Daylily Bridge*
1999
Oil on Canvas
34" x 48" x 1¼"

Eleanor Himmelfarb

"Celebration of quotidian phenomena that recognizes universal application attracts me. Rather than painting things I prefer to paint ideas. The manner of presenting an idea is as important to me as the idea itself. Therefore I am painting on more than one level at a time. Sometimes an idea suggests more than two layers of image—that really gets exciting. Pushing beyond is where the fun is.

Whether it's an unfamiliar alphabet, a gate that invites as well as restrains, color that moves in and out or up and down, the intention is to create a fresh visual experience that provides as many questions as answers. Enjoy the trip up the hill, watch the letters play, participate in festivity or in exotic calm. The implied velocity of strong diagonals underlying the fluid forms of nature or the sinuous forms of letters create a mesmerizing kaleidoscopic mood."

40. *Inside or Out?*
1999
Acrylic on Canvas
48" x 60"

41. *Signs on the Gate to the Park*
1998
Acrylic on Canvas
48" x 48"

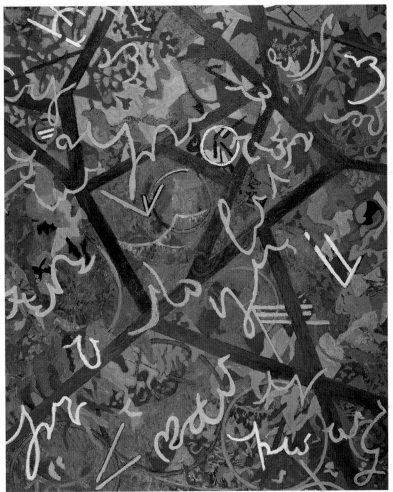

42. *Alpha Fest*
1996
Acrylic on Canvas
58" x 47"

BIOGRAPHY

Himmelfarb is a native of the Chicago area. At the time she studied art history and design at University of Chicago, no studio work was offered. Later, while working at The Morton Arboretum, she took classes at The School of the Art Institute and the School of Design, and studied with Abbott Pattison, Claude Bentley and Morris Barzani. A major part of her training also came from working in her husband's studio.

Himmelfarb has taught courses in painting and design for many years at Rosary College, Triton College and the College of DuPage. In 1993 she was artist-in-residence at Illinois State University in Normal. Currently she teaches exclusively for the DuPage Art League.

Her solo exhibitions include Gallery 1756, University Club, and Jan Cicero Gallery in Chicago; Evanston Art Center; Chicago Street Gallery in Lincoln, Illinois; and Gallery 72 in Omaha, Nebraska. Her group shows at various Illinois locations include the Norris Gallery Invitational in St. Charles, Lake County College in Grays Lake, and Elmhurst Art Museum. In 1990 she was part of *The Chicago Show* at The Art Institute of Chicago and Museum of Contemporary Art. Outside of Illinois, she has shown at Peltz Gallery in Milwaukee; John G. Blank Center for the Arts in Michigan City, Indiana; and Johnson County Arts Council Gallery in Iowa City, to name a few.

Himmelfarb's work is in many private and public collections, such as The National Museum of Woman in the Arts in Washington D.C.; Mary and Leigh Block Museum of Art at Northwestern University; and Normal Editions Workshop at Illinois State University. She is represented by Gallery 1756 in Chicago.

Jean Hirsch

"Fossils and stones tell the story of time. Time, defined by us in terms of a human construct, is not really human-bound at all. These small rock that I paint can predate the advent of life and are certainly not carved by a person. However, they do record past epochs and the movement of chemical and geological forces that no person ever saw or recorded. Nature left its marks in the stones and rocks and those marks can be read, just like the written word, if one knows how to look and interpret.

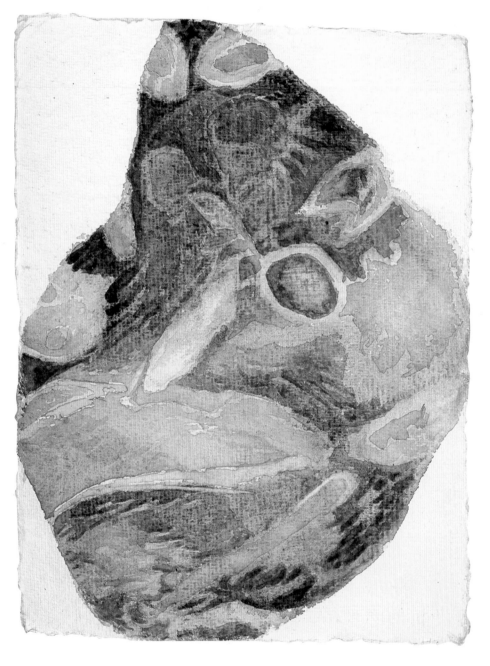

I, as a landscape painter, have earlier used nature's large primal markers—upheaved mountains and prehistoric-made waters to record, ask about and interpret Earth's story visually. However, wherever I have gone, I found evidence of earth's immense forces recorded in very small objects—stones and fossils. That such strength of forming can be seen in the very rocks and pebbles found at our feet astonishes me. I am an artist, not a scientist, and these paintings are meant to ask questions, not answer them. The painterly and sculptural qualities of stones are provocative to me as an artist. The amalgam of colors, the way the forms can catch and reflect light, the crevasses formed by past living creatures, the edges which turn into form are the abstract qualities which I try to bring into the works. The fact that these works are in watercolor adds an allusive quality to the time-marks of the stones. Watercolor is the most delicate and vaporous medium a painter can work with. To be able to bring the hardness, grittiness and strength of these stones and fossils to a presentation on paper is a formidable challenge. My purpose is to alert the viewer to the visual possibilities of these natural markers of history, their importance in time and their innate beauty."

43. *Rock Mark IX*
1999
Watercolor
8" x 6"

BIOGRAPHY

Hirsch was born in Detroit, Michigan and has taught art in Ann Arbor for a number of years. She received her Bachelor of Fine Arts in Painting from University of Michigan. For the past 27 years, she has lived in the Chicago area with extended stays in Bloomington, Indiana; Palo Alto, California; and Tucson, Arizona. She is currently a faculty member of the Evanston Art Center, teaching Watercolor, Drawing and Outdoor Landscape Painting. In 1999, she demonstrated watercolor techniques at The Kraft Education Center of the Art Institute of Chicago.

Hirsch's work has been exhibited in galleries and museums around the country. In the last two years, her work was shown at the Downey Museum of Art in Downey, California; the Annual Greater Midwest International Exhibition at Central Missouri State University in Warrensburg; University of Richmond in Virginia; and Snowgrass Institute of Art in Cashmere, Washington. Locally she has exhibited at

45. *Rock Mark VII*
1999
Watercolor
8" x 6"

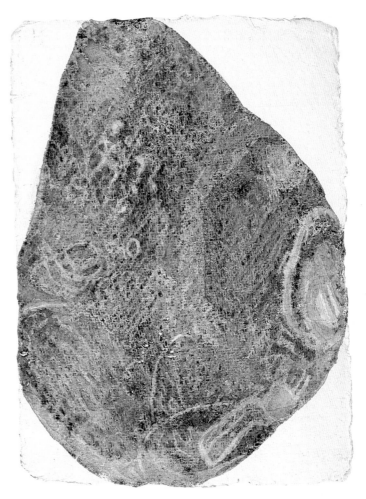

Union Street Gallery in Chicago Heights, Chicago Botanic Garden in Glencoe, and at Gwenda Jay Gallery, An Art Place Gallery and Woman Made Gallery in Chicago. In 1999, she exhibited her work at Belloc Lowndes Fine Art as a featured artist of *The Chicago Art Scene* by Ivy Sundell (1998).

44. *Rock Mark V*
1999
Watercolor
8" x 6"

Ken Hoffman

"For the past fourteen years, the anthropomorphic subject matter of my animal portrait paintings have been the central focus of my artistic endeavors. My main objective has been to pursue this vigorous and quasi-surreal approach to the human head. It is my intention to convey to the viewer animal-people expressions and to show how close humans are to animal counterparts. In certain respects, it is my hope that the imagery parallels certain kinds of modern literature such as that written by Orwell, Kafka, Beckett and others, that is, of *Animal Farm, Metamorphosis, Waiting for Godot,* etc.

Technically I try to achieve painterly surface effects and a sensuous buildup of oil paint. Color is used as a complex and expressive method of mark making which is incorporated into the primary forms and surrounding space."

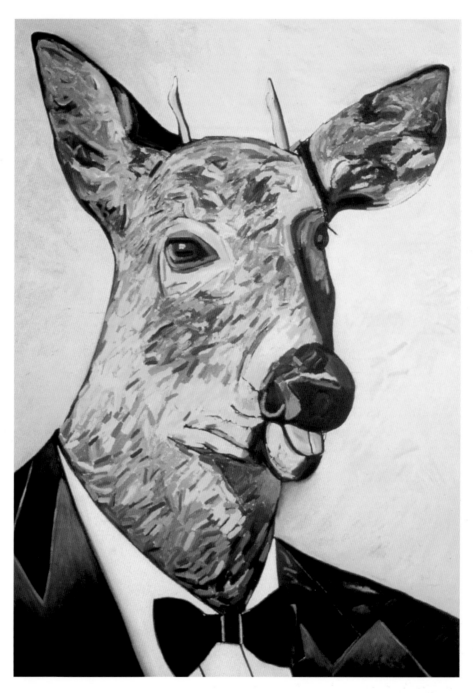

46. *Deer Man*
1996
Oil and Collage
72" x 48"

BIOGRAPHY

Hoffman received his Bachelor of Fine Arts and Master of Fine Arts degrees from San Francisco Art Institute. He has studied painting and drawing with Richard Diebenkorn, Julius Hatofsky, Jack Jefferson, Bruce McGaw and James Weeks, and has been teaching art at Bradley University since 1969.

Hoffman has an extensive exhibition list. In 1999 alone, he had solo exhibitions at Northwestern University Settlement's CCT Gallery in Chicago, Skokie Public Library and Gippsland Art Gallery in Sale, Australia and group exhibitions at Harper College National Exhibition in Palatine, Illinois; Pump House Regional Arts Center in La Crosse, Wisconsin; and Leftbank Gallery Annual National Small Works Competition and Exhibition in Salt Lake City, Utah. He also participated in art auctions, such as those organized by WTVP Channel 47, Heart of Illinois United Way, and Evanston Art Center. His work is in many private and public collections, including Rockford Art Museum, and Lakeview Museum of Arts and Science in Peoria.

Hoffman is currently represented by Animalia Gallery in Saugatuck, Michigan; and Walter Wickiser Gallery in New York.

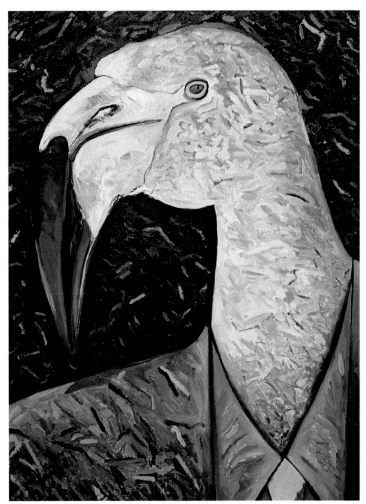

48. *Flamingo Man*
1999
Oil and Collage
56" x 39"

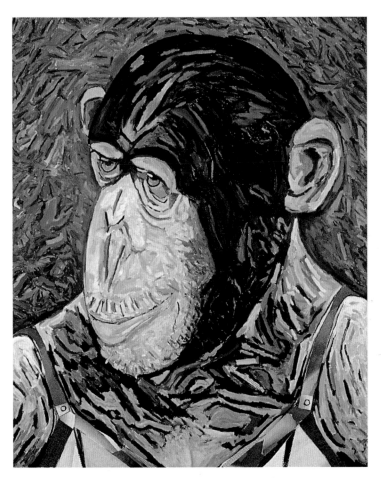

47. *Monkey Woman*
1997
Oil and Collage
60" x 48"

Stephen Horan

"I have been a landscape artist for the last twenty five years. During this time, I have worked in acrylics, pastels and silk screen printing. I have concentrated on landscapes of the rural Midwest and landscapes of the city. I am interested in capturing the basic geometric relationships and some of the spirit of a city such as Chicago, and the basic geological, agricultural and ecological order to be found in rural landscapes."

BIOGRAPHY

Horan holds an undergraduate degree from University of Chicago in economics and political science. He then worked on an advanced degree in Art History there and was awarded a European Fellowship for a summer. His interest in art has been long-standing. His father was a commercial artist.

After serving two years in the Army during the Vietnam War, he worked as a graphic designer for a while. Later he decided to become a full-time artist. He has served as Treasurer of the Midwest Pastel Society and as a juror and board member of the Wilmette Arts Guild. Horan has been juried into many national exhibitions and has had many one-man shows. His recent solo exhibitions were at Barrington High School Gallery in Barrington, Illinois and DiFalco Gallery in Chicago. He has also shown his work as a member of the Wilmette Arts Guild and the North Shore Art League.

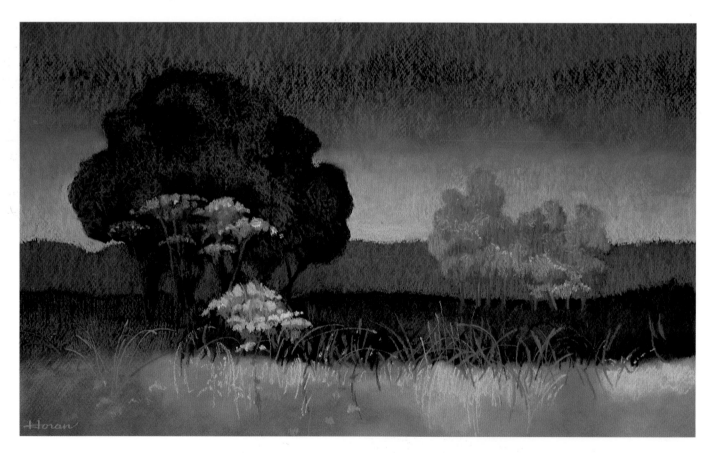

49. *Illinois Prairie*
1995
Pastel
18" x 30"

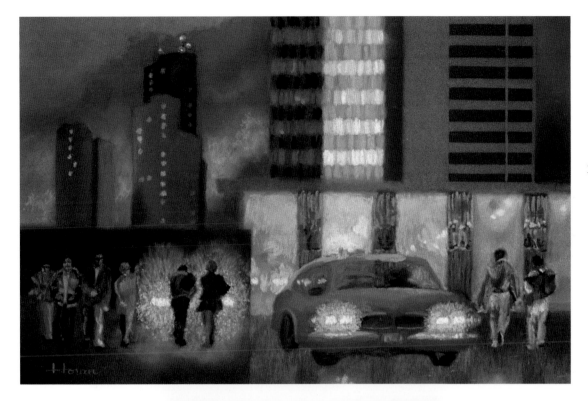

50. *Night Classes*
1996
Pastel
22" x 28"

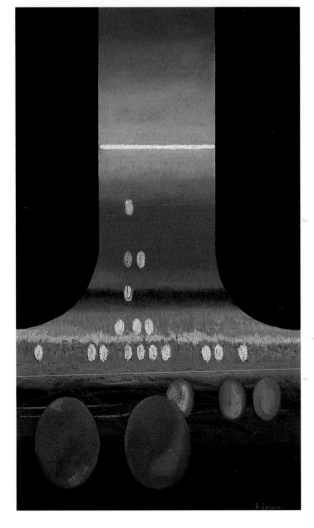

51. *Headlights Abstracted*
1995
Pastel
30" x 18"

Horan was juried into three national exhibitions of the Midwest Pastel Society, thus becoming a signature member. He has had New York and Chicago gallery representations. His work is on public display as far away as Canbarra, Australia where William Pei & Associates installed a collection of his prints in a hotel they designed and helped to furnish.

Horan's studio is located in Greektown which is in the West loop area of Chicago. It is open to visitors by appointment.

Regin Igloria

"The work grouped together in this series arises from my interest in recreating the relationships people have with certain objects and other people, and how those subtle, sentimental events that occur between them become emotional factors in our lives. As metaphors, they try to answer questions about why we place such importance on the links created between relatives, whether it be the genetic resemblance siblings may have or the ideas reflected onto them by each other and their parents.

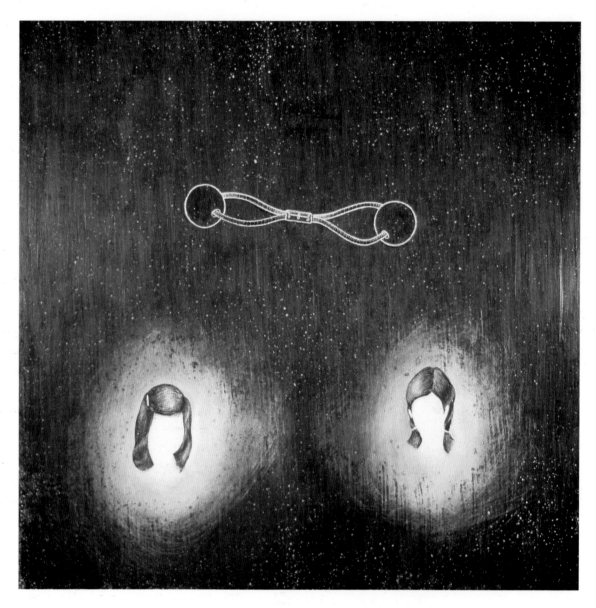

A common object I use to represent these metaphoric relationships is the hair tie, a simple object regularly used by my sisters as children and an object which I have associated with links between two entities: something that holds and supports, and something that remains attached in some way. These types of images represent the reasons people have for developing affections for others, or why the actions of close individuals affect your own. Other objects used include various articles of clothing and accessories which deal with ideas of comfort and ownership, and occurrences which take place because of them.

52. *Hair Ties*
1998
Graphite on Panel
12" x 12"

53. *Sleeping in Comfort*
 1999
 Graphite on Panel
 12" x 12"

The medium of my choice has been graphite, and although much of my work was done on paper, I gradually developed an inclination for a harder surface. My current work is graphite drawn onto chalk-gesso panels. After preparing them in the traditional manner, using several layers of gesso and sanding down the surface to a smooth finish, I then use one of two approaches to achieve the images. One is to completely cover the surface in a layer of graphite and use a drypoint or etching needle to scratch images onto the surfaces of the panels. The other approach is to draw directly with graphite pencils, using the porous texture of the surface to create more subtle and spontaneous gradations. Both techniques are used to portray memories or thoughts in its simplest form."

54. *Hanging and Waiting #1*
 1999
 Graphite on Panel,
 12" x 12"

BIOGRAPHY

Igloria was an exchange student at Emily Carr Institute of Art and Design in Vancouver and graduated from The School of the Art Institute of Chicago in 1996. She is now the Program Assistant, Co-chair of Alumni Advisory Board, and Lead Teacher of Grade 7 through 12 visual arts classes at Marwen. She has held bookmaking workshops for Terra Museum of American Art, Harold Washington Library Center and Francis Parker School. She has taught etching at Anchor Graphics, and adult bookmaking and high school painting and drawing at Kenosha Institute of Arts.

Igloria held a solo exhibition entitled-*Ties* at Marwen Alumni Gallery in 1998. She has also exhibited at 9MM Gallery in Benton Harbor, Michigan; Chicago Art Open; Anchor Graphics; and Northwestern University Settlement House. Her work was chosen as Curator's Choice of the Around the Coyote Arts Festival in 1998 and 1999.

Yumiko Irei–Gokce

"Being of Japanese heritage and having underlying Buddhist philosophies, I am profoundly aware of my native aesthetic. At the same time, for many years I have been exposed to international influences which continue to affect my work at both conscious and unconscious levels. As a multicultural artist I wrestle with both the Western conceptions of art based on the notion of individualism and the Eastern perceptions that are rooted in long established tradition.

In recent years my work has been concerned with expanding the metaphysical notion of an illusive, flat surface into an actual three-dimensional depth. These newer works often imply ambiguity in the duality between microcosm, in which the human body itself provides an archetype of the universe and a macrocosm, in which nature can contain either the centrifugal or centripetal forces of energy as well as the changing processes of evolution and erosion.

My printmaking media include drypoint, etching, monotype and collagraph print construction, which consists of prints in multiple colors that have been layered and built into relief. In order to create depth in these layers and to depict notions of continuity, cycle, and the diversity of natural phenomena within their surfaces, I use multiple prints in an unconventional way to create a single work of art. The layers of desiccated and eroded paper peel back images of magma from the center core of the Earth. They also hint at a metaphorical duality: is it the vital energy of natural phenomena or does it reveal the boiling passion and rage of human emotions?

Many dualities are explored in my subjects: evolution and decay, birth and death, beginning and end, high and low, creation and destruction, and germination and devitalization."

55. (above)
The Urge of Growth: Sprouting I
1996
Monoprint on Paper
24" x 18"

56. (left)
The Germination
1996
Sumi-Ink, Pencil
and Collage
20" x 30"

57. *An Urban Hermit*
1999
Sumi-Ink on Paper
36" x 24"

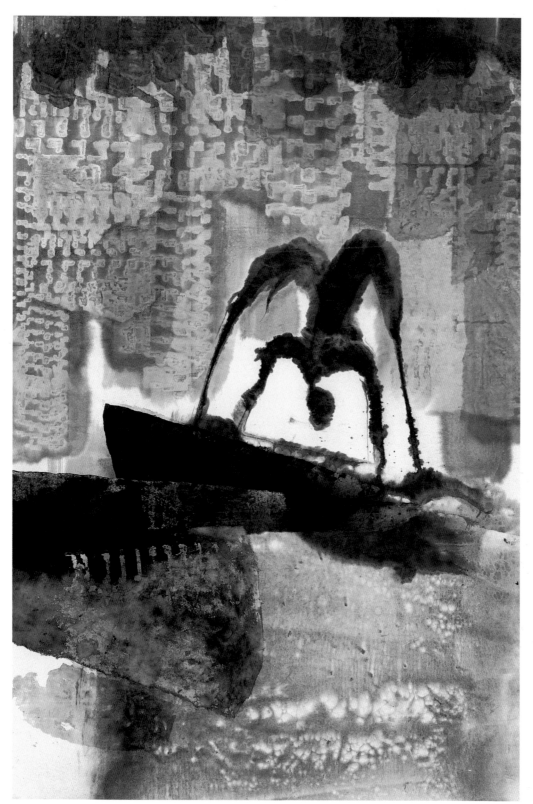

BIOGRAPHY

Irei-Gokce was born in Osaka, Japan. She graduated from Osaka University of Fine Arts and studied the Bauhaus method of Graphic Design under Josef Muller-Brockmann of Switzerland. She then studied at The School of Calligraphy in Tokyo. After moving to the United States in 1970, she studied water-base monotype at the OxBow Summer School of The Art Institute of Chicago.

Irei-Gokce worked as a graphic designer before becoming a full time artist. She has exhibited her work in a number of galleries in Osaka and Tokyo, as well as in a Summer Fest in La Chaux-de-Fonds, Switzerland. In 1999 she was part of an exhibition of Japanese artists in Japan and at the Japan Information Center in Chicago. Within the U.S., she has recent exhibitions at Pyramid Atlantic in Washington D.C. and The Breck School in Minneapolis.

Her recent Illinois exhibitions include the Midwest Juried Print Show of the North Shore Art League at Loyola University and Walsh Gallery in Chicago. In 1999 she exhibited at an invitational group exhibit at Suburban Fine Arts Center in Highland Park and at a juried show at the Fine Arts Building Gallery.

Irei-Gokce ia a freelance writer for Japanese newspapers and art publications, such as Asahi Shimbun International, Inc., Komei Shimbun in Japan and Chicago Shimpo. She has held workshops including a children's class at the Palette & Chisel Academy of Fine Arts in Chicago, and has also given many presentations.

Irei-Gokce is represented by Edelmira Ruiz Fine Arts, Inc. in New York, and KL Fine Arts in Highland Park, Illinois.

Thomas H. Kapsalis

"In my earlier work I used the mediums of watercolor and oil paint to render city scenes, still life and human figures. The treatment of the subject matter was in a realistic mode with an expressionistic tinge. The next phase of my work was to make some sculptures in iron. These sculptures were semi-abstract and the subject matter was stylized figures. For another decade, I created some paintings that had organic and geometric shapes with no subject matter.

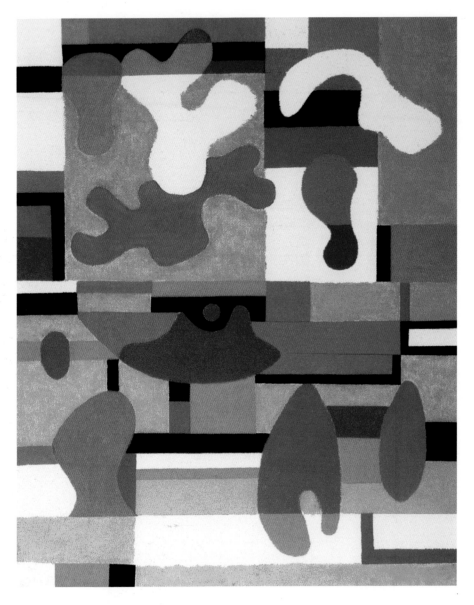

In the interim, I was doing still life paintings entitled *Cut Glass* that depicted impossible situations of sliced tables and sliced drinking glasses against a two-dimensional floor background. From that surreal idea I also constructed some sculptures of sliced cups that were cast in bronze. My recent oil paintings depict square planes that could form a cube or box or any other configuration. I never explain my work in literal terms because I am creating something visual. My artistic intent is to express ideas of beauty in the twentieth and twenty-first century. "

58. *American Landscape II*
1994
Oil on Canvas
15" x 12"

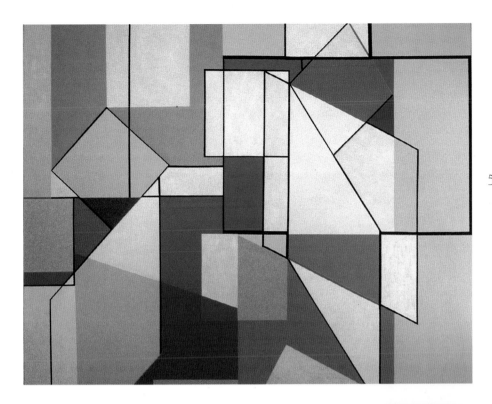

59. *Prime Space Time*
1992
Oil on Canvas
40" x 50"

BIOGRAPHY

Kapsalis served in the U.S. Army Infantry in World War II, fought in the Battle of the Bulge in Belgium and was prisoner of war for five months. After his return he studied at and graduated from The School of the Art Institute of Chicago with a Bachelor's and a Master's degree. He received a Fulbright grant to Germany and studied with Willie Baumeister at Staatliche Akademie de Bildenden Kunste in Stuttgart. He has taught art in the Chicago Public High Schools, The School of the Art Institute and Northwestern University.

In recent years Kapsalis has participated in The School of the Art Institute Ox-Bow Benefit Auction and the Hyde Park Art Center Benefit Auction. In 1996 he showed his work in the *Don Baum Says: "Chicago Has Famous Artists"* exhibition at Hyde Park Art Center.

He is represented by Roy Boyd Gallery in Chicago.

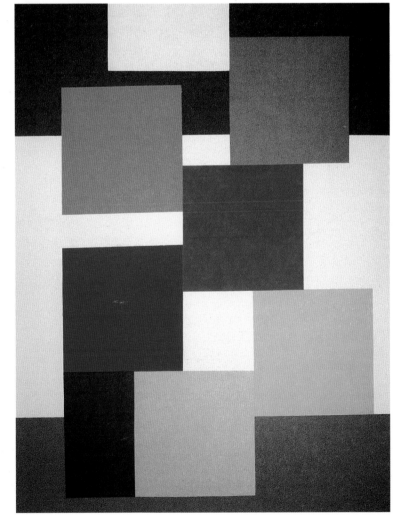

60. *Big Transition*
1998
Acrylic on Canvas
50" x 38"

Donna June Katz

"Each of my quilts is made of hand-painted fabric. I carefully paint each image, background and pattern on unbleached muslin, using acrylic paint thinned to the consistency of a dye or stain. Small, detailed hand-painted pieces are sewn together. They are then quilted by hand or by machine. The painting within each quilt is lavishly detailed. The larger, more elaborate quilts have required up to three hundred hours to complete.

Landscapes, nature-scapes and other images from far away places form a basis for my art-works. I express my awe and sense of wonder about the natural world and depict my view of nature as both a concrete thing and a state of mind. I use the imagery of nature, place, landscape and maps in order to portray journeys and searches that are emotional as well as physical. The restless artist's preoccupation with travel, navigation and mapping is an attempt to reconcile, resolve, find meaning in serenity—at least temporarily. These works are statements about my reverence for nature and belief in its and art's restorative powers."

61. *Riparian Zone*
1997
Acrylic on Muslin, Pieced, Quilted
49" x 31½"

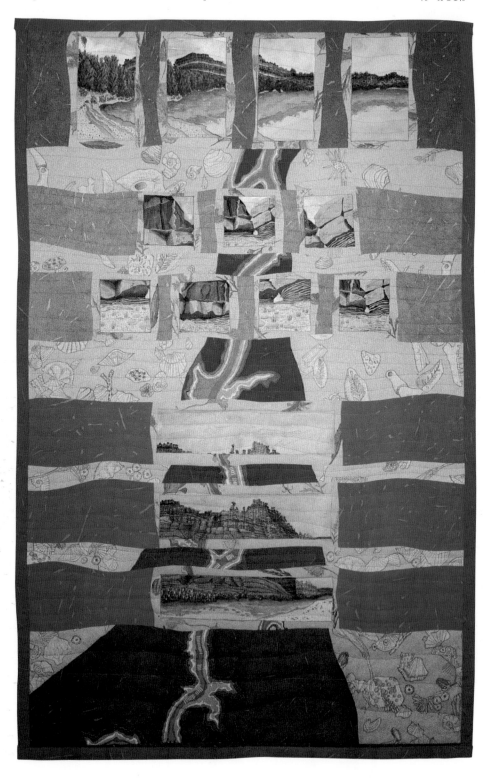

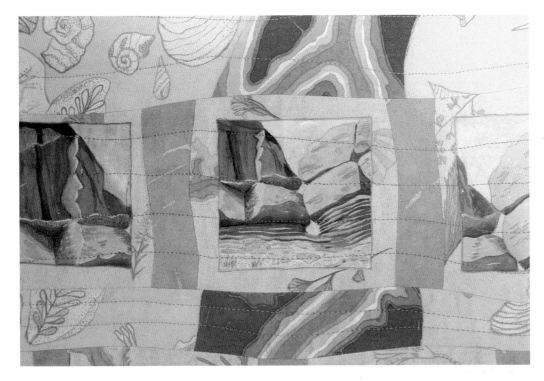

62. *Riparian Zone*
Detail

BIOGRAPHY

Katz received her Bachelor of Arts from Antioch College in Yellow Springs, Ohio and her Master of Fine Arts from Rutgers University in New Brunswick, New Jersey. She has taught printmaking and design fundamentals at University of Dayton and Central State University and was an instructor of printmaking and fiber art at Dayton Art Institute. She is currently teaching collaborative textiles at Gallery 37 Schools Program in Chicago.

Katz's quilts have been exhibited in New York, Iowa, Kentucky, Wisconsin, Minnesota, Missouri and Indiana. Locally she has exhibited at Oak Park Art League, Freeport Art Center, David Adler Cultural Center in Libertyville as well as N.A.M.E. Gallery and Artemisia Gallery in Chicago. In 2000 she exhibited her work as a member of F.A.C.E.T., a Chicago-based textile arts group at Textile Arts Centre in Chicago and Kendall College in Evanston.

Katz's work has been published in five books, including one entitled *Connecting Stitches: Quilts in Illinois Life* by Illinois State Museum in 1995.

63. *Orcas Island*
1997
Acrylic on Muslin,
Pieced, Quilted
27" x 33"

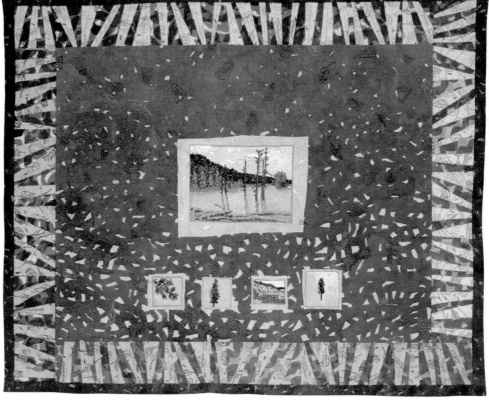

Jill King

"I paint to find where my spirit resides. My current paintings are entries into the unknown, works that transcend the boundaries of the physical world and transport the viewer into regions where the soul has passed through. I see my paintings as living fields of energy made up of mythoglyphic forms and patterns. Painted with weight and fullness, these patterns represent an infinite, eternal presence. It is important to me that my art convey realms of light and darkness, time and timelessness, space and void. I am captivated by the nature and mystery of the human experience and continue to explore this phenomenon so that I might share a glimpse into the substance of the universe."

64. (left)
Reawakening
1999
Oil on Linen
54" x 45"

65. (opposite, top right)
Tears for Solomon
1999
Oil on Canvas
75" x 56"

66. (opposite, bottom left)
Above Center
1999
Oil on Linen
60" x 42"

BIOGRAPHY

King's academic credentials include a Bachelor of Fine Arts in Sculpture from Northern Illinois University and a Master of Arts in Painting from University of Wisconsin-Milwaukee. She taught at the American Academy of Art in Chicago from 1991 to 1995. In the Summer of 1999, she was the instructor of a Gallery 37 program for 24 apprentice artists and assisted them in painting City of Chicago buses based on public images of the sponsoring organizations: Museum of Contemporary Art and Milly. Currently as an Instructor and Facilitator for Art Encounter, she teaches Drawing and Painting at Noyes Cultural Center in Evanston, and has served as a creative mentor to teenagers at Madonna St. Joseph Center and Lincoln Park High School, and the elderly at King Retirement Home in Evanston and Self Help Retirement Home in Chicago.

King works as a freelance artist in design, illustration, packaging and exhibition. Her latest commercial work is three large scale murals

commissioned by Banbury Properties for a new theater complex in Arlington Heights called the Metropolis.

King was juror for a Beacon Street Gallery exhibit, *Redefining Feminism*, in 1999. Her work has been exhibited at the Milwaukee Art Museum; the Burpee Art Museum in Rockford, Illinois; Wright Museum of Art in Beloit, Wisconsin; Gwenda Jay/Addington Gallery in Chicago and many other galleries in the area. She is currently part of a four-person traveling exhibit called *Womanspirit* from Eastern Washington University in Cheney, Washington to galleries and museums throughout the country.

King is represented by Gwenda Jay/Addington Gallery in Chicago. She is a featured artist of *The Chicago Art Scene* by Ivy Sundell (1998).

Kathleen King

"Organic and botanical fragments inspire me. They are dynamic forms that reveal endless variety in nature. Combined with photographic elements, such as magazine clippings, as well as drawn and painted passages, these flora cast-offs can be used to construct a range of abstracted and evocative images.

I have been increasingly employing a collage approach in gathering and assembling these elements in my compositions. Since I am a process artist, the two-dimensional works shown here are mixed media, which can run from traditional media such as oil and acrylic pigments to computer generated ink-jet and photocopying transfers.

I am interested in exploring the life of the mind, the poetic, musical and picturesque as opposed to just the socio-political. The tone of this work is fanciful, sometimes quite baroque and romantic mixed with dark undercurrents. The arts movements I have been influenced by most consistently are early 20th century surrealism and abstraction. Infusing images of dreams and fantasy with a feeling of tangibility has always been an objective of mine."

68. *Memory Matrix Links*
1999
Oil, Acrylic and Acrylic
Transfer on Canvas
36" x 24" x 1½"

67. *Siren's Spiral Song*
1999
Oil, Acrylic and Acrylic
Transfer on Canvas
45" x 49" x 1½"

BIOGRAPHY

King received her Bachelor of Fine Arts and Master of Fine Arts degrees from The School of the Art Institute of Chicago. She has taught at University of Wisconsin at Madison and Evanston Art Center. She is currently teaching drawing, painting, watercolor, design and printmaking at Loyola University in Chicago, and printmaking at The School of the Art Institute and its OxBow Summer School.

In 1996 King lectured at Silpakorn University in Bangkok, Thailand. She was a visiting artist at Terra Museum of American Art and demonstrated monotypes during the reception of the *Singular Impressions: 100 years of American Monotypes* exhibition in 1997. She also held a workshop for teachers at The School of the Art Institute that year. Her work was featured in several Korean arts magazines such as *Wolgan Milsool* and *Art World*.

Recently King has shown her work in solo exhibitions at the Fine Arts Building Gallery in Chicago, Tyler School of Art in Philadelphia and École des Beaux-Arts de Saint-Etienne in France. She has also shown her work in group exhibitions in Arizona, Wisconsin, Tennessee as well as in Brazil, France, Russia and Korea. In both 1995 and 1997 she exhibited at the M.A.N.I.F. Art Expo in Seoul, Korea; and in 1996 to 1997 she was part of a traveling exhibit from Columbia College Art Gallery in Chicago to Oakton Community College and Carlton College. Her work was in the Evanston Art Center 2000 *Evanston + Vicinity Biennial Exhibition*.

King is represented by Fine Arts Building Gallery and Jan Cicero Gallery in Chicago, Viridian Gallery in New York City and Gallery Ami' in Seoul, Korea.

69. *Ominous Subterfuge*
1999
Oil, Acrylic and Acrylic Transfer
on Canvas
39" x 31" x 1½"

Ken Klopack

"My work portrays glimpses of greatness in people and slices of how poetic, among other things, we are in our society. I draw these bits of life from my experiences living in Chicago and the Midwest. The substantive nature of my characters is taken from interactions formed in the human circles of life. All people live in a unique framework, a circle of human sorts, sometimes struggling within that structure, at times flowing comfortably, or a combination of both.

I perceive people and events taking place in these circles and that fascinates me no matter how ordinary or trivial they seem to be. Putting a dramatic twist on such situations is my personal statement on the processes of living. I enjoy the challenge of turning common

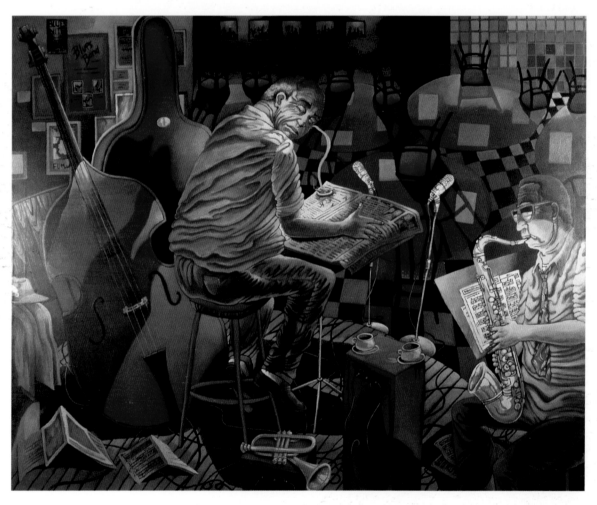

players of this process into heroes, using the plain, unassuming characters of our world in a beautiful way, amplifying their significance, pride, courage, and human sensitivities. My work has stylistic inventions in composition and form developed over the last two decades through a series of work that is uniquely mine. I have been influenced by the Regionalists and several other American artists such as Motley and Bellows. Painting techniques and compositional considerations from this influence are definitive factors of my work.

Setting an atmosphere, a tone, an attitude for the players on the canvas is a process that sets my work as a 'visual puzzle of views' that the observer must solve. However I prefer the observer to decipher my work in a personal manner. When one observes my work, I would like one to gain skills in perceiving, in seeing things not noticed before about our daily existence."

70. *After Hours*
1995
Acrylic on Canvas
48" x 60"

BIOGRAPHY

Klopack has been teaching art in the Chicago Public Schools since 1971 and is a part-time faculty member in Art Education at The School of the Art Institute of Chicago. He has won several awards for his teaching, notably the Golden Apple Award and the Kohl International Teaching Award. Klopack was honored as the 1996 Elementary Teacher of the Year in Illinois by the Illinois Art Education Association.

Over the years Klopack has been active in the Chicagoland art fair circuit in such events as the Gold Coast Art Fair and the 57th Street Hyde Park Art Fair. More recently several affiliations with local galleries and coop groups have taken his work into different circles of the art community. He has exhibited his work at the New York Art Expo and Galerie Hamptons in West Hampton Beach on Long Island. Locally he is a member of Artists of Rogers Park and has had a solo exhibition at Peter Jones Gallery in Chicago.

71. *Couple I*
1996
Acrylic on Canvas
30" x 24"

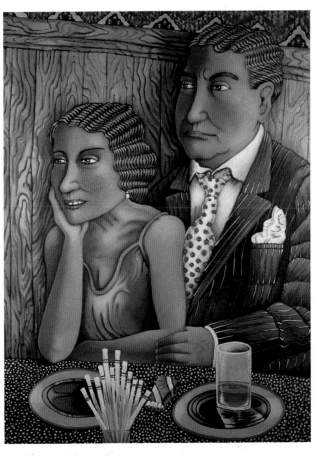

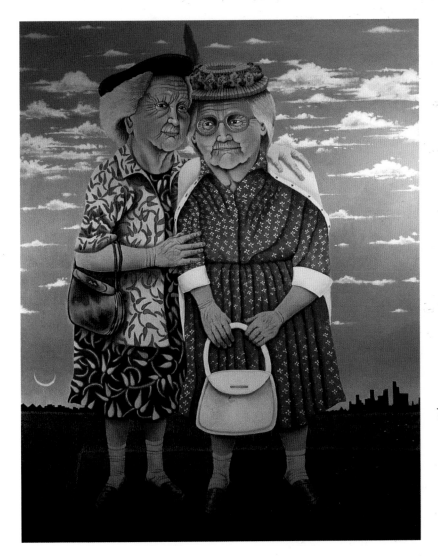

72. *Sisters*
1994
Acrylic on Canvas
60" x 48"

Gosia Koscielak

"I am interested in the archaeology of my time. My concerns focus on two different levels: the macro- and micro-world of man. My subject deals with Prehistory—the border between the geological origin of the Earth and the origins of human civilization; History—the development of contemporary mass culture such as advertising, television, the telephone book of a huge metropolis (condensed information in which a man is only a name and a number); and Man—the main character in history, the border between privacy and global history.

In my paintings, collages and reliefs, I use elements including wooden wheels, stones, earth, small video monitors, cut-up phone books, and holograms. For me they represent our personal search for identity in a multicultural and multimedia world. My compositions are very abstract but the components and details are realistic."

73. *Light Instrument*
1997
Light, Wood and Strings
24" diameter disks

74. (above)
Book Collection
1997
Phone Book, Dirt
24" x 30"

75. (right)
Traces
1999
Painting, Fiber Optic
108" x 47" (diptych)

BIOGRAPHY

Koscielak holds two Master of Fine Arts degrees: one in Graphics and one in Ceramics, and a Ph.D. in Art History from the Academy of Fine Arts in Wroclaw, Poland as well as a Master of Fine Arts from The School of the Art Institute of Chicago. She has been a designer for a theatre and an artistic director of a gallery in Wroclaw, and has lectured at The School of the Art Institute of Chicago and St. John Fisher College in Rochester, New York. In 1998 she was the exhibit and lighting designer for The Field Museum Millennium Projects.

Koscielak has had numerous solo exhibitions at galleries and museums in Poland, Italy, Germany and the U.S. In 1994 she exhibited at ARC Gallery, The New Pier Show and Mindy Oh Gallery in Chicago; in 1995 at University of Arkansas in Little Rock; and in 1997 at The Polish Museum of America. She also had group exhibits in Greece, Holland, Poland, Germany, Spain, Portugal, Austria, Brazil, Norway, and the U.S., including the Museum of Modern Art in Hunfeld-Fulda, Germany in 1994; and Balzekas Museum of Lithuanian Art in Chicago in 1996. In 1999 she exhibited at the National Museum in Warsaw, Poland. Her work is in public and private collections in many countries.

Linda Kramer

"In recent years I have concentrated on a series of very subjective self-portraits. It has been a series of over one hundred works on paper.

In these portraits I see the many faceted aspects of the self. Sexual identity, historical references, aspects of cultural style and beauty, agelessness and aging are all depicted in these various portraits.

Who is more interesting and is more looked at than the self? The self is always there and always changing; from birth to death the mirror reflects a different face at each gaze."

76. *Portrait # 47*
1996
Watercolor on Paper
24" x 18"

BIOGRAPHY

Kramer received her Bachelor's degree from Scripps College in Claremont, California and her Master of Fine Arts degree from The School of the Art Institute of Chicago. She has taught Graduate Critiques at The School of the Art Institute, and held a workshop at Columbia College. She has also been a visiting artist at Southern Illinois University at Carbondale, an artist in residence at Purdue University in Indiana, and a guest speaker at numerous schools and art organizations such as University of Wisconsin, Midwest Women's Art Conference, Barat College in Lake Forest and Columbia College in Chicago.

77. *Portrait # 70*
1998
Watercolor on Paper
24" x 18"

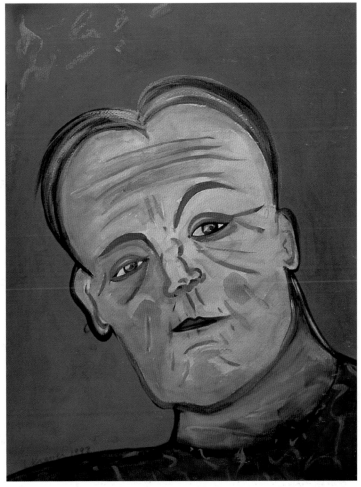

78. *Portrait # 110*
1998
Watercolor on Paper
22" x 15"

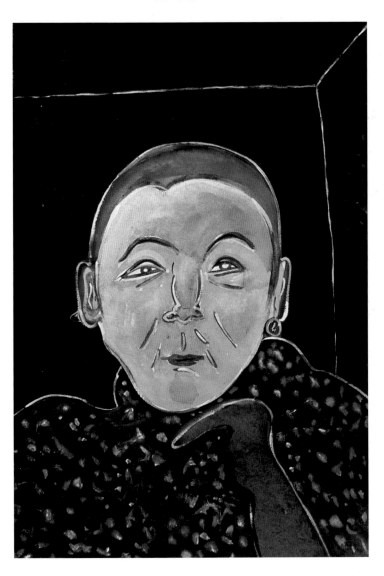

Kramer has exhibited her paintings and sculptures at numerous museums and galleries. Her work had been shown at The Art Institute of Chicago, Museum of Contemporary Art in Chicago, Kalamazoo Institute of Arts in Michigan, Illinois State Museum in Springfield, Lakeview Museum of Arts and Sciences in Peoria, Art Gallery of Slovenj in Gradec, Slovenia, and the galleries which represent her.

In 1999 Kramer was given a retrospective exhibition at the Hyde Park Art Center. She has been featured in many books and catalogs, including *Spirited Visions, Portraits of Chicago Artists* by Patty Carroll in 1991. Her work is in the collection of Museum of Contemporary Art in Chicago and Mint Museum of Art in Charlotte, North Carolina, as well as in private collections in Chicago, New York and California.

Kramer is locally represented by Jean Albano Gallery and Printworks Gallery.

James A. Krauss

"I have always been an abstract painter. After having spent the last thirty years working on a grand scale, i.e. six foot by nine foot canvases, in 1995 I switched from working extremely large and on canvas to extremely small and on paper.

Using a combined media approach of watercolor and acrylic titanium white on 300 pound Arches cold pressed watercolor paper, my work has evolved to what you see now. While color and expression remain my primary interests, the use of paper along with the more intimate scale has allowed me to work more with subtle nuances and poetic moods, not necessarily visual references."

BIOGRAPHY
Krauss was born in Philadelphia and graduated from Tyler School of Art at Temple University with a one-year study in Rome. He then studied and received his Master's degree in painting, sculpture and printmaking at University of Wisconsin. He is an art professor and chairman of the Art Department at Oakton Community College.

80. *Amor de Lune*
2000
Watercolor and Acrylic on Paper
4" x 4"

79. *In the Wake of Time*
2000
Watercolor and Acrylic
on Paper
4" x 4"

81. *Crabapple Cove*
2000
Watercolor and Acrylic on Paper
20" x 22"

Krauss has had numerous group shows and two one-man shows at Jan Cicero Gallery. He is currently represented by Corporate Art Works in Schaumburg; Artifax Gallery in Naperville; Deer Path Gallery in Lake Forest; Gallery Ten in Gills Rock, Door County, Wisconsin; and Beech Tree Gallery in Sioux City, Iowa.

Marion Kryczka

"For the past seven years I have focused on still life painting. Prior to this I have been exclusively a figure painter for a period of fifteen years. I tend to look at my work prior to 1976 as having little coherence or direction of any kind. In 1976 I began to engage my efforts in the practice of perceptual painting. The importance of the observed situation and the uniqueness of that experience became the basis from which my formal structure evolved.

I found that I needed some kind of transition to break away from figure painting. At first I used objects that were stylized versions of humans—my daughter's dolls and toys. The narrative dynamics of dolls transformed into mythological beings or archetypal symbols dominated my work for the first two years of still life paintings. Eventually I found that the practice of arranging objects for their formal dynamics could, by the visual tension they created, allow a variety of iconographic and symbolic relationships to develop. The objects I chose began to vary from the doll and patterned surfaces. As the number of works grew, I found that some objects became very important players in many paintings and held important roles repeatedly. These particular objects began to take on personaes that fit the context of each work. Some objects informed, some observed and other objects acted upon each other. They all functioned in formal consort while having their own unique informative role.

As satisfying as the concentration on still life painting is, I still religiously continue to draw the figure at least once a week. The direct and experiential nature of figure drawing has been an indispensible practice to me as a perceptual painter. I find that the two subjects now more richly inform one another and need not be separate in a conceptual sense."

82. (above)
Three Sources of Light
1997
Oil on Canvas
24" x 36"

83. (opposite, above)
Untitled
1995
Oil on Canvas
18" x 24"

84. (opposite, below)
Vanitas
1999
Oil on Canvas
24" x 36"

BIOGRAPHY

Kryczka was born in Germany. He received his Bachelor of Fine Arts degree from The School of the Art Institute of Chicago and his Master of Fine Arts degree from University of Illinois in Champaign-Urbana. He has taught drawing at Mundelein College, Prologue Alternative High School and Triton Community College, and has been teaching drawing and painting at The School of the Art Institute since 1981.

In 1997 and 1999 Kryczka had one man shows at the Fine Arts Building Gallery. He has also shown his work at N.A.B. Gallery, The Art Institute of Chicago, Chicago Cultural Center, Central Washington University, Riverside Art Center, Space Gallery, Wood Street Gallery, Peter Jones Gallery, and the galleries which now represent him—Fine Arts Building Gallery and NFA Space in Chicago.

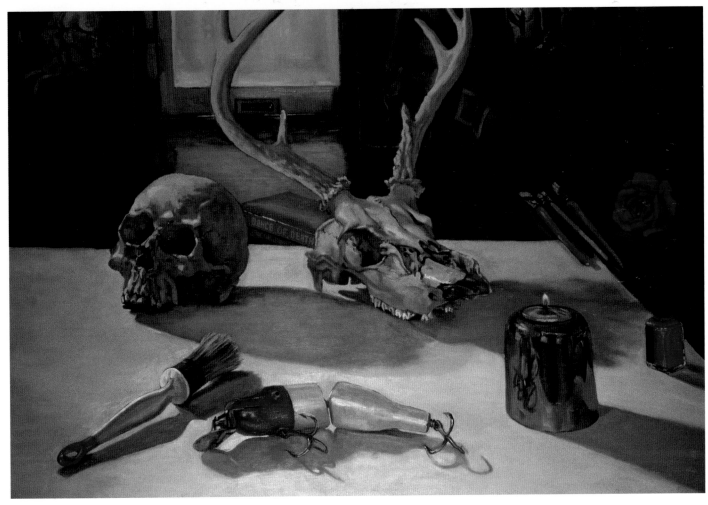

Roland Kulla

"These paintings are inspired by my environment on the south side of Chicago. I've lived in Hyde Park for thirty years and scenes from the neighborhood, my apartment, the park and the lake offer continual sources of inspiration.

There are several themes that intrigue me. The juxtaposition of the lake and the city contrasts man-made reality against the void. Painting light is an exercise in capturing the effects of unseen energy sources. I am fascinated by the effect of natural light and human lights. Similarly the built environment provides me with a proxy for human experience. I choose subjects that reveal the effect of time on the things people have made.

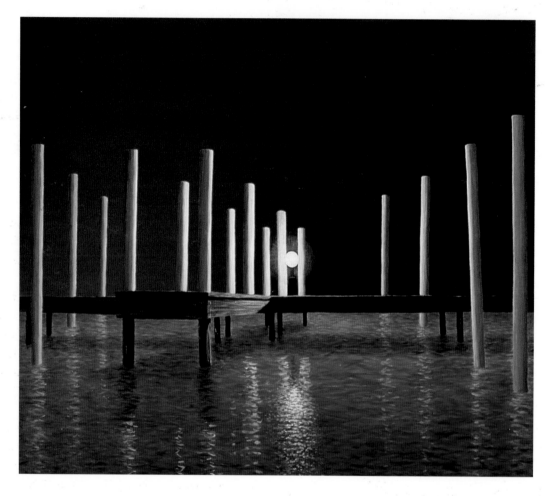

85. *Lakelight*
1997
Acrylic on Canvas
54" x 60"

When I see one of the images I use to express my art, it resonates with feelings and ideas that prompt an image in my mind's eye—like a mental snapshot. Sometimes the image forms in an instant. Other times it can be something I've seen repeatedly that comes alive when I see it in a certain light or in a special mood. At that point the external view becomes an abstraction—a symbol for ideas and feelings.

These feelings have to inspire me enough to spend the considerable energy to externalize it in a painting or drawing. What was outside now comes inside and moves through me in the process of composing the image, choosing the size and colors, preparing the frame and canvas, and completing the actual work of putting the paint on the canvas. Sometimes I'm conscious of the idea I'm trying to express. Other times the image itself works through me on an unconscious level. I know it's finished when it stops talking to me."

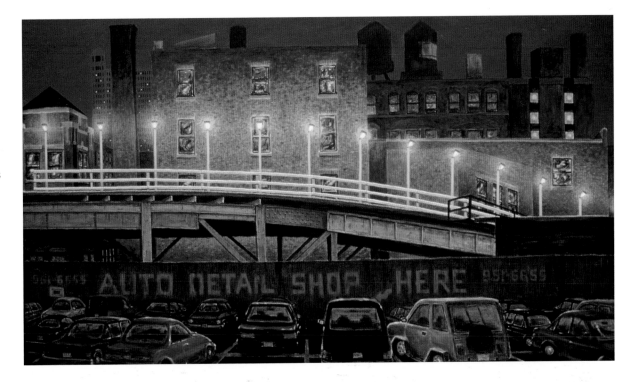

86. *City Stop*
1998
Acrylic on Canvas
35" x 60"

BIOGRAPHY

Kulla was raised in St. Louis. He spent ten years in the seminary before he moved into social work. For the past thirty years he has been a case worker, administrator, researcher, teacher, and now a lecturer at University of Chicago and a consultant on child welfare. Three years ago, he decided to work part time in order to have more time to paint.

Even as a child, Kulla liked to sketch architectural details while traveling to violin lessons on a bus in St. Louis. Sketching and drawing led to watercolors in his college years in Louisville. In 1989 he started painting in oil after an eight-session course offered to University of Chicago alumni. In the last three years, acrylic paint has become his primary medium.

Kulla has also cultivated his other interests. He sang for a decade with the Grant Park Chorus. He designed sets, costumes, and performed in community music theater, including Hyde Park's Gilbert and Sullivan Opera Company. He has also restored a 1890 Victorian house and his 1907 apartment.

Kulla has had solo exhibitions at Bloomingdale Art Museum, Vedanta Gallery in Chicago, and J.R. Kortman Gallery in Rockford. He has also exhibited at many juried shows, including the Annual Baer Art Competition at Beverly Art Center; Area Invitational Art Exhibition at Aurora University; and the Biennial Exhibition at South Bend Regional Museum of Art in Indiana.

Kulla is represented by The Vedanta Gallery in Chicago.

87. *El Stop*
1998
Acrylic on Canvas
40" x 53"

John Kurtz

"There is fixed in my mind a construction—an architecture of things—some real and some not real. They are alien and terrestrial things that mingle together as animals, comic tunes, flora, burlesque and erotic vaudeville, goofy events and personal symbols. Layers of visual communication. It's my secret planet—the world I would love to wander through if I was a traveler just landing on it. This cosmic swirl is part of my own history, both real and imagined. It is a gift that feeds my art and what I make of it. For me a curious adventure filled with awe and wonder."

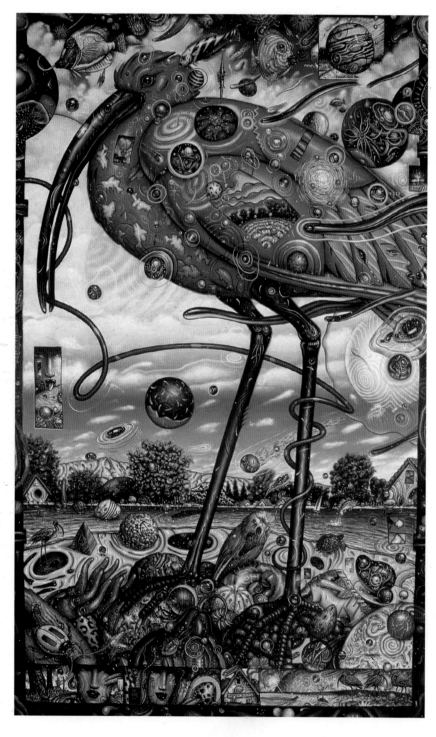

BIOGRAPHY

Kurtz began his education at The School of the Art Institute of Chicago in 1961 on a scholarship he received from the Park Ridge Art League. In 1962 he joined the U.S. Navy and trained as a photographer. Since the late 1960's Kurtz' photography, paintings and papier mache sculptures have been exhibited at a number of galleries in Chicago, including Zaks Gallery, University of Illinois-Chicago, DePaul University, Wood Street Gallery, Contemporary Art Workshop, Rockford Art Museum, Evanston Art Center and Artemisia Gallery. His work was shown at two Chicago and Vicinity shows at The Art Institute of Chicago. He also shows his work annually at his home studio.

Most recently Kurtz' paintings have been exhibited at Strawdog Theatre and Northlight Theatre, at Uncle Fun's *The Fun Show* and at *The Toy Show* at August House Gallery. In 1999 his work was exhibited in two shows at the Lucky Horse Gallery in Chicago. Kurtz' illustration history is quite lengthy and includes *Libido Magazine*, *Oui Magazine*, *Playboy Magazine* and *Chicago Magazine*.

88. *Untitled (Red Ibis)*
2000
Acrylic on Canvas
56" x 34"
Collection of Dr. David and
Cristina Evakus

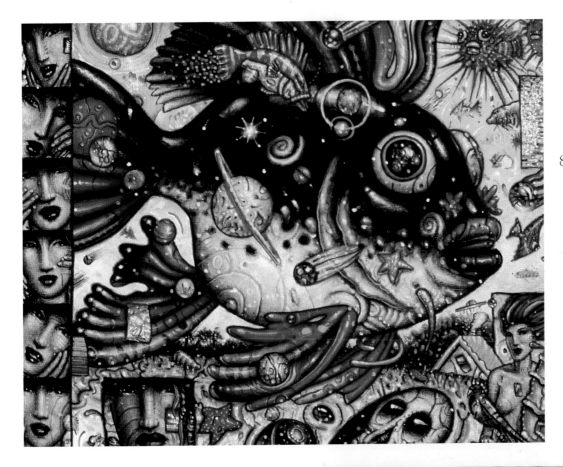

89. *Dream in Color*
1999
Acrylic on Canvas
8" x 10"

90. *Two of Three*
1998
Acrylic on Canvas
10" x 10"

Deborah Maris Lader

THE TOOLS SERIES

"As humans we invent and utilize tools in order to function more efficiently and to perform the tasks of the day-to-day. Driven by the hand and brain, a hammer hits the nail, a spoon ladles soup, and a pencil writes a poem. Due to our great ingenuity, we have also created other enabling tools such as the wheelchair, the writing orthosis and the talking computer programs that facilitate communication.

Some folks use their daily planners in order to function, others use prozac. Certain tools are associated with varying types of 'disabilities' or 'special needs' to describe those who use them.

91. *Pronation Splint/Clamp from the Tools series*
1999
Gum Print on Wood,
Graphite Drawing on
Gessoed Walnut Panel
9½" x 10"

The images in my current series explore and expand upon the idea of tools as a metaphor for how we personally function in a social environment which seems inclined to categorize, label, and discriminate according to each of our abilities, non-abilities and differences. As a parent of a young child diagnosed with one of those many 'definitions', these issues are all too present and real. Differences need to be celebrated. We all need tools to survive and perhaps that is the great equalizer."

92. *Pronation Splint/Clamp from the Tools series*
Detail
2¼" x 2½"

BIOGRAPHY

Lader is Director and Founder of Chicago Print-makers Collaborative. She is affiliated with Mid America Print Council of which she was a Board member, American Print Alliance, College Art Association, Autism Society of America and Chicago Artists' Coalition.

Lader received her Bachelor of Fine Arts in Printmaking from Cornell University and her Master of Fine Arts in Printmaking from Cranbrook Academy of Art. Her work was exhibited widely in this country as well as overseas. In the last two years, she has exhibited her work locally at Wood-shop Print Gallery, Pi Gallery, Wood Street Gallery and Belloc Lowndes Fine Art, all located in Chicago, and at Northwest Cultural Council in Arlington Heights and Riverside Arts Center. In 1999 she was represented by Belloc Lowndes Fine Art at the International Art Exposition in San Francisco. That same year she received the Paul Berger Arts Entrepreneurship Award along with prestigious recipients such as The Field Museum, The Terra Museum of American Art and Shakespeare Repertory. Her work has also been exhibited at Cotman Gallery in Wimbledon, England; Shinsegae Gallery in Seoul, Korea; and at the Twenty Fifth FISAE Ex Libris Congress Artist Bookplates Exhibition in Milan, Italy. Her work is in many private and public collections.

Lader is a featured artist of *The Chicago Art Scene* by Ivy Sundell (1998). Belloc Lowndes Fine Art held an exhibition for the book in 1999 and continues to represent Lader in her work. She is also represented by Wood Street Gallery in Chicago.

93. *Wrist Splint/Needle and Thread from the Tools series*
Detail, 1999
Graphite Drawing on Gessoed Walnut Panel
2¼" x 2½"

Riva Lehrer

CIRCLE STORIES

"The paintings that make up Circle Stories are portraits of well-established artists in a variety of fields, including theater, dance, writing and visual arts. Each artist has a significant physical disability and an interest in exploring body issues in his or her work. I have been working on this project for three years.

The Circle Stories portraits begin with interviews in which we discuss the participant's life, work and experience of disability. We combine biographic information with imagery from their work in order to arrive at a composition. Historically people with disabilities have had little control over their cultural depictions. Therefore I feel that it is important that my collaborators have a great deal of control over their presentation. The paintings are done using a combination of live sittings and photo references."

94. *Circle Story #5 —*
M. Erwin & A. Stonum
1998
Mixed Media on Paper
22" x 21"

"Mike Ervin is a journalist, writer and playwright and his wife, Anna Stonum, a poet and visual artist. Mike's work appeared in *Staring Back: The Disability Experience from the Inside Out,* an anthology. His latest play, *The History of Bowling,* opened in 1999 at Victory Gardens. His articles appear in the Reader and other publications. Anna and Mike were both dedicated disability rights activists and traveled the country to participate in political actions. Mike's disability is Duchenne's muscular dystrophy and Anna's was Friedreich's ataxia. Anna died of heart failure in 1999."

BIOGRAPHY

Lehrer received her Bachelor of Fine Arts degree from University of Cincinnati in 1980 and returned to study at The School of the Art Institute of Chicago in 1993. She has been a visiting artist at The School of the Art Institute and Columbia College in Chicago and Hebrew Union College in Cincinnati. She currently teaches at Evanston Art Center, University Club of Chicago and Suburban Fine Arts Center in Highland Park.

Lehrer has had solo exhibitions at College of Lake County in Grayslake, Illinois; Notre Dame University in Indiana; Lyons Wier Gallery and Sazama Gallery in Chicago; and A.I.R. Gallery in New York. She has also shown her work in group shows around the country.

Lehrer's work is part of an exhibit, *Illinois Women Artists: The New Millennium,* that travels to the National Museum of Women in the Arts in Washington D.C., Illinois State Museum in Springfield, State of Illinois Gallery in Chicago and Peoria Museum of Art from Spring 1999 to 2001. Locally, her work has been exhibited at Chicago Cultural Center, The International Museum of Surgical Science, Fourth Presbyterian Church, and Printworks Gallery in Chicago, Northwestern University Dittmar Gallery in Evanston and Elmhurst Art Museum. She is represented by Lyons Wier & Packer Gallery in Chicago and Susan Cummins Gallery in Mill Valley, California.

Lehrer has spina bifida, a congenital birth defect.

95. *Circle Story #6 —*
Tekki Lomnicki
1999
Acrylic on Panel
48" x 36"

"Tekki Lomnicki is a performance artist and writer. She has done numerous solo and collaborative shows at Blue Rider and other theaters. Her work uses her costumes to explore, parody and manipulate the ways that small stature is perceived. A recent piece about her father entitled *Letting the Dead Rest* was featured at Link's Hall and other Chicago festivals."

96. *Circle Story #7 —*
Hollis Sigler
2000
Acrylic on Panel
18" x 32"

"Hollis Sigler is a nationally known painter whose work has been very influential in the Chicago school of painting. For the last decade she has been openly exploring and exposing her 15-year struggle with breast cancer. Her show, *The Breast Cancer Journals: Walking with the Ghosts of My Grandmothers,* was shown in 1998 at the National Museum of Women in the Arts in Washington, D.C."

Carol Luc

"My work deals with the urban environment devoid of human figures, and the objects that I use are chosen for their familiarity and ordinariness.

Defining architectural space is an effective way to present the experience of emptiness. A void can only be defined by its relationship to objects within it. There's a familiar, graspable emptiness, like the corner of a room.

I want to evoke a certain range of emotions—peace, melancholy, nostalgia, regret—as opposed to the grand passions. Like the artist Edward Hopper, I am compelled by the psychological effects of light and space.

Being an Illusionist painter, I am allowed to create convincing images of something that's not there...but might have been."

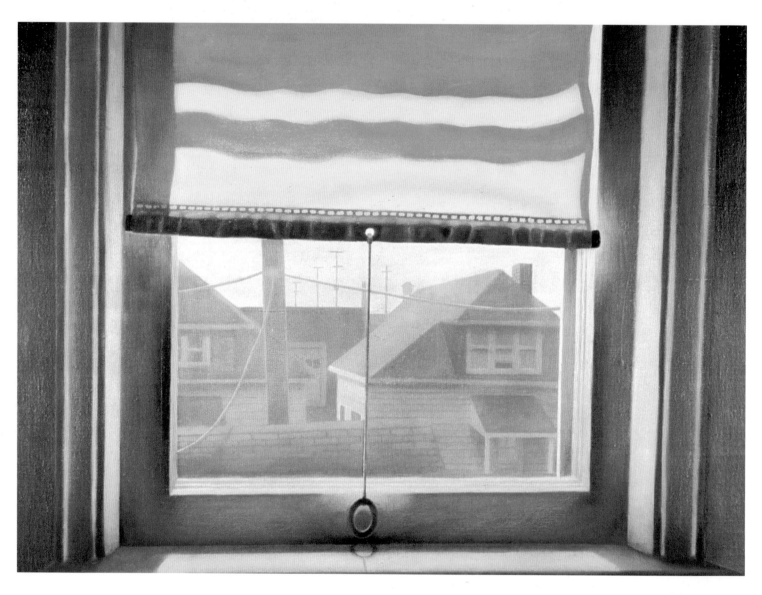

97. *A Good Day*
1999
Oil
24" x 30"

98. *Smell of Old Music*
1999
Pastel
24" x 30"

BIOGRAPHY

Luc holds a Master's degree in Painting from Wayne State University in Detroit, and a Master of Fine Arts degree from Northern Illinois University in DeKalb. She also attended the Advanced Painting Institute at The School of the Art Institute of Chicago. She is currently an instructor of computer illustration and design at the American Academy of Art in Chicago.

Luc has had many awards and honors from her exhibitions. They include a People's Choice Award from the 15th Michigan Art Competition in 1993, Business Patron Awards from the *Women's Work* exhibits in Woodstock in 1995 and 1996, and Artist's Choice award and Honorable Mention from Rockford Art Museum's 1996 Stateline Vicinity Exhibition. In 1999 she was selected from a national pool of artists for the Studios Midwest Summer Residency Program in Galesburg, Illinois.

Locally Luc has had solo exhibitions at University of Illinois in Chicago, Unitarian Church of Evanston, Expressions Graphics in Oak Park, and Moraine Valley Community College in Palos Hills. She has also shown her work in invitational exhibits at Elgin Community College, Indianapolis Art Center, and Birmingham-Bloomfield Art Center in Michigan; and in juried competitions such as Harper National Print Exhibition, Annual Juried Exhibition at Sioux City Art Center in Iowa, Annual Quad-State Juried Exhibition in Quincy, Illinois, and the National Oil & Acrylic Painters' Society Exhibit in Osage Beach, Missouri.

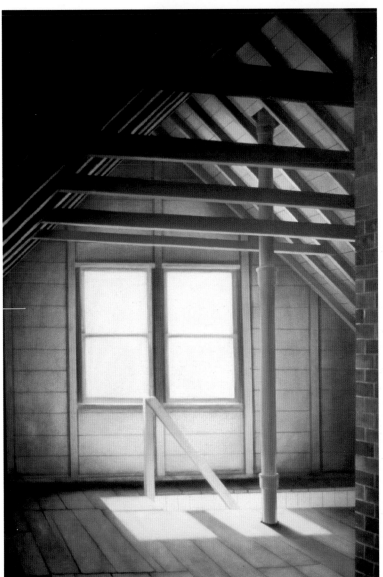

99. *Revelation*
1999
Oil
40" x 60"

Irene Ryan Maloney

NIGHT POOLS

"I have been working with the subject matter of night pools since 1990. I find it to be the perfect visual metaphor for describing internalized thoughts and emotions.

Visually explosive events in my life served as a catalyst for producing imagery. When I experienced pools at night I could not release the overall enjoyment mixed with terror, which I felt. The aqua pool at night seemed to contain everything I wanted to talk about with paint.

The water as a metaphor represents the environment in which one lives his or her life. The water contains elements of danger, instability, calm, terror, soothing and nurturing. The figures are in this mass of unsettled water with only the pool's light to illuminate them.

Enjoyment derived from the color and water has kept me painting *Night Pools*. Water lends itself visually to a hidden passion, a liquid with an intoxicating aqua color and the darkness adds to the sense of potential danger and vulnerability."

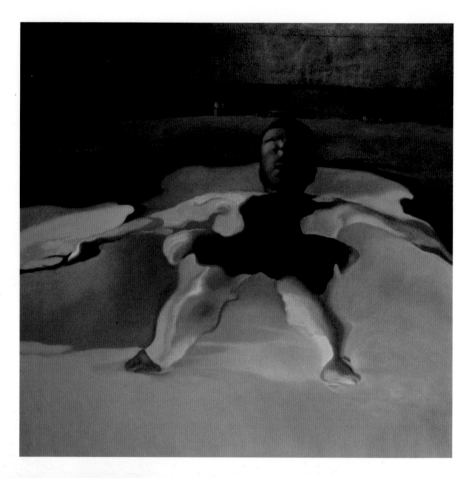

100. **Just Float**
1996
Oil on Canvas
54" x 52"

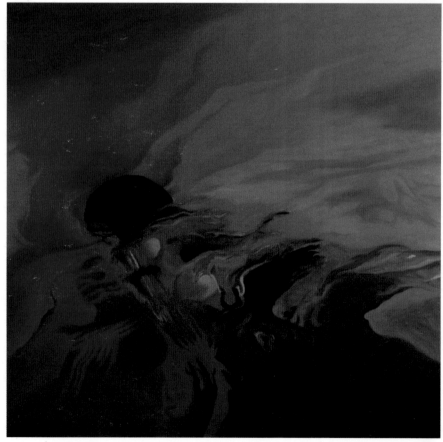

101. *Seattle Pool I*
1997
Oil on Canvas
54" x 52"

AFTER IMAGES

"My current work has taken a drastic shift in that the earlier pieces were very large oil on canvas pieces and now they are in 8" x 10" format. Another change can be seen in the use of beeswax instead of a primer on canvas and monochromatic images imposed on the beeswax. Layers of beeswax are placed on the image so that it is almost lost and then it is repainted to bring back parts of the image. The process seems to speak of preserving something, in this case images of children in pools.

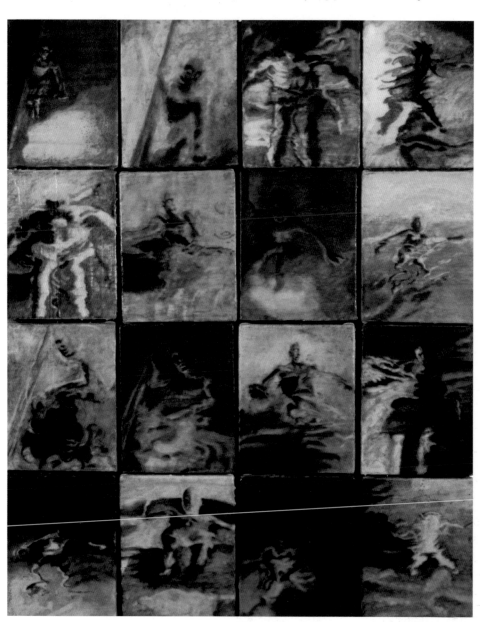

The images are related to earlier images from the *Night Pool* series. Their titles, such as *Life Flashing...*, allude to the life changes we cannot prevent. This series of paintings are installed together to form a continuous line or a large rectangle. They are likened to entries in a diary."

BIOGRAPHY

Maloney graduated from Loyola Marymount University in Los Angeles with a Bachelor's degree in Art. She then received her teacher certificate from Northeastern Illinois University and in 1990 her Master of Fine Arts from University of Illinois at Chicago. She has taught art at Montay College, Truman College and Evanston Art Center, and is currently teaching at Illinois Institute of Art in Schaumburg.

Maloney has had solo exhibitions at Fine Arts Building Gallery, Artemisia Gallery, Gruen Gallery and Saint Xavier University. Many of her exhibitions led to awards and honors. She received Awards of Excellence and an Award of Merit for displaying *Recent Works* at College of Lake County in Grayslake in four separate years. At the *Women's Works* exhibit in Woodstock, she received an Artistic Merit Award, a Purchase Award, a Third Place Award, and a Second Place Award in another four separate years. She also won First Place for the *Personal Investments* exhibit at Gallery 10 in Rockford in 1998.

Maloney is the Public Relations Chairperson and Curator at the Fine Arts Building Gallery in Chicago. Locally she is represented by Fine Arts Building Gallery in Chicago, Millennium Gallery in Libertyville, and SMD Arts Inc. in Medinah, Illinois.

102. *Life Flashing...*
1998
Oil on Beeswax on Canvas
42" x 34"

Heath Matyjewicz

HEAVEN WEEPS

"A look behind the scenes at the interaction between Heaven and Earth."

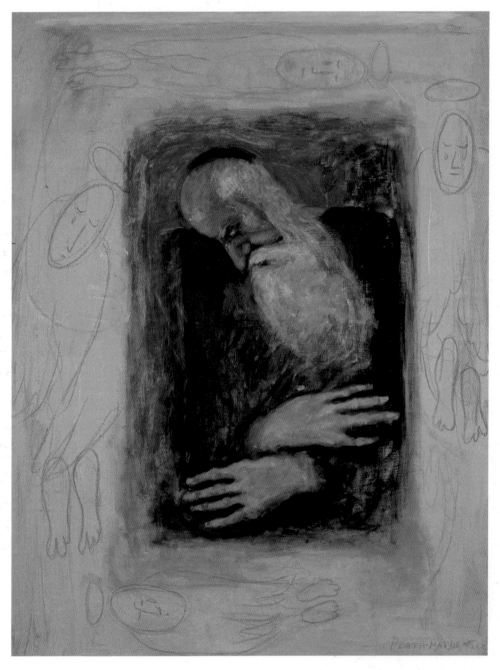

BIOGRAPHY

Matyjewicz is a Chicago-based artist whose work deals with biblical and human rights themes. He graduated from Pratt Institute in New York City in 1992.

Matyjewicz was the winner of the Louise D. Yochim award in 1999 at Northwestern University. He has shown in the *Works on Paper* exhibition at the Fine Arts Building Gallery in Chicago and at the Ward Nasse Gallery's International Salon in New York City. He also won grand prize at an exhibit at the William Carlos Williams Center for the Arts in New Jersey.

103. *Jeremiah Lamenting Over Jerusalem's Destruction*
1998
Acrylic on Paper
36" x 31"

104. *Faith*
1997
Acrylic and Crayon on Paper
32" x 23⅛"

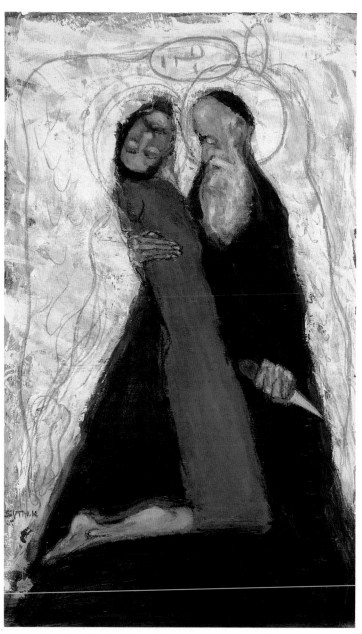

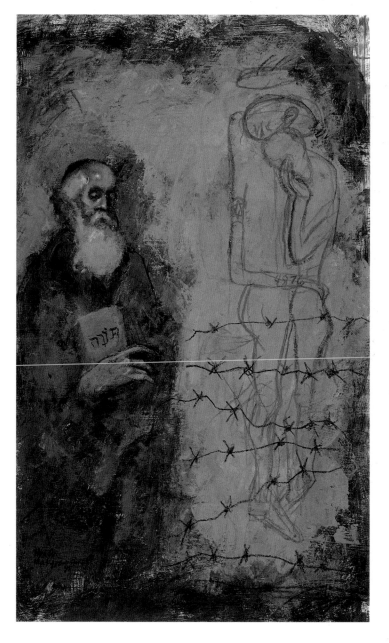

105. *The Sacrifice of Isaac*
1997
Acrylic on Paper
35" x 24½"

Bert Menco

"My Dutch-Jewish background has inspired much of my art. Being a second generation post-war Jew and having lived a large part of my life in The Netherlands, history has had an unavoidable personal impact on me. The traumatic events of World War II affected every post-war Jewish child, often by things unspoken. I am no exception. I am sure that in many ways my parents' history has affected my art as it is impossible to separate myself from these events that have had a major impact on the course of my life.

My work is often quite spontaneously generated. Though they may seem simple, my images are actually quite elaborate; half a year's work on an image is no exception for me. I use small sketches, even doodles, as image-generating nuclei, often combining two or three that appear to complement each other. I rarely use concrete references but rather work from inner visions. I tend to do poetic narratives. I don't see my images as telling a story but rather as imagist reflections of inner feelings, similar to some poetry. I like to believe that my work carries a certain mystery. My images are very much 'inside out'. I usually have some idea of what I want to obtain but much of the image is generated while I draw or paint. The end product always surprises me; I am often amazed that there is even an end product. Analyzing my own art

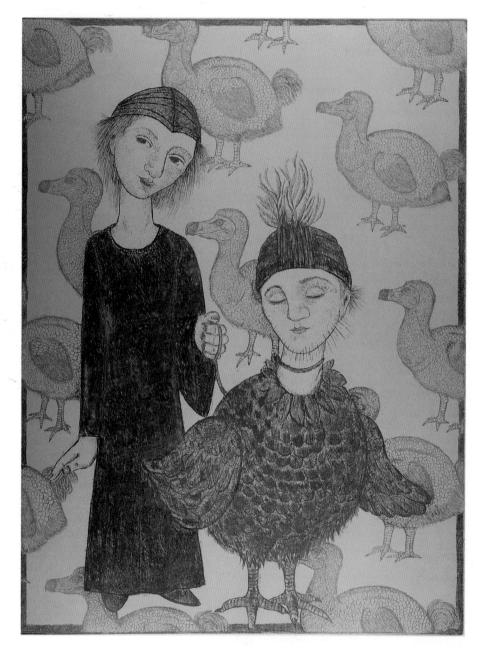

106. *Extinct (dodos)*
1999
Etching on Aquatinted
Yellow Background
18" x 24"

is difficult but I think that the dreamlike images tend to deal with confined spaces which contain certain characters that reach out to one another yet do not quite succeed in meeting. Most of the figures are somewhat lost in space. All of this probably reflects some of my own life's quests. To me there are at least two worlds: the one you are in and the one you aspire to be in. One balances on the edge between the two."

BIOGRAPHY

Menco has received numerous awards. In 1995 he received an Award of Excellence from the North Shore Art League's Midwest Print Show in Chicago. In 1996 he received the Sponsor's Prize at the 3rd Sapporo International Print Biennale in Sapporo, Japan, and in 1997 he was included in *The Best of Printmaking* by Rockford Publishers in Gloucester, Massachusetts.

Menco has had many solo exhibitions. They include shows in Illinois at Evanston Art Center, Noyes Cultural Center and Levy Center in Evanston; Sharp/Danka Gallery of South Suburban College in South Holland; and Elmhurst Art Museum. His recent group exhibits include University of Pittsburgh Art Gallery, Northwestern University Dittmar Gallery, Davidson Galleries in Seattle for the International Juried Mezzotint Exhibition, Art Academy of Cincinnati, and Hunterdon Museum of Art in Clinton, New Jersey. Menco exhibited at Printworks Gallery in 2000 and is part of American Print Alliance's ten-location traveling exhibit entitled *Common Ground* from 1998 through 2001.

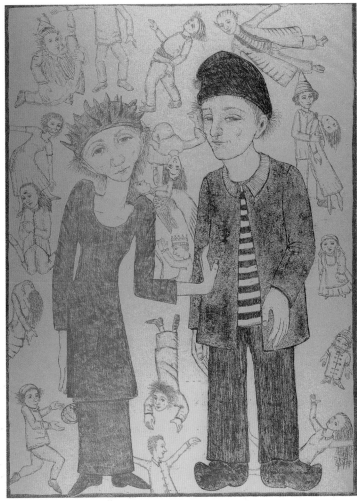

107. *Repulsion*
1998
Etching on Aquatinted Yellow Background
18" x 24"

Locally Menco has curated shows for Columbia College Center for the Book and Paper Arts in Chicago, Northwestern University Dittmar Gallery in Evanston, and Suburban Fine Arts Center in Highland Park. He is represented by Anatomically Correct in Chicago and is a featured printmaker at www.anatomicallycorrect.org. His work can also be seen at www.ArtofChicago.com and www.ohioonlinearts.org.

108. *Manipulation*
1996
Etching on Aquatinted Yellow Background
18" x 24"

James McNeill Mesplé

"For many years my work has drawn from mythology. This new body of paintings derives its inspiration from *The Metamorphoses* of Ovid. Both the dialogue and the action in those stories conjured up images in my mind that were dense and full of colors, two components with which I especially like to work.

My approach to painting uses a combination of egg tempera and oil in a mixed technique. My forms are my own idealized visions of historical prototypes which are often just that—a previous artist's reinterpretation of an even earlier prototype, which was itself a reinterpretation... This unbroken link to the past is something I cherish.

Many of Ovid's myths and stories are concerned with transition and change, which seem most cogent as we begin a new century as well as end a passing millennium."

109. *Pan and Syrinx*
1999
Oil, Egg Tempera on Panel
29½" x 24"

110. *Blue Oboe*
(Apollo Changing
Bamboo into
Oboe Reeds)
1999
Egg Tempera and
Oil on Canvas
on Panel
28½" x 36"

111. *Echoes from Pompeii*
1999
Egg Tempera and Oil
on Canvas
20" x 16"

BIOGRAPHY

Mesplé attended University of Missouri, Northern Illinois State University and The School of the Art Institute of Chicago. He had taught painting, drawing and ceramics at The School of the Art Institute from 1978 to 1988, and held workshops in egg tempera painting for Ed Paschke's MFA students at Northwestern University from 1991 to 1993. In 1997 he held a workshop on egg tempera and pigment grinding for art teachers at The School of the Art Institute, and in 1999 he held a lecture and demonstration of the new Maimeri Oil Paints for Chicago Artists' Coalition.

In 1997 Mesplé was commissioned by the Oriental Institute to create a mythological 16-foot steel beam to be embedded in the museum as a site-specific time capsule. In 1999 he painted a *Classic Cow* for Cows on Parade™, a public art display on the streets of Chicago.

In the last two years Mesplé has shown his work locally in solo exhibitions at Bailiwick Arts Center and Union League Club in Chicago, and College of Lake County in Gray's Lake; and in group exhibitions at University of Illinois at Springfield, O'Hare International Airport Terminal 2, Lockport Art Gallery, Hyde Park Art Center, Klein Art Works in Chicago and Illinois State Museum in Springfield.

In 1998 Mesplé's work was featured in *The Chicago Art Scene* by Ivy Sundell.

Dale Miller

"I have always been fascinated with symbols, ancient and tribal art, philosophy, science and religion. In part my work explores how communication evolved from cave drawings, pictographs and hieroglyphics to modern day language. My interest in these early art forms and symbols extend beyond their aesthetics to include their mystical and spiritual qualities. To me they embody the human quest for answers regarding the meaning of our existence.

Through my art, I am investigating the connection between spirituality and science. As a part of the process, I often juxtapose scientific writings and diagrams, philosophical and religious texts, along with ancient symbols from various cultures.

I hope to illustrate a similarity between many seemingly different ways of looking at the world. My intention is to peel away the layers of time and language that separate these truths to reveal the common elements that bind them."

112. *Essence of the Source*
1999
Acrylic and Paper on Canvas
36" x 48"

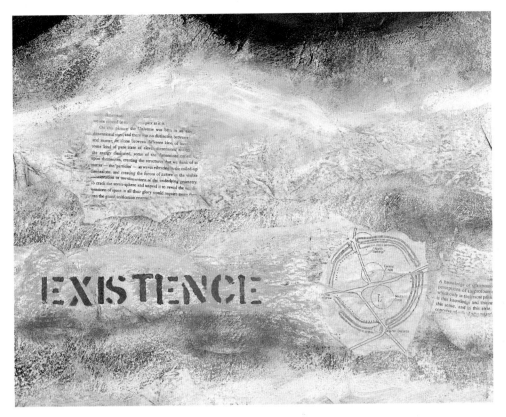

113. *Essence of the Source*
Detail

114. *Remembering*
1999
Acrylic and Paper on Canvas
20" x 24"

BIOGRAPHY

Miller was born in Chicago. She received her Bachelor of Fine Arts degree in painting, photography and filmmaking from University of Illinois in Chicago.

After graduation, Miller worked as a freelance assistant photographer, stylist and associate producer before becoming a full-time artist.

Miller has exhibited her work at galleries and art centers in the Chicago area. In 1997 Miller had a solo exhibition at the City Hall Rotunda in Highland Park. In 1999 her work was shown at Woman Made Gallery, and at Belloc Lowndes Fine Arts as part of the group exhibition featuring artists from the book, *The Chicago Art Scene*, by Ivy Sundell. She is a member of the Chicago Artists' Coalition, Woman Made Gallery and the Suburban Fine Arts Center in Highland Park.

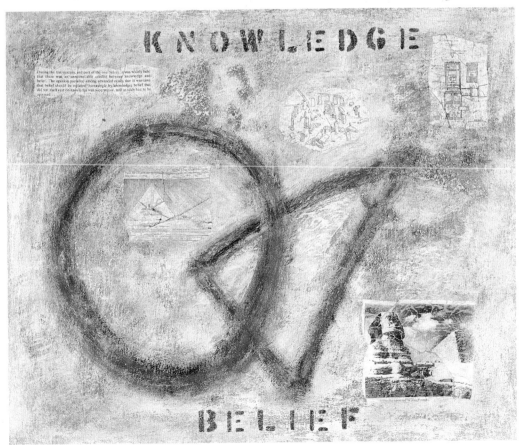

Herbert Murrie

"I believe my works are an insight into who I am and what makes me behave and feel the way I do. When I started painting Italian landscapes I never realized that part of my fascination with Italy and the Italian people had to do with the fact that they truly know they are going to die. We on the other hand give lip service to this fact. We <u>really</u> don't believe it."

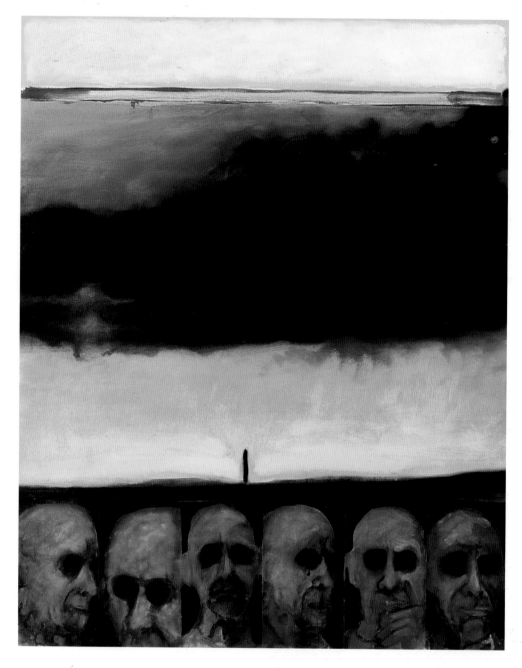

115. *La Facce Della Tempesta*
(Faces of the Storm)
1999
Oil on Canvas
60" x 48"

BIOGRAPHY

Murrie was born and raised in Chicago. At a young age his parents enrolled him in a private art school headed up by a nationally recognized watercolorist, Lucille Leighton. Soon afterwards he won the Chicago Young Artists Competition (for artists 21 and under). He continued his education at the Chicago Academy of Fine Art and the American Academy of Fine Art, and received his Fine Arts degree from University of Illinois.

Soon after graduation Murrie started a graphic design firm and it became very successful. While managing his business, he continued to paint privately and until this past year, had never shown his work publicly.

After traveling extensively to Italy for many years, Murrie established a second home and studio where he paints the Italian landscape with a vitality and passion that expresses his love for Italy: the land, the people, the food and wine.

In the summer of 1998 Lydon Fine Art in Chicago held his first public exhibition. Since then his work has won several national awards including a Best of Show award at the 1998 Absolut Vision in Chicago, an Artists Showcase Award at Manhattan Arts International, and 1st Place and Best of Show awards at The Baker Arts Center in Liberal, Kansas. His work has also been shown in Arizona, Pennsylvania, Texas, Maryland and at the New Art International Exhibition in Woodstock, New York.

Murrie is represented by Lydon Fine Art in Chicago and Sloane-Jordan Gallery in Austin, Texas.

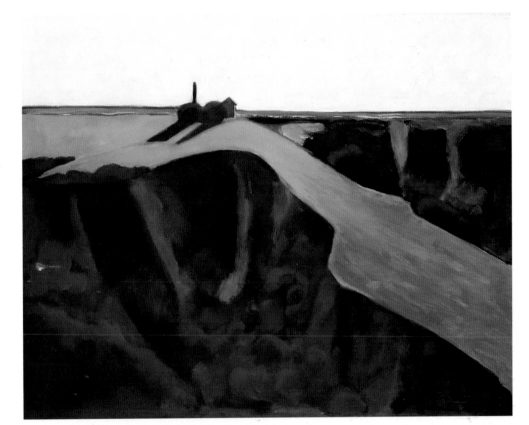

116. *La Strada*
 (The Road)
 1999
 Oil on Canvas
 48" x 60"

"My landscapes began to look lonely and indeed I have always felt lonely. I started to explore my life in my work—my father's death when I was eleven years old; my struggles with religion, life and death; my furious, frustrated anger when a buddy of mine lost his legs and hand in Vietnam and the way he was treated in the VA hospitals when he got back.

I guess you could just say that my works are really self-portraits. When I finish with this therapy I'll start on the rest of the world."

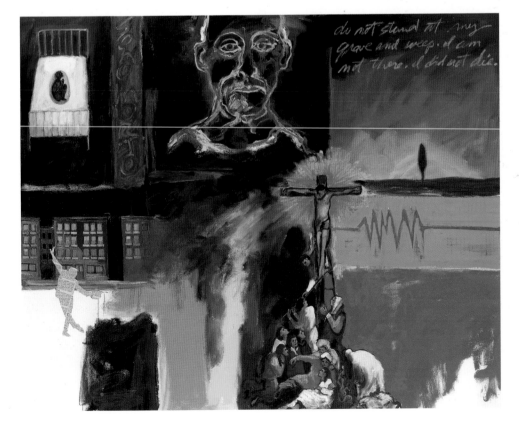

117. *Father and Son*
 2000
 Oil, Paint Stick and Paper on Canvas
 48" x 60"

Julia DelNagro Oehmke

"Portraiture is my driving force and I continue to reach for excellence. In these paintings I visualized the contents, composition, color and the general structure, and then I transcend the facts to become a true form of my expression. I go for a powerful visual impact with a strong play on shadow and a dramatic view of the subject.

Recently I have focused on different ethnic groups and especially the Native American life, which has surfaced several times throughout my painting career.

Portraiture is demanding on your senses. It forces you to be aware of not only the likeness but of the soul."

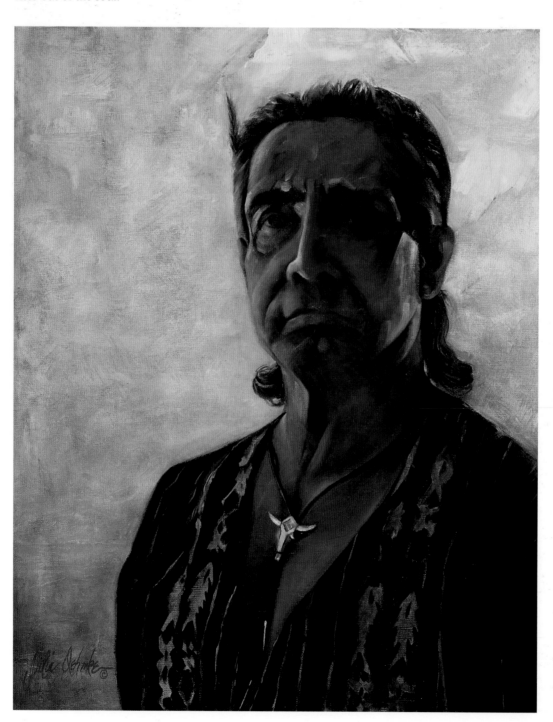

BIOGRAPHY

Oehmke attended Ron Riddich's Workshop at the American Academy of Art in Chicago. She has been a professional artist for over 20 years, working primarily in portraiture. For the past seven years she has been Treasurer for the Chicago Society of Artists.

Oehmke is a member of the Oil Painters of America and have participated in many regional and local juried exhibitions. In 1999 she was commissioned by North Central College for the portrait of Professor H.C. Smith. That same year her drawing of the late artist, Francis Badger, was purchased by the Vanderpoel Museum in Chicago for its permanent collection. She is also an art agent, presently representing artist Peter Volay.

Oehmke is represented by Griffin Graphics, Inc. Gallery in Chicago and Barnstein and Sigg Gallery in Carmel, California. She is also represented by Maximus Gallery in Flossmoor, Illinois for Limited Edition prints over the internet. She is a featured artist of *The Chicago Art Scene* by Ivy Sundell (1998).

118. *Miguel*
1999
Oil on Linen
30" x 27"

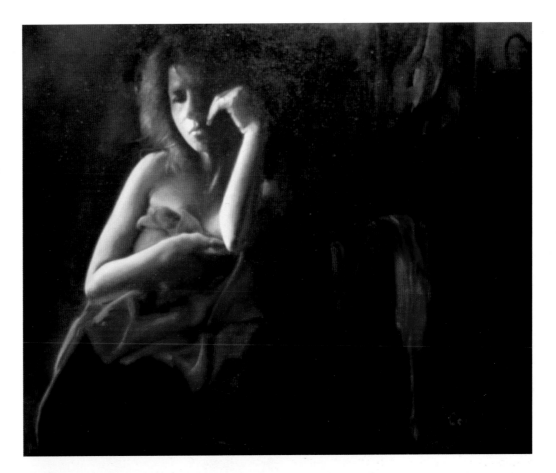

119. *The Rose Cloth*
1995
Oil on Linen
18" x 22"

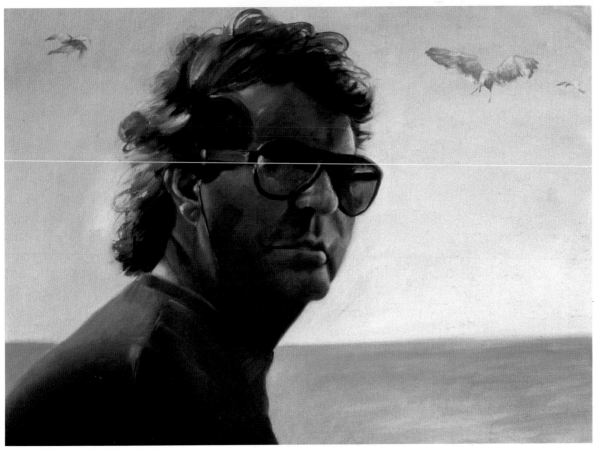

120. *Blue Blockers*
1997
Oil on Linen
20" x 24"

Helen Oh

"I paint on copper panels using a meticulous oil technique developed by 16th century Flemish artists. The glass-smooth, reflective copper surface facilitates the rendering of minute details and creates luminous shadows. My skylighted workspace in Chicago's historic Tree Studios produces the kind of cool, dramatic light one sees in Baroque paintings, which are my inspiration.

I aim to produce still lifes that make the viewer aware of the beauty of everyday objects. I include things like seasonal fruit and flowers, pottery or seashells that hint at the transitory nature of our lives.

I compose objects under the skylight, arranging them to create strong patterns of light and shadow. These initial bold shapes help the viewer 'read' the painted image from across a room and, I hope, draw him in. Up close, the surface of the painting is photographically detailed with each object carefully rendered in strokes so fine, they disappear from view. I paint with this high degree of reality to create a disorienting pleasure in the viewer's mind: is this painted or is it real? Of course, it is only an image, but if he for even a second mistakes the image for the genuine article, I have achieved my goal."

121. *Still Life with Fruit and Shells*
1998
Oil on Board
8" x 10"

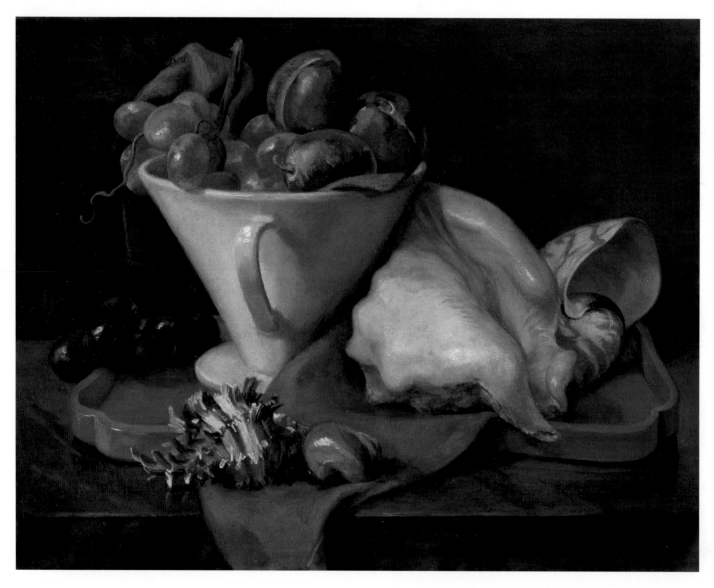

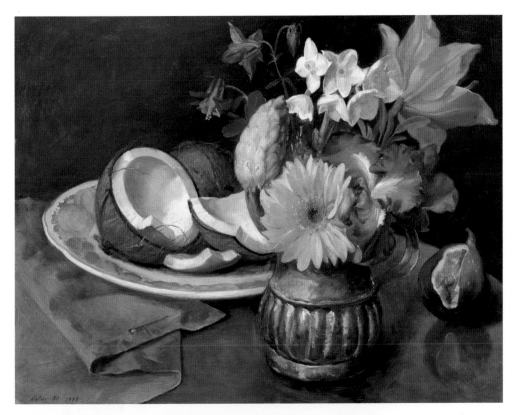

122. *Spring Still Life*
1998
Oil on Copper
12" x 16"

BIOGRAPHY

Oh attended the Art Students League of New York, School of Visual Arts, and National Academy School of Fine Arts in New York. She also studied with Aaron Shikler and David Levine and independently in Italy, Spain, Holland, Belgium, England and France. In 2000 Oh held Baroque painting technique workshops at both The School of the Art Institute of Chicago and The New York Academy of Art. She currently holds Traditional Painting Workshops at Tree Studios in Chicago.

Oh was given a number of awards from Audubon Artists, Allied Artists of America and National Academy of Design in New York, and has been featured twice in *American Artist* magazine.

Her work has been exhibited at the National Academy Museum and Frank Caro Gallery in New York; Lyons Wier Gallery in Chicago; The College of William and Mary in Williamsburg, Virginia; Francesca Anderson Fine Art in Lexington, Massachusetts; and St. Anselm College in Manchester, New Hampshire. She is represented by Lyons Wier & Packer Gallery in Chicago and Salander O'Reilly Gallery in New York City.

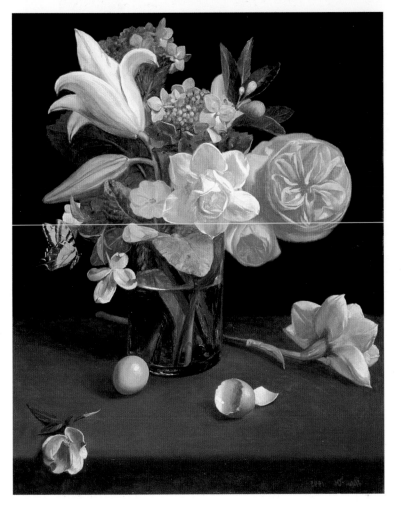

123. *Spring Still Life II*
1999
Oil on Copper
15" x 12"

Chris Peldo

"McDonald's corporate symbol—the golden arches—is now more recognized than the Christian cross." *Rolling Stone Magazine,* November 1998

"I came across this quote recently and it really made me stop and think. I understand that it's saying the arches are only more recognized than the cross, not more popular. Not like when John Lennon proclaimed that he and the Beatles had more fans than Jesus. Nobody's suggesting we trade eternal salvation for a BIG MAC®. Still, I find it troubling that more of us know where to get a cheeseburger than nourishment for the soul.

So, that's what my paintings are about. These symbols. These icons. How they impact absolutely every aspect of our lives. I'm fascinated by the way these symbols are packaged with guilt and fear. Scope makes us feel guilty about our breath; Charlie the Tuna helps keep our mind off dead dolphins. (Does anyone else think it's weird that Charlie actually begs us to kill and eat him?)

Take this tuna, for it is my body.

These symbols sell us everything from pimple lotion to birth control pills. Wear a short sleeve knit shirt and you're a geek. Put an alligator on it and suddenly you're smart, hip-desirable. That is, until

124. *Coke Head*
1998
Acrylic, Enamel and
Silk Screen on Canvas
24" x 24"

a few months later when you realize that any idiot can buy an IZOD®. Lucky for us, Ralph Lauren realized he could replace the alligator with a polo player, charge twice as much and everything was right in our world again.

By altering these symbols and layering them one on top of another the viewer is forced to see them in a new way. A green BURGER KING® logo combined with a pink HEINEKEN® logo becomes what?

My goal is for the work to feel familiar yet challenging at the same time."

125. *Hobbs*
1999
Acrylic, Enamel and Silk Screen on Canvas
18" x 12"

126. *Juxtaposition*
1995
Acrylic, Enamel and Silk Screen on Wood
48" x 42"

BIOGRAPHY

Peldo is a self-taught artist born in California.

In 1992 he was selected by Absolut Vodka to represent the State of Illinois in a national art program and advertising campaign. Over the past year he was commissioned by Walt Disney to produce a 5½ foot circle in plexiglass, and by Chicago ESPN Zone to produce a Michael Jordan garbage ball for the VIP room in their restaurant.

Peldo is represented by the David Leonardis Gallery in Chicago.

Mark Pelnar

"In the nineteenth century George Perkins Marsh wrote, "To the natural philosopher, the descriptive poet, the painter and the sculptor…the power most important to cultivate, and at the same time, hardest to acquire, is that of seeing what is before him. Sight is a faculty; seeing an art." Henry David Thoreau had also made a similar comment in his journal, "The question is not what you look at, but what you see." It might be added that looking is done with the use of the eyes, seeing is done with the use of the mind, and is the reason two people with excellent vision looking at the same thing may see something quite different.

127. *Still Life with Architectural Study #1*
1999
Acrylic and Colored Pencil
28" x 30¼"

I believe it is how sensitive a person is to visual subtleties that determines how well he or she sees. In my own work I concentrate on the subtleties of tone, texture and design. Tone and texture are important because I want everything I do to have a very tactile, almost sculptural presence. I try to achieve this through careful attention to many layers of paint and subtle changes of tonality. In designing a painting I think the spaces between objects are just as important as the shapes and form of the objects themselves, and I paint these between spaces as carefully as I paint the objects. It is my hope that viewers of my work will become as aware of these elements of pictorial construction as I am, and as a result, become conscious of cultivating the art of seeing."

128. *Still Life with Architectural Study #3*
2000
Acrylic
24¼" x 38"

BIOGRAPHY

Pelnar received his Bachelor of Fine Arts degree from Drake University in Des Moines, Iowa and his Master of Fine Arts degree from Tufts University and the School of the Museum of Fine Arts in Boston, Massachusetts.

In recent years he has had solo exhibitions at Fine Arts Building Gallery, Illinois Institute of Art and DeFalco Gallery, all in Chicago. He received the Juror's Award at the 1997 New Orleans National Fine Arts Exhibition in Metairie, Louisiana; and a Runner-up Award in the cover contest for the *Encyclopedia of Living Artists*. In the last two years he has exhibited his work at the National Fine Arts Exhibition of Navarro Council of the Arts in Corsicana, Texas; the National Fine Arts Exhibition at Elmhurst Art Museum; and the National Works on Paper exhibition at Columbia College in Missouri.

In 1999 Pelnar exhibited his work at Belloc Lowndes Fine Art as a featured artist in *The Chicago Art Scene* (1998). He is represented by Fine Arts Building Gallery in Chicago.

129. *Still Life with Astrolabe*
1999
Acrylic and Colored Pencil
19" x 38"

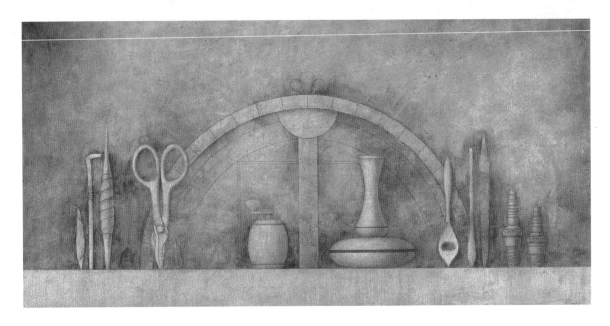

Joyce Martin Perz

COLOR CONSTRUCTS

"Color Constructs explore the boundary between painting and sculpture. The visually ambiguous pieces hang unframed on the wall and are constructed using conventional two-dimensional painting methods and materials—canvas, wood strips and acrylic paints. Although the work shares much in common with abstract painting, the constructs are also concerned with issues of form, shadow and surface modeling more usually associated with sculpture.

A low relief is achieved in some cases by applying wood or canvas pieces to the stretched canvas surface; several are composed of more than one stretched canvas, either adjoining or atop one another; and in many cases the canvas has undergone a process of folding, pleating or seaming prior to being stretched. The resulting three-dimensional pieces are at the same time paintings on the wall and sculptural elements in the interior environment."

BIOGRAPHY

Perz attended Sonoma State University in California and received her Bachelor's degree from University of California at Davis. She also studied at The School of the Art Institute of Chicago.

Her work has been shown in San Anselmo, California; Phoenix, Arizona; and Brattleboro, Vermont. Locally she has exhibited her work at An ArtSpace, Wood Street Gallery, Evanston Art Center, Women Made Gallery, Bloomingdale's Design Studio at Merchandise Mart, and Klein Art Works.

In 1998 she was the recipient of a Community Arts Assistance Program grant from the City of Chicago, and in 1999 she participated in the Cows on Parade™ public art event in Chicago.

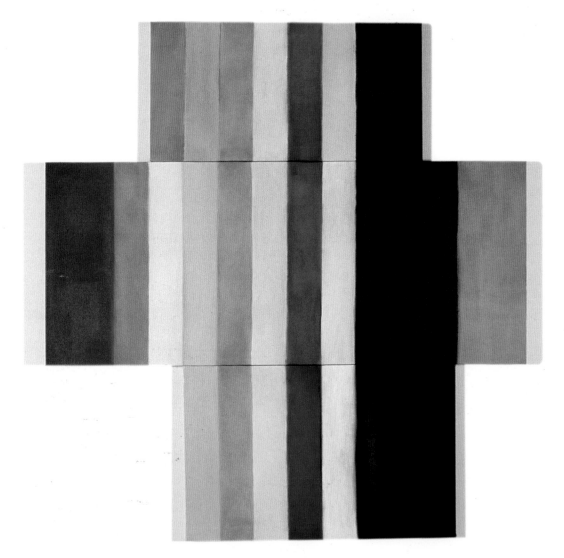

130. *#2—Stripe Color Construct*
1998
Acrylic on 3 Canvases
59" x 56" overall

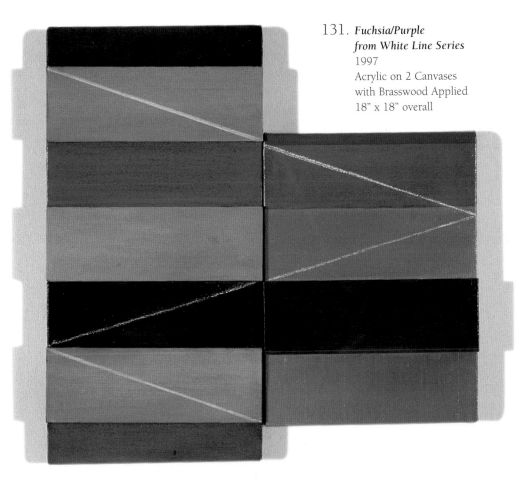

131. *Fuchsia/Purple*
from White Line Series
1997
Acrylic on 2 Canvases
with Brasswood Applied
18" x 18" overall

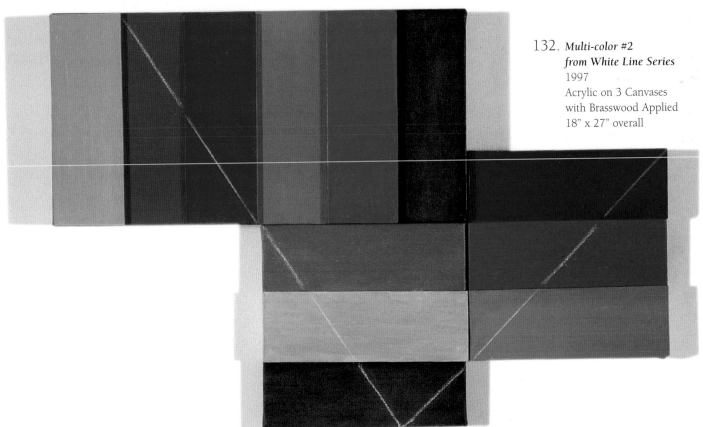

132. *Multi-color #2*
from White Line Series
1997
Acrylic on 3 Canvases
with Brasswood Applied
18" x 27" overall

Frank Piatek

"The basic form configurations which exist in these paintings and drawings are of an ancient and continuing story. They are visually resonant structures at once open and referential. They are what they are yet they are always more. The representations in these paintings and drawings are composed of the visual language of illusion which itself is created out of deeper layers of varying material process. The reference is transparent, multiple and liminal, partaking of the language of correspondence broadened by an attitude of abstraction. The reference is akin to the spirit of Arp's concretions and the purifications of Brancusi, to Chinese guai shi— auspicious dragon stones in painted image or found root, to Henry Moore's reading of the traditions of the odalisque crossed with earth gods and river gods—Gebs and Chacs; to the pulsing facades of Hindu temples, and to the Naga doors and shields of Borneo, and more—always more and significantly less.

133. *Double Stacked Odalisque*
1996
Charcoal, Pastel and
Acrylic on Canvas
52" x 70"

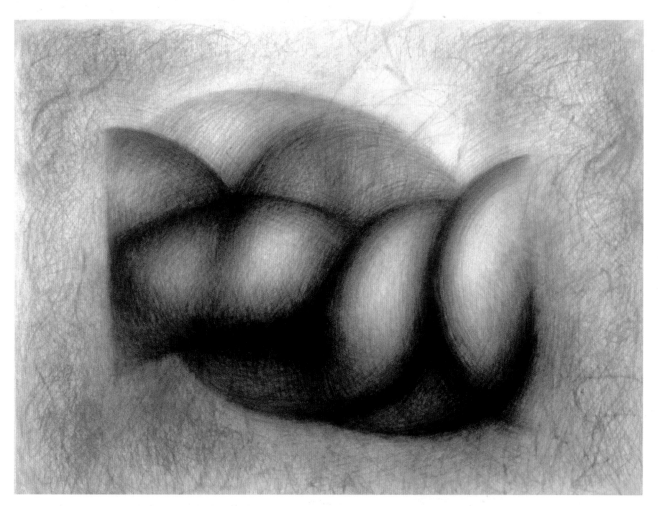

At the core of the feeling or thought which generates the image and where the resultant image generates others is a field of meaning grounded in the perceived crossing point of various magnifications of natural and cultural form, like Batteson's 'pattern of patterns that connect' or Baudelaire's 'forest of symbols'.

Earlier in my career I wrote that tubes are arms, trees, legs, coils, bodies, balloons, boyscout knots, dirigibles, parachutes, pillows. I would add to the expanding list, DNA Double Helix chains and speculative visions of vibrating Super Strings in multiple dimensions."

BIOGRAPHY

Piatek received his Bachelor of Fine Arts and Master of Fine Arts degrees from The School of the Art Institute of Chicago and was on a fellowship to study in Europe for 1½ years. He is currently an Associate Professor at The School of the Art Institute.

Piatek has had solo exhibitions at Hyde Park Art Center, Phyllis Kind Gallery, N.A.M.E. Gallery, Richard Gray Gallery and Roy Boyd Gallery in Chicago. Over the years he has exhibited at the Whitney Museum of American Art in New York City; Terra Museum of American Art in Chicago; The Art Institute of Chicago; Museum of Contemporary Art in Chicago; Illinois State Museum in Springfield; National Gallery of Canada in Ottawa, Ontario; and many others.

In recent years he has also exhibited at Northwestern University Block Gallery in Evanston, Ukranian Institute of Modern Art in Chicago, The School of the Art Institute's Betty Rymer Gallery, and NFA Space in Chicago.

Piatek is represented by Roy Boyd Gallery in Chicago.

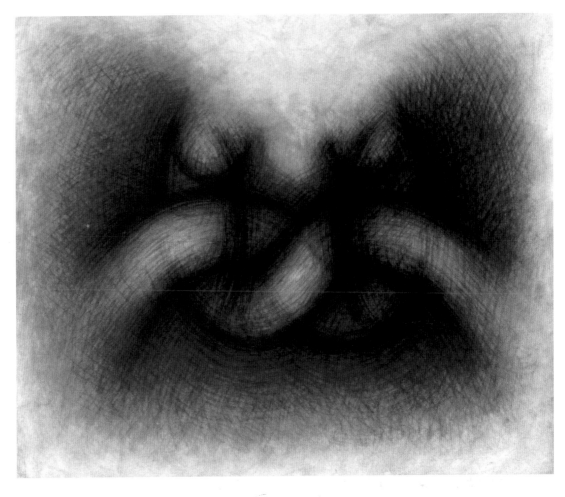

134. *Double Reversed Odalisque—Blue*
1998
Acrylic over Charcoal on Gessoed Canvas
58" x 72"

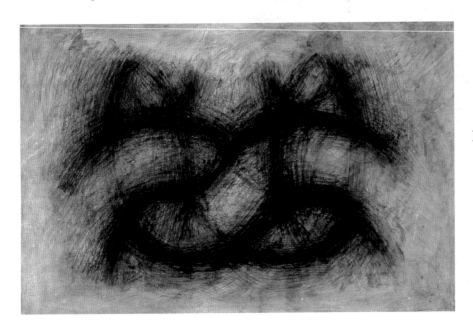

135. *Double Reversed Odalisque*
1998
Charcoal and Acrylic over
Yellow Acrylic Ground on Paper
32¼" x 46¼"

Nancy Plotkin

"After a period of using sculpture and drawing to create imaginary narratives, I had a great desire to make work that was more directly expressive. I wanted to generate the energy one sometimes sees between an artist and a human subject. In the process I surprised myself. I became a realist painter and a lover of the human face.

I worked on this installation of heads on and off for the last five years. They belong to friends, relatives, acquaintances, alive and dead. They comprise, therefore, a record of my life and a commemoration of theirs. I painted them objectively, with minimal expression, so as to avoid distracting the viewer from their deeper and more subtle truths. They are painted without topical allusions so as to suspend them free in time and space.

As I painted each head, I inevitably analyzed that life. As I looked into their eyes, they looked into mine. Face after face enriched me and I grew in understanding and compassion. I believe, at this moment in history, it's good to be reminded of the human face."

136. **Wall**
1999
Oil on Canvas
8' x 13'

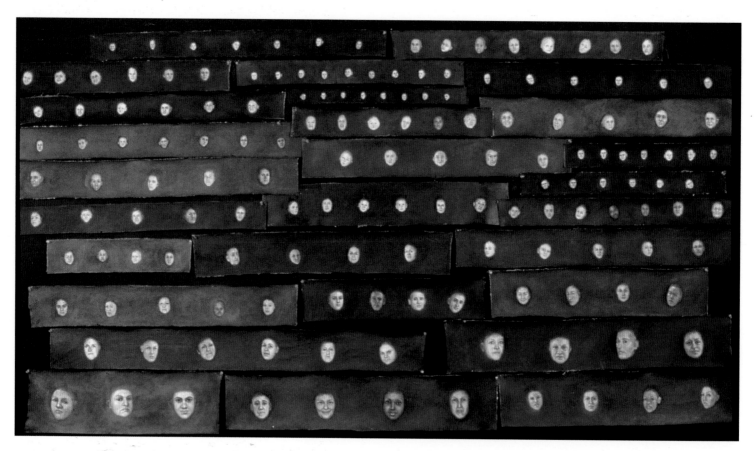

BIOGRAPHY
Plotkin graduated from University of Illinois, Urbana with a degree in English Literature, then proceeded to study sculpture and painting at The School of the Art Institute of Chicago. She holds both a Bachelor of Fine Arts and a Master of Fine Arts from The School of the Art Institute. Plotkin has taught at the Museum of Contemporary Art in Chicago and Governor's State University. In the early 1990's she was a resident artist in Israel.

Plotkins' exhibitions are numerous. They include solo exhibitions at local venues such as Artemisia Gallery in Chicago; Countryside Art Center in Arlington Heights; Evanston Art Center; Morton College in Cicero; Elmhurst Art Museum; and as far away as Artists' House in Jerusalem, Israel. In 1990 she received a Palmer Award from the Chicago Cultural Center. She has also exhibited at Hyde Park Art Center, Museum of Contemporary Art in Chicago, International Art Expositions at Navy Pier, Illinois State Museum in Springfield, Union League Club of Chicago, and Suburban Fine Arts Center in Highland Park. In 1999 Plotkin exhibited her *Heads* at Elmhurst Art Museum, Moraine Valley Community College in Palos Hills, Park Forest Fiftieth Anniversary celebration, and HERE Gallery in New York City.

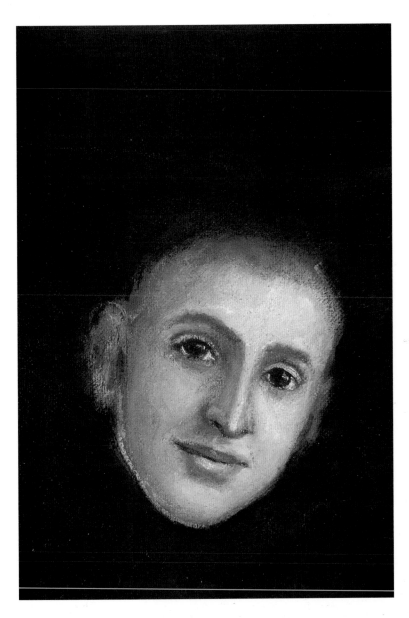

137. **Wall**
Detail
1998
6" high

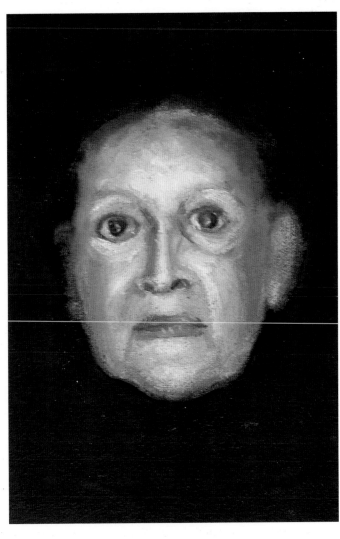

138. **Wall**, Detail
1999
5" high

Sandra Principe

"My recent series of oil paintings features the beauty of orchids. I focus especially on light illuminating the blossoms. My goal is to paint the juncture of light, silence and beauty. I create a tranquil, contemplative atmosphere in which to work. Painting becomes a meditative experience which offers a respite from the overstimulation of today's world.

I prepare my own panels, painting medium and varnishes, using formulas handed down through generations of artists dating back to Rubens. These materials and methods allow me to achieve gemlike colors and fine detail. I paint these orchid paintings from life and under natural light. I raise the orchids that I paint. This affinity for and knowledge of my subject is reflected in my work. I believe the attention to quality in materials and craftsmanship contributes to the elevation of the painting and therefore of the spirit of the viewer."

139. *Trio*
1999
Oil on Canvas
24" x 20"

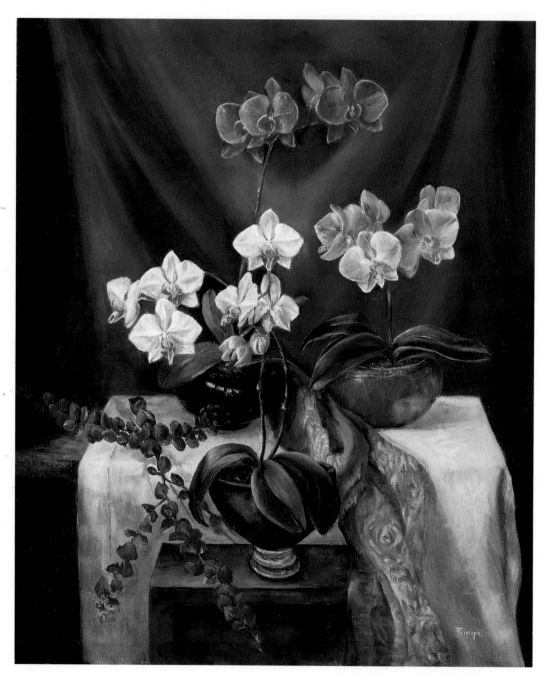

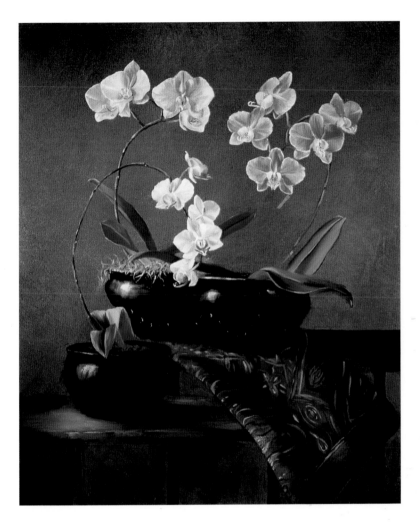

140. *Three Phalaenopsis*
1999
Oil on Panel
24" x 20"

BIOGRAPHY
Principe has attended The School of the Art Institute of Chicago for two years and studied with Irving Shapiro at the American Academy of Art for five years. She also studied with Nita Engle at Dillman's Workshop in Lac du Flambeau, Wisconsin; and David Leffel at Quinlan Art Center in Gainsville, Georgia and again at his Montreal workshop and at Scottsdale Artists' School in Arizona. The local workshops she attended include the Kreutz Workshop and the Scott Burdick Workshop in Chicago.

Principe has had recent solo exhibitions at Palette and Chisel Gallery in Chicago; Drucker's Cottonwood Farm in Galena, Illinois; and University of Dubuque in Iowa. In 1993-1994 she received a Silver Medal at Palette and Chisel's Watercolor Exhibition and Spring Exhibition. She has also exhibited at juried exhibitions of the Oil Painters of America and the Chicago Open.

Principe is represented by the Gallery at Shoal Creek in Austin, Texas; Hildt Gallery in Chicago; and Palette and Chisel Gallery in Galena, Illinois.

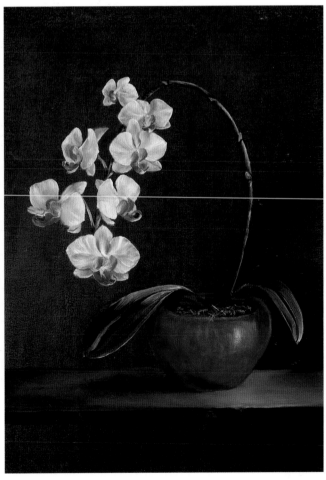

141. *White Orchid with Crimson Bowl*
1999
Oil on Panel
14" x 10"

Gay Griffin Riseborough

DARK TIMES

"Sometimes life events are so powerful that it is years before we can appropriately process them. This painting series is, and will continue to be, my attempt to come to terms with certain dark events in my life. I hope that by using them to make art, I can transform their meaning for me as well.

The dramas depicted are not all to be understood literally although any resemblance to persons living or dead is purely intentional. It is my hope that viewers, while they may not know my story nor the individuals portrayed, will weave their own narratives of them."

BIOGRAPHY

Riseborough graduated from Washington University in St. Louis, Missouri with a Bachelor of Fine Arts degree in 1958. She is Director and Instructor at Studios-on-Florence in Evanston since 1990 and is a Faculty at The School of the Art Institute of Chicago since 1992. She had previously taught portraiture and figure drawing at Evanston Art Center for nine years.

Riseborough has been active in arts organizations in the Chicago area. She was Vice President and Exhibitions Co-Chair of Suburban Fine Arts Center in Highland Park, and Vice President and School Chair of Evanston Art Center. She served on the Board of Directors for both organizations.

142. *Doll House II*
1999
Oil on Linen
36" x 43"

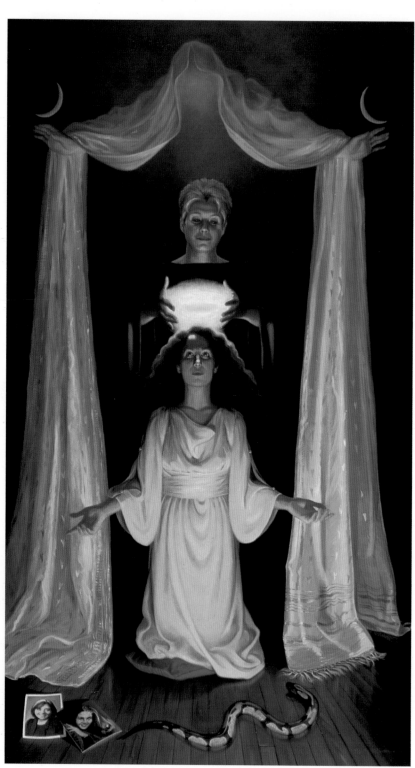

143. *Heiress*
1999
Oil on Linen
77" x 44"

Riseborough has had many solo and group exhibitions. In recent years she has exhibited at Beverly Art Center, Evanston Art Center faculty exhibits, Nomad Central, Wood Street Gallery, and the Old Courthouse Gallery in Woodstock, Illinois. In the past year her paintings from the *Dark Times* series were juried into two local shows: the 13th Annual Women

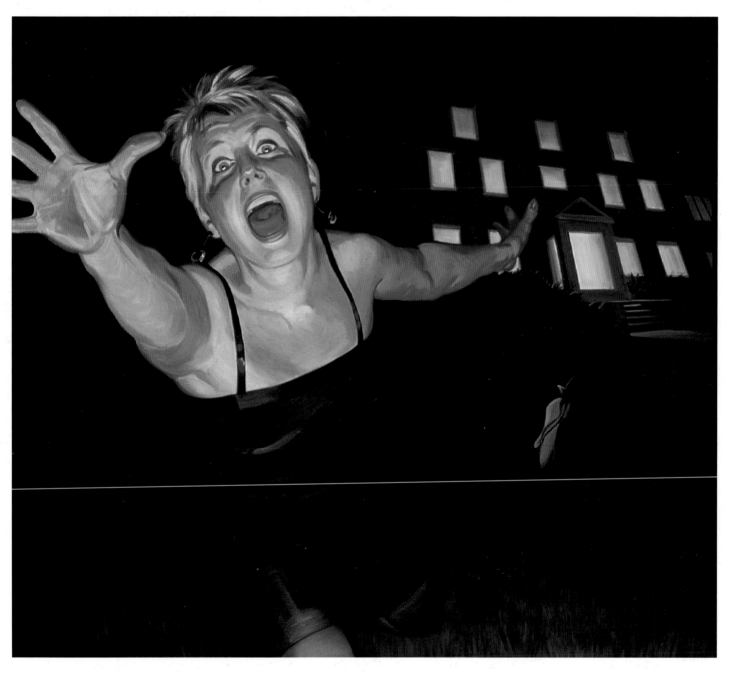

144. *Runaway*
1998
Oil on Linen
35" x 40"

Works in Woodstock and Brickton Gallery in Park Ridge, and published in two periodicals: *Red Magazine* (www.red.magazine.com) and *Manhattan Arts International*.

Her work is represented by Wood Street Gallery. She also does commissioned portraits and her portraits are represented by Portraits/Chicago.

E. Charles Rolwing III

"The making of art is for me a spiritual journey. It is the path I take in order to place myself in the continuum of human existence, the artworks are the footprints of this experience. I believe that there is a place between thought and physical action where an element of chaos or accident occurs. It is through an investigation of this accident in conjunction with intellectual processes that new possibilities of meaning or understanding may be found.

In many ways deciphering my work is similar to the interpretation of dreams, and it is no accident that my paintings sometimes appear dreamlike. It is the logic or illogic of dreams and where they intersect that is the beginning of this thought process. I consider my work to be realism but not in the traditional sense. I am after the way things are, not the way we have learned to see them.

When I create a painting that contains objects or figures floating in space, turned sideways or upside down, it is used to break away from the blinding effect of the expected; to open a dialogue with dream-like logic where things happen in time and space in continuous non-linear, non-Euclidean form.

The figures in my paintings are at once self-portraits, and at the same time portraits of anyone. Symbols float or fly, gravity exists in some places and not in others, the heads themselves become topographical maps—they are dreamers, human and humane. My interest is not in answers, but in the search for truth in the questions."

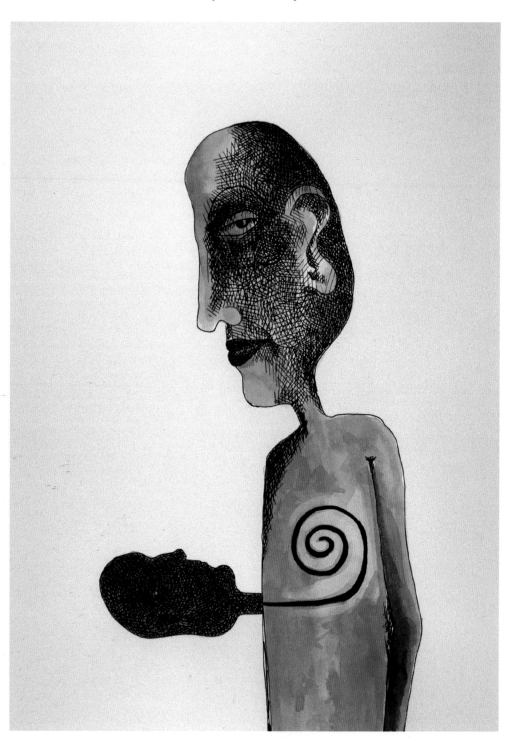

145. *Man with Conscience*
1999
Ink and Watercolor on Paper
13" x 9"

146. *Poet Deconstructed*
1999
Watercolor on Paper
9" x 6"

BIOGRAPHY

Rolwing received his Bachelor's degree in Fine Art from University of Louisville and his Master of Fine Arts in Photography and Printmaking from Ohio University. He is the recipient of the 1976 National Scholastic Gold Medal for Artistic Achievement.

Rolwing has had recent one-person exhibitions at Judith Racht Gallery in Harbert, Michigan and Southport Gallery in Chicago. He has also shown his work at Hyde Park Art Center, Chicago Cultural Center, David Adler Cultural Center in Libertyville, An Art Place Gallery in Chicago and The Barth Galleries in Cleveland, Ohio. In 1999 he exhibited at Los Manos Gallery in Chicago, and then served as a guest curator of their exhibit, *The 7 Deadly Sins.* In 2000 he exhibited at the 23rd National Exhibition on Small Works at Harper College in Palatine, Illinois.

147. *Keeping Flies at Bay*
1998
Watercolor on Paper
24" x 32"

Sallie Gilmore Roniss

"My work is a process of juxtaposing ancient cultural embodiment within today's social structure.

By traveling to exotic countries I try to develop an understanding of the poetic sensibility found in ancient myths. Through my painting I try to express how emphatic these beliefs are embedded in various societies. It is ironic that these myths continue to flourish in an adaptable manner even when the inhabitants are lured to large cities by the premonition of material wealth and an easier life. I sense that this migration damages the bond that accompanies familiar customs and ceremonies by weakening the strength that is shared in communal living.

I like to think that a recognizable feature of my work expresses a domino effect. If I include more than one representational portrait or figurative form in a painting, each form will reflect on what the other form or forms are doing. In some cases the symbolism rationalizes the need to translate this effort.

My love of painting and desire to continue traveling assures me that a kaleidoscope of images will forever be available for resurrection and interpretation."

148. *Music of Madras*
1999
Oil on Canvas
60" x 72"

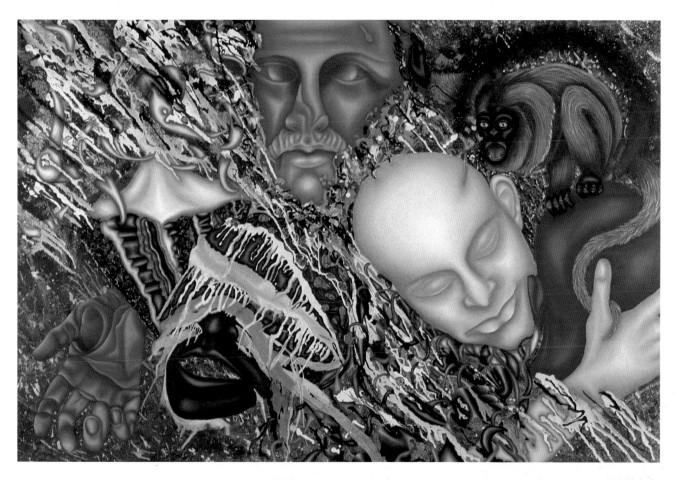

BIOGRAPHY

Roniss attended Layton School of Art in Milwaukee, Wisconsin and also studied specialized techniques in painting under Chicago artist Ed Paschke. She has been teaching adult and children's painting for the Chicago Park District since 1988.

Roniss has had one-woman shows at Gruen Gallery, University of Wisconsin at Manitowoc, and Old Town Triangle Association. More recent solo exhibitions were held at St. Xavier University in 1998, and the Chicago Cultural Center from December 1999 to January 2000. In the last two years she has also exhibited locally at Norris Cultural Center in St. Charles; Brickton Gallery in Park Ridge; and Woman Made Gallery, Chicago Art Open, and Time & Life Building in Chicago.

150. *Lizardo*
1997
Oil on Canvas
36" x 48"

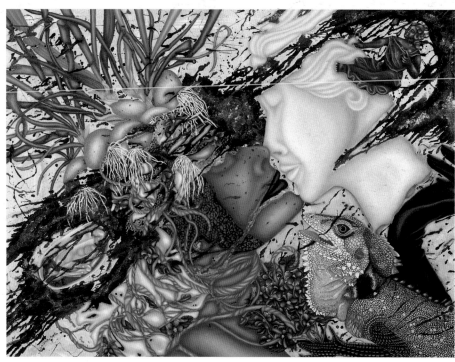

Eric Semelroth

"I make uncommissioned pastel portraits on paper. Some of my subjects appear in costume. The costumes are part of identities that these people have assumed on their own. These images are meant to oscillate between the individual character of the sitter and his assumed persona. Their masks both conceal and reveal. I feel a connection to these subjects because they too are creators of artifice.

I select subjects based on how interesting I think they look or who they are or what they do or how accessible they are to me. Sometimes I have no idea what the subjects look like before I arrive with my camera. I take my own photographs and work from them.

My formal concerns are simple. I am interested in carving out space in which the head can exist. It is my challenge to convey a convincing illusion of depth on a two-dimensional plane."

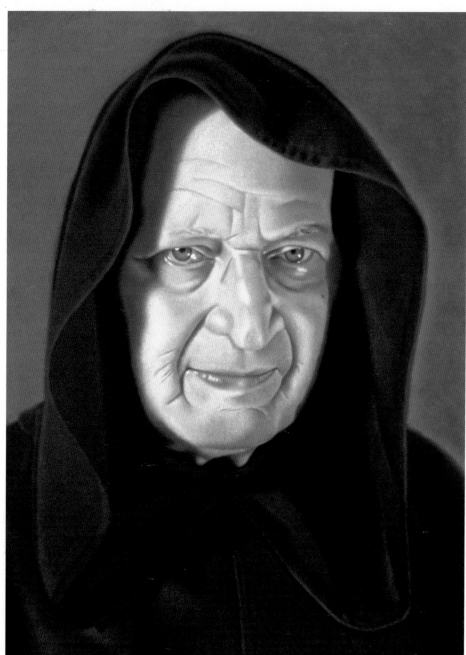

151. *Carmelite
Priest*
2000
Pastel on Paper
21½" x 29"

152. *Imitation À La King*
1998
Pastel on Paper
21½" x 28½"

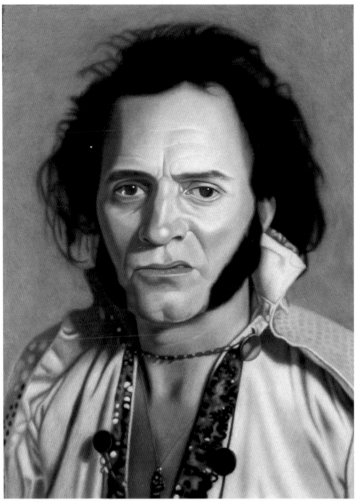

153. *Cross Dressing Draft Resister*
Who Chanted Hare Krishna for 7 Years
1998
Pastel on Paper
21½" x 29½"

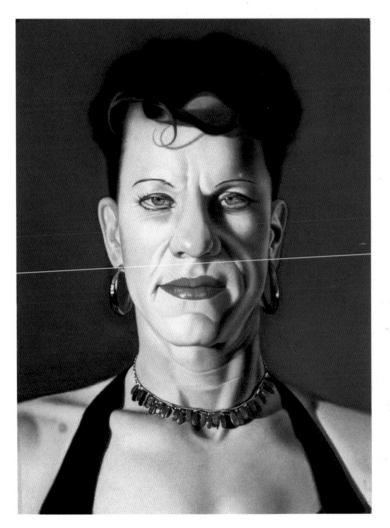

BIOGRAPHY

Semelroth received his Bachelor of Fine Arts degree from University of Illinois at Urbana-Champaign and his Master of Fine Arts degree from Northwestern University, where he studied under Ed Paschke. He is an editorial artist at the *Daily Herald* and has been teaching at the College of DuPage in Westmont and Glen Ellyn, Illinois since 1991. He has also taught at Triton College, Art Encounter, Lill Street and Northwestern University. Semelroth was a cartoonist for *Lombardian and Villa Park Review*, *Strong Coffee*, *The Daily Illini*, and *Courier* for a period of time. From 1991 to 1993 he published a collection of 50 of his cartoons in *Cartoon Manifesto*.

Semelroth is a recipient of numerous awards. In 1999 he was awarded Best of Show at the Norris Cultural Arts Center national juried exhibition in St. Charles, Illinois.

Semelroth has had one person shows at Northern Indiana Arts Association in Munster, Indiana; Contemporary Art Center in Arlington Heights, Illinois; and Contemporary Art Workshop and Triangle Gallery of Old Town in Chicago. In recent years he has also exhibited locally at Riverside Arts Center and Rockford Art Museum, ARC Gallery, Fine Arts Building Gallery, and the Chicago Art Open.

Barry A. Skurkis

"I am intrigued with the chronology of mankind, nature and environment, how each affects and influences one another through history and cultures, and the simultaneous living of differing species sharing the same space. Each of my works contemplates the influences of history whether it be past or present. Archaeology and historical data provide windows to the future. I want my art to be reflective of these principles.

Inquiries into human existence and understanding of the life cycle and the environment help the viewer appreciate the multiplicity of life. I use juxtaposed images in a natural setting to bring attention to my interpretation of the situation. I want the observer to experience my feelings and commitment towards these subjects."

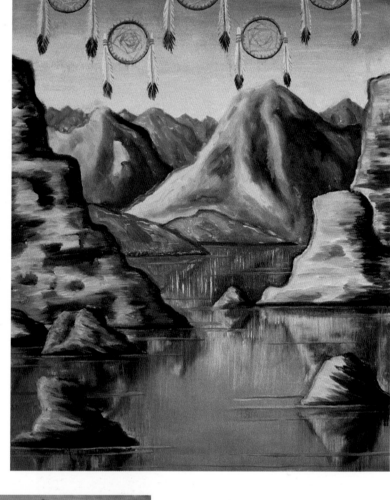

154. *Land of Dreams*
1993
Monoprint
36" x 30"

155. *Forests and Chainsaws #5*
1995
Monoprint
18" x 24"

BIOGRAPHY

Skurkis is currently President of the Chicago Society of Artists, the oldest art organization in the U.S. He received his Bachelor of Fine Arts degree from The School of the Art Institute of Chicago and his Master's degree from University of Notre Dame. He also obtained an Illinois Special Type 10 Teacher's Certificate during his undergraduate studies. He has been teaching at North Central College in Naperville since 1983 and has served as Chairman of its Art Department for three four-year terms. He has also served as a member of the Board of Directors for The School of the Art Institute Alumni Association and the Naperville Sculpture Committee.

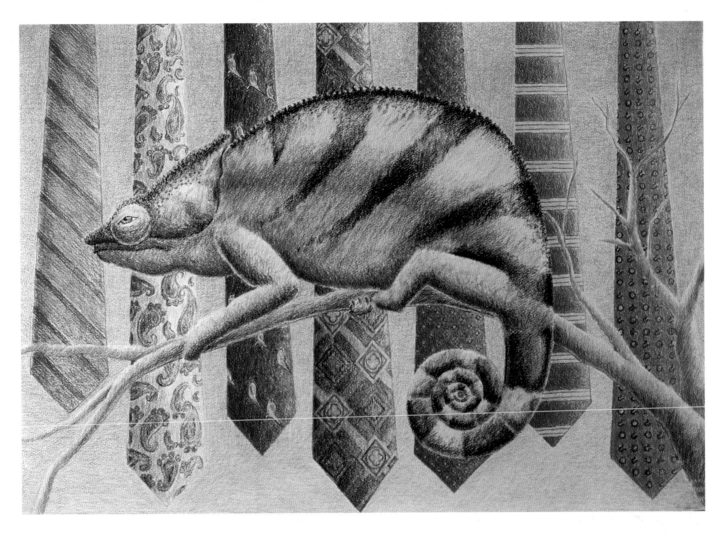

156. *Old & New World Camelions*
1994
Pastel
30" x 38"

Skurkis has participated in numerous national and international competitions. From 1993 to 1999 he was part of the Mini Print International Traveling Exhibit, touring Barcelona, Spain; Wingfield, England; Giron, Spain; Seoul, Korea; Joensuu, Finland; and Bages, France. He was also part of a Traveling Block Print Exhibit, displaying his work in Chicago and Naperville, Illinois; and International Falls, Minnesota. Skurkis has exhibited at a number of one-person exhibits, most recently at Rainy River College in International Falls, Minnesota. His recent group exhibits were held at Anderson Art Center in Kenosha, Wisconsin; and Catskill Gallery in New York.

Deb Sokolow

"These mixed media pieces came about as a result of a personal fascination with the ways certain cultures and professions use visual forms and linear/nonlinear formats to record information or narratives. After studying hieroglyphics, mapmaking and scientific notation, I have pieced together a coded shorthand of pictographs and objects in which to recount personal narratives and map out passages of time.

The process begins with the application of multiple layers of gesso, acrylic and varnish onto found postcards, board or wood. It takes several weeks for the backgrounds to achieve an aged, patina-like look. I then search through my image bank which consists of notebooks and boxes full of images, man-made objects, and organic matter from junk mail, magazines and park refuse, and select a few images that correspond with the narratives I plan to recount. I appropriate these items into each piece along with painted and drawn images, and then mount each piece onto a wood box base. The pieces range in theme from the urban experience to identity timelines and pseudo-scientific documentations of sleep patterns."

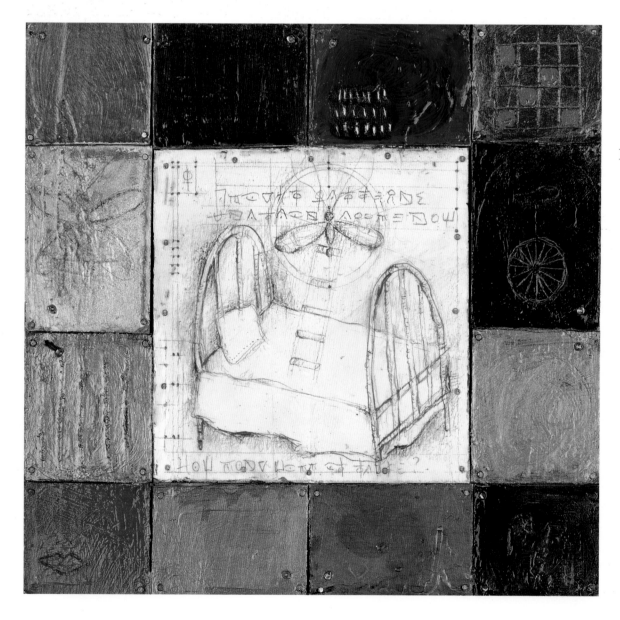

157. *Blueprint #8*
1998
Mixed Media
on Board on Wood
7" x 7¼"

BIOGRAPHY

Originally from California, Sokolow now lives in Chicago and paints in her Ravenswood area studio. She received her Bachelor of Fine Arts degree from University of Illinois at Urbana-Champaign in 1996.

During her years in Champaign, Sokolow became involved in the local art scene. She was one of the founding members of the Champaign Fine Artists Collective and played an active role in its development as a resource for artists functioning outside of the community's college art scene. She has also functioned as an art coordinator for two local cafes downstate and has hosted a series of live music and art collaborations in her own studio in downtown Champaign, two of which were called *The Peeping Tom Show and Beer Bottle Art Exhibition* and *Help Us Pay Rent, A Two Woman Show*. Sokolow has exhibited her work in several of Champaign's Artist Against AIDS shows, and at Krannert Art Museum.

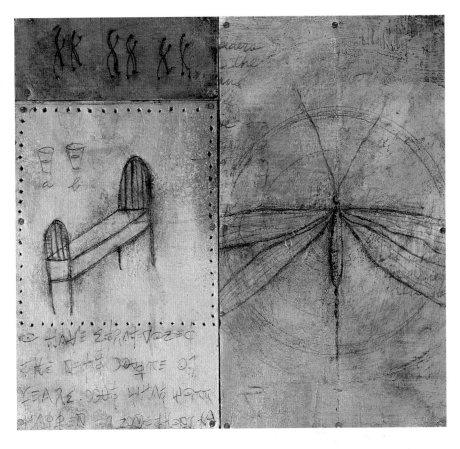

158. *Blueprint #11*
1998
Mixed Media
on Board on Wood
6" x 6½"

In Chicago Sokolow's work was shown at the Ukranian Institute of Modern Art as part of the Curator's Choice Show for the 1999 Around the Coyote Arts Festival. She has also shown her work at I space Gallery and Prairie State College.

159. *Blueprint #1*
1998
Mixed Media
on Board on Wood
6" x 6½"

Eleanor Spiess–Ferris

"My work uses nature as metaphor for the human condition."

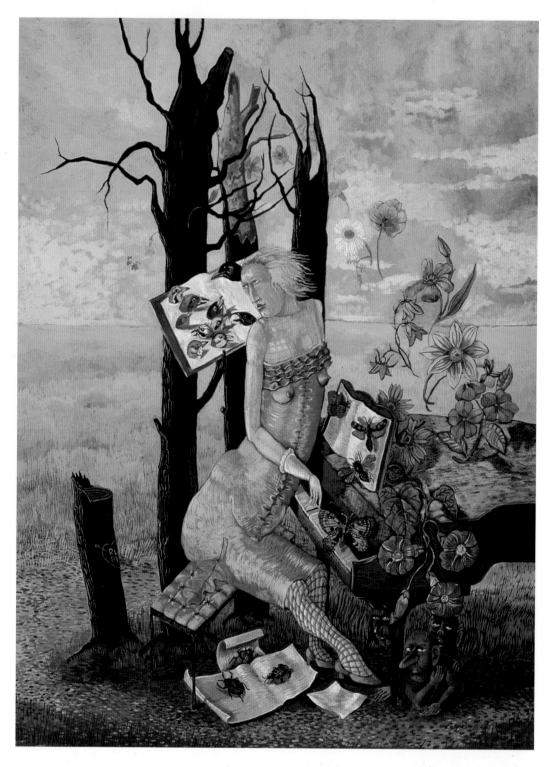

160. *Spring Composing Summer*
1999
Gouache
30" x 22"

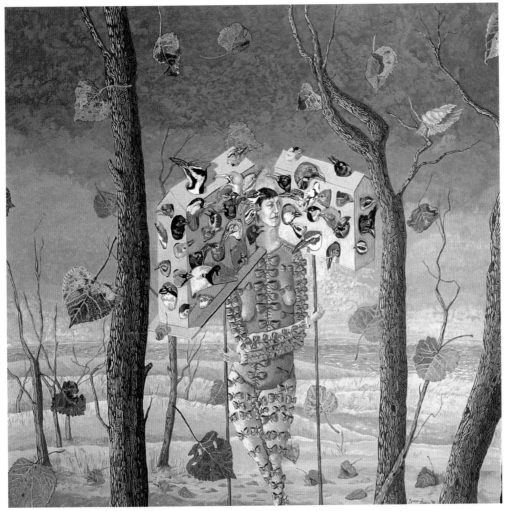

BIOGRAPHY
Spiess-Ferris was born in Las Vegas, New Mexico. She received her Bachelor of Fine Arts degree from University of New Mexico in Albuquerque. She also attended The School of the Art Institute of Chicago and has been teaching at the Evanston Art Center since 1984.

Spiess-Ferris has received the Illinois Arts Council Artists Fellowship Grant in 1989, 1991 and 2000. Her work was part of several traveling exhibitions, including the 1982 Smithsonian Institution Traveling Exhibition, and the 1999 to 2002 *Illinois Women Artists: The New Millennium* exhibit traveling the State of Illinois. Her most recent solo exhibition was at Zaks Gallery in 1999 and her recent group shows were held at the Chicago Cultural Center, Wood Street Gallery, and Northern Illinois Art Museum in Chicago, as well as the Suburban Fine Arts Center in Highland Park; Northwestern University Dittmar Gallery in Evanston; and Wustum Museum in Racine, Wisconsin.

Spiess-Ferris is represented by Sonia Zaks Gallery in Chicago.

161. *Fall*
1999
Gouache
30" x 30"

162. *Garden War*
1999
Gouache
22" x 30"

Rubin Steinberg

"There are those who would say that anyone with two Master's degrees, one in Fine Arts and one in Education and Supervision, could not be a self-educated artist. Yet neither of these schools at the time taught anything as sophisticated as that into which my art has evolved.

After the Army (1958-1959) I sang for four years with the Lyric Opera Chorus before discovering that art is much more satisfying. Mistakes in singing could ruin a chorus but mistakes in art could be incorporated into the art piece itself and used as a learning device on which to build.

Much of what I create has the flavor of 'Outsider Art', 'Folk Art' or 'Ethnic Art'. I have always been an artist out of the mainstream. 'Crossover Art' has recently found its way into the art lexicon: the idea of there not being one function or one approach to an art piece. I have been combining materials and objects for over thirty-five years. In this time I have taught myself a distinct form of sculptural weaving and collage which I combine with many different materials: leather, machine parts, wood, fabrics, copper repoussé and acrylic paint. With this I have developed a unique design sense.

Various approaches to my work have roots in diverse areas of the art world. I have always enjoyed collage and weaving and finding ways to combine them with acrylic painting. My art straddles the line between crafts and fine art and and now leans more toward collage painting."

163. *Brave Hearts*
1999
Sculptural Weaving, Acrylic Paint, Brass Repoussé, Brass-Gold Assemblage, Toy Figures, Skeletons, Cork, Leather, Material on Canvas
36" x 48"

BIOGRAPHY

Steinberg received his Bachelor of Education degree from the Chicago Teachers College, his Master of Fine Arts degree from The School of the Art Institute of Chicago and his Master of Education from Roosevelt University.

Steinberg was in the Army from 1958 to 1959. In 1960 he obtained a teaching position with the Chicago Board of Education. After many travels around the world and writing fifty art teaching articles over fifteen years for *Arts and Activities Magazine,* he retired from teaching in 1995 to create art full-time.

Steinberg has participated in many juried exhibitions, including the Illinois State Museum in Springfield; the Southern Ohio Museum in Portsmouth; The Art Institute of Chicago, Museum of Science & Industry, Chicago Society of Artists, American Jewish Art Club, Hyde Park Art Center, and the Gold Coast Association in Chicago. He has won numerous awards from various exhibitions as well. In 1999 his work was displayed at Time & Life Building in Chicago and Taipei Fine Arts Museum in Taiwan.

Steinberg's work is in many private and public collections and has been featured in several books, including *The Life and Works of Artist Rubin Steinberg* published in 1999 by Louise Dunn Yochim, a Chicago area artist.

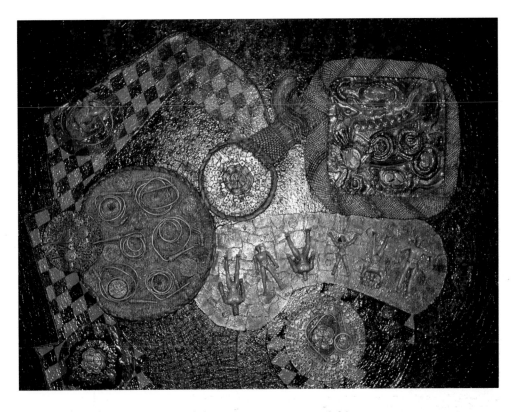

164. *Space Pizza Meets Harlequin*
1998
Acrylic Assemblage, Toys,
Copper Repoussé, Furnace
Parts and Leather Mosaic
36" x 48"

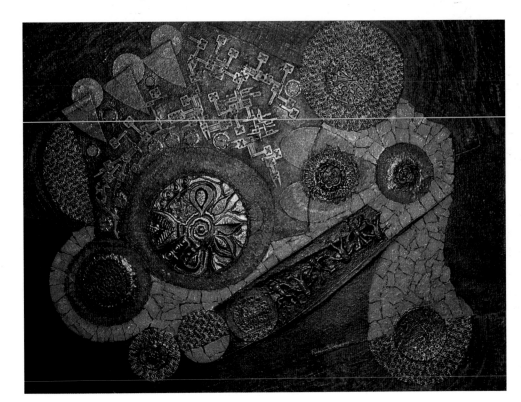

165. *Space Fall*
1998
Assemblage, Toy Figures,
Mechanical Parts, Leather Mosaic,
Acrylic Paint, Copper Repoussé,
Material on Canvas, Cork, Felt,
Sewn and Glued
36" x 48"

Allen Stringfellow

"I have worked with most mediums but am now working with collage and watercolor. Collage presents a fresh approach to composition. I can get so much depth and movement in the piece. I can achieve a lot of action with the bold colors and textures. There is excitement in collage.

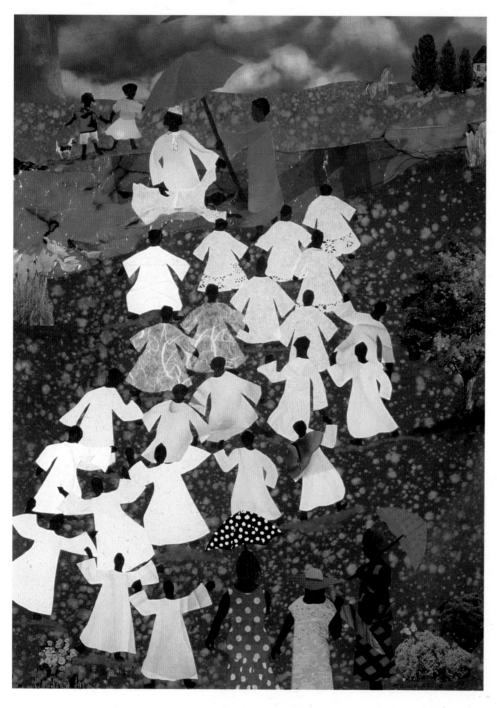

Jazz and religion are my two major influences. The themes of my paintings are drawn from my recollections. I have long since despaired of the church, yet the gospel sanctuary remains fresh in my mind. I was the son of a nightclub singer and a jazz guitarist, and was raised around entertainers and in nightclubs in Chicago. For me, the church and jazz are the same—they have the same rhythms. Entertainers in the clubs have the love for the people that the church folks talk about. If you are down and out and someone else has something, they would share it. Show people have love for each other."

BIOGRAPHY

Born in Champaign, Illinois Stringfellow studied art at University of Illinois in Champaign and Milwaukee Art Institute in Wisconsin. He has taught art at Douglas Art Center in Champaign and silk screening at Chicago's South Side Community Arts Center in the 1930s and early 1940s.

Stringfellow owned one of the original art galleries in Chicago's Old Town called Walls of Art in 1960. It was from there that he started the Wells Street Art Fair.

Stringfellow has won numerous competitive awards. His signature works such as *Ladies Day* involve papier mache figures. His work has been shown in many galleries and museums, such as the Museum of Science & Industry, The Art Institute of Chicago, and the Historical Society, all in Chicago. He is represented by Nicole Gallery in Chicago and Essie Green Galleries in New York City.

166. *Gonna Lay Down My Sword and Shield*
1998
Collage
30" x 19"

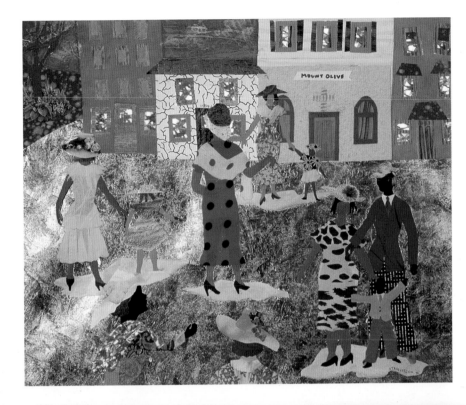

167. (left)
Sunday Morn
1997
Collage
19" x 22"

168. (below)
Ladies Day #10
1997
Collage
32" x 40"

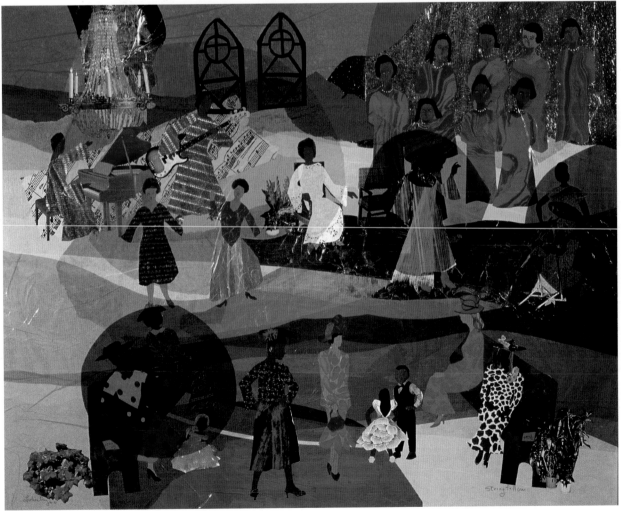

Bruno A. Surdo

"The artistic forms I have created are images that communicate a personal commentary on an issue or question in my mind. These shapes are then arranged in a pictorial space using the human form as the main vehicle for my expression. I use iconic and metaphoric symbolism which echo the narrative expressed by the use of space and the human form. I strive to communicate a message to the viewer—to engage this person in a conversation between what I put forth and what he or she can then interpret. The interchange of response and curiosity are goals I set when composing my ideas. I believe art is a continual form of expression and I feel committed to search for a language that brings my thoughts and feelings to the surface."

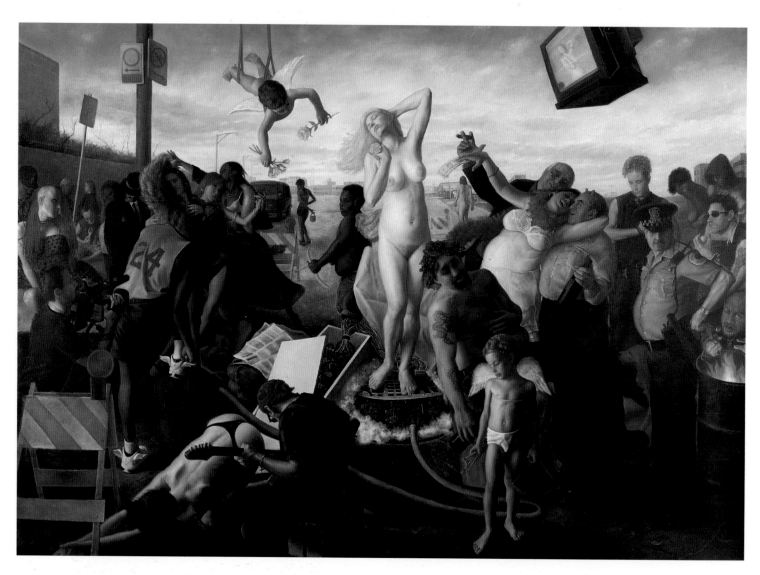

169. *Re-emergence of Venus*
1999
Oil on Canvas
102" x 142"

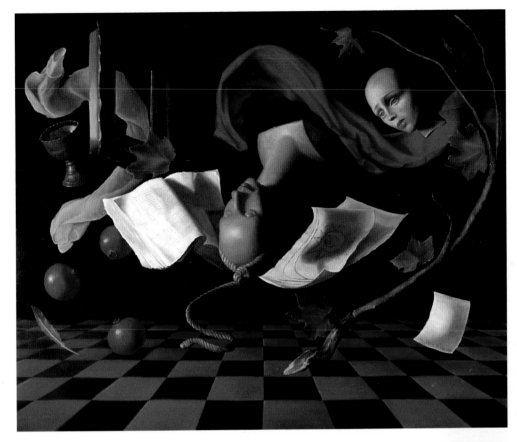

170. *Still in Motion*
1999
Oil on Canvas
52" x 60"

171. *Where is My Life Going?*
1998
Oil on Canvas
42" x 30"

BIOGRAPHY

Surdo was born in Chicago. At the age of fifteen he moved to Bari, Italy with his family and studied drawing and art history at Liceo Artistico di Bari. After returning to the States he continued to study art at the American Academy of Art in Chicago. He then enrolled in the Atelier Lack in Minneapolis, Minnesota, a school that structured itself like the ateliers that flourished in western Europe in the eighteenth and nineteenth centuries. There he learned the traditional methods of drawing and painting and perfected his ability to dramatically depict the human form. Soon he was back in Europe again studying at the Studios Cecil-Graves in Florence, Italy.

Since his return to Chicago, Surdo is regularly commissioned for portraits, landscapes, still lifes, and figurative and allegorical compositions. Most recently he has depicted biblical and literary messages in modern settings. In 1995 the Chicago Department of Cultural Affairs sponsored the show, *Life, Struggle and Hope—Paintings by Bruno Surdo*. In 1997 he was commissioned by the College of Lake County to create a 20' x 30' mural entitled *Where There is Art, There is Life* for their newly constructed Cultural Arts Center.

Surdo is the Founder and Director of The School of Representational Art and has been teaching there since its inception nine years ago. This atelier is the only place where Chicago area students can study in a structured curriculum, modeled after the schools of the great European masters.

Surdo's work can be found in many private and public collections. He is represented by Ann Nathan Gallery in Chicago.

Shari Swartz

"I am always experimenting with materials and mediums. Charcoal and pastel are mediums that I've always felt comfortable with because I am able to move the material directly with my hands and arms. This lets me feel like I am part of the material and what I've put on the paper has come immediately from my heart. Gouache on paper is more of a cerebral challenge for me. Like a chess game, I'm thinking five moves ahead in regard to space, color, shape and form and how these elements will play off one another.

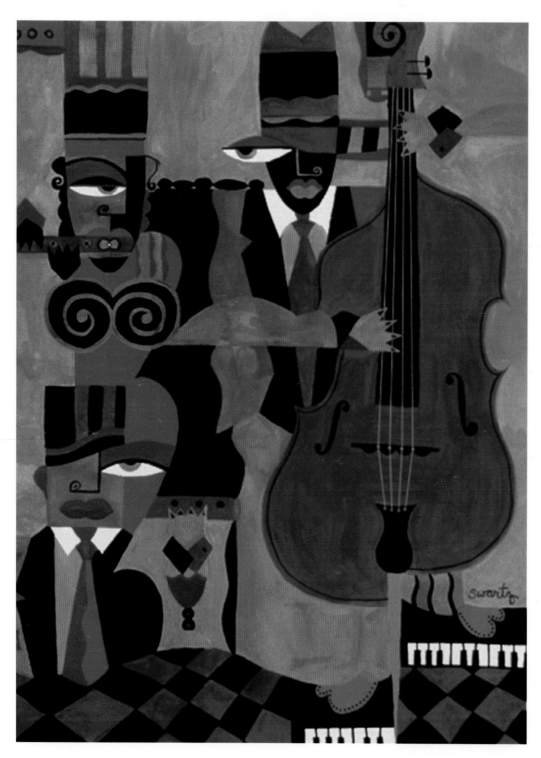

The music series came out of a continuing exploration of my roots. I grew up in a home where a lot of music was played. During the swing era my father had been a sax and clarinet player and played in local bands and orchestras on Long Island, New York. My father recently told me the story about when he auditioned for and won a saxophone seat in Benny Goodman's band and where they played gigs around the country. I was always in awe of his talent and to hear that he played with that band made me realize how talented he had been. Growing up, he always played the clarinet and piano with the swing records. The connection I feel to that era of music and the memories I have of him playing the clarinet have been a source of inspiration for this series. My paintings of this series reflect the rhythms, colors and shapes I learned from those early years of listening and learning about music from my father.

172. *Pink Venus*
1999
Gouache on Paper
34" x 28"

The bird series comes from my recent interest in these creatures and in insects and the elaborate designs and patterns some of them possess. I've been fascinated with the intricate designs of their coats, and their elaborately designed bodies and heads. This series stems from my exploration of how such forms come to be."

BIOGRAPHY

Swartz was born and raised in New York. She received her Bachelor of Graphic Design in Fine Art from University of Florida in Gainsville. She is currently teaching at Gallery 37 in Chicago.

Swartz is the winner of the 1999 poster art contest for the Chicago Latino Film Festival. She also received First Place awards in editorial illustration and graphic design from American Jewish Press Association in three consecutive years: 1996, 1997 and 1998. Commissions have included art and illustrations for posters, promotional art and program guide cover art for Chicago Symphony Orchestra, Chicago Opera Theatre, Steppenwolf Theatre, Goodman

173. *Untitled*
2000
Pastel and Charcoal
29" x 21"

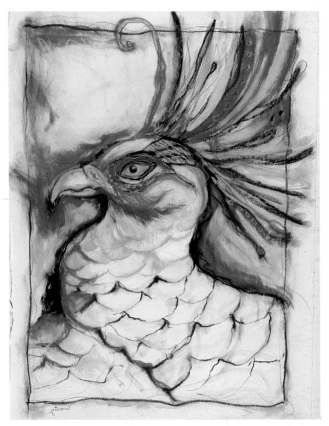

Theatre, Old Town School of Music, Chicago Jazz Festival, Footlights Theater, The Guild Complex, National Pastime Theater, Mercury Theater, and others in Chicago.

In 1999 Shari was chosen by the League of Chicago Theatres to paint a mural at the State and Lake Streets 'El' train station. In the same year, she was one of 300 artists chosen to paint a life-size cow as a participant in the Cows on Parade™ public art project.

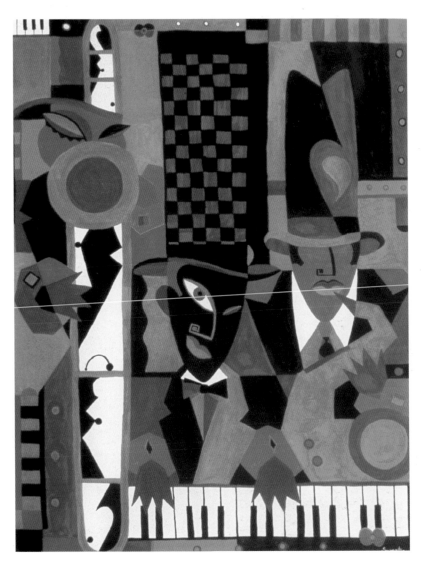

174. *Checkerboard Players*
1998
Gouache on Paper
34" x 28"

Dannielle Tegeder

POP BIOLOGY

"My art consists mainly of brightly colored abstract paintings of the human body's inner anatomy. I take as my subject DNA, cells, viruses, neurological systems, and various microbiological images and transform them with vivid colors.

Starting with a scientific or diagrammatic base, I draw on paper and canvas images of isolated, dissected human body parts from medical books. I work mostly with oil paint but also use a variety of media including gouache, ink, colored pencil, marker and pastel.

Color is a crucial element in my paintings; I consciously select striking, unusual combinations. These color combinations are partly derived from popular American culture. I take my inspirations from a minute observation of daily life. A dress in a store window, Easter decorations and candy are only few of the seemingly mundane things that influence my choice of color. My travels throughout India and West Africa play an equally major part in my work.

175. *Ring around Vitiligo*
1999
Colored Pencil, Marker,
Gouache and Pastel on Paper
18" x 24"

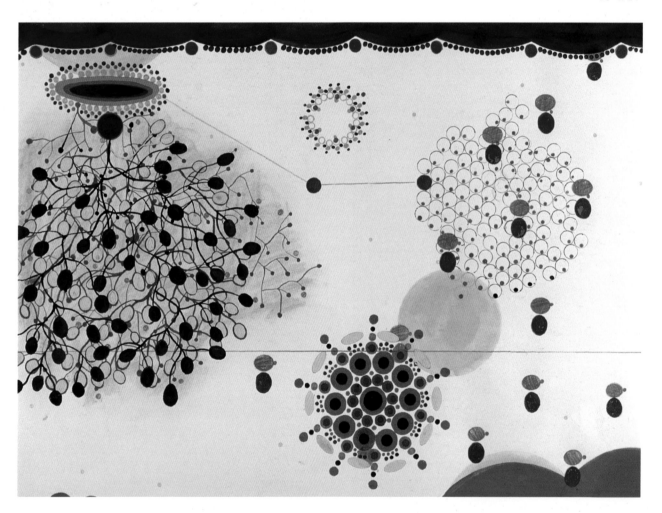

My palette seeks to activate the viewer's eye. Although bright colors predominate my paintings I often counter them with softer hues to set a meditative mood. The concept of beauty firmly grounded upon proportion, order and color compels me. The creative process enables me to understand abstractions on my own terms. At the same time I attempt to juxtapose our inner mortality with modern society's obsession with pop culture through the combination of biology and color."

BIOGRAPHY

Tegeder studied at The Amsterdam School of Fine Arts in Holland in 1991. She graduated with honors from the State University of New York at Purchase in 1994 and from The School of the Art Institute with a Master of Fine Arts degree in 1997.

Tegeder was a Peace Corps volunteer to Ghana, West Africa in 1994, living with the Ashanti tribe and teaching art classes there. In 1997 she was a visiting artist at Baroda University in Gujarat, India. She now teaches at The School of the Art Institute and the Illinois Institute of Art.

In the past year Tegeder has had solo exhibitions at ARC Gallery, Contemporary Arts Workshop, Illinois Institute of Art Gallery and the Museum of Surgical Science in Chicago. She also participated in group exhibitions at Marwen Foundation, Northwestern University Settlement House

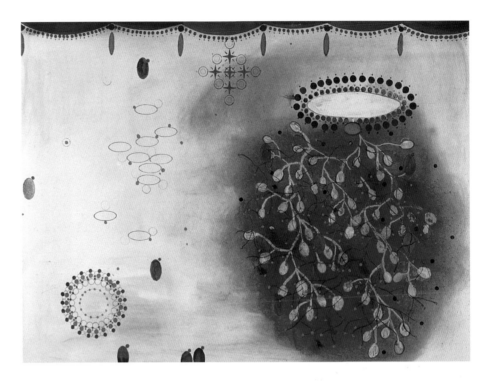

176. *Sugar Blue*
1999
Colored Pencil, Marker, Gouache and Pastel on Paper
18" x 24"

in Chicago and Silverstein Gallery in New York City. In both 1998 and 1999 Tegeder was a recipient of the Chicago Artists Assistance grant.

177. *Abduction*
1999
Oil and Gouache on Canvas
33" x 33"

133

Charlie B. Thorne

"I happen upon scenes of idiosyncratic beauty,
 often during evening walks in the city around me,
 and from them find inspiration for my art.

I'll turn a corner and spot some graffiti tagging, ugly in almost all circumstances but, through a fluke of composition, made strangely appealing. Or I'll look across an empty street and see the grim humor and raw poetry of an employees entrance overgrown with weeds.

I try to use realism as a tool of recognition, not as a trick for the eye. Haven't we all looked out on a moment of calm in what we know is an ongoing storm and received an emotional charge from the sight. That's what I want to put in my artwork."

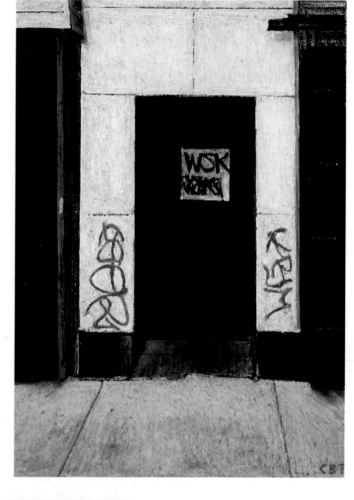

178. *Graffiti II*
1997
Oil Pastel
14" x 10"

179. *Employees Entrance*
1998
Oil Pastel on Black Board
11" x 17"

BIOGRAPHY

Thorne was born and raised in Bensenville, Illinois. He moved to Chicago while attending the American Academy of Art and has been a Northside resident ever since.

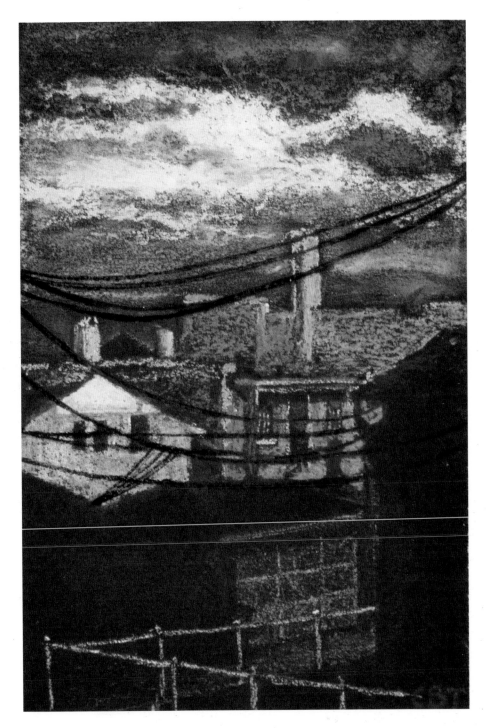

180. *Break in the Storm*
1999
Oil Pastel on Black Board
9½" x 6½"

Thorne has been in exhibitions sponsored by the Wicker Park Art Gallery and the Northshore Women's Art League. His work has appeared in juried shows at both Northwestern University and University of Chicago, where he won a First Place Award. In 1992, he was asked by the Greenview Arts Center to participate in *The Neighborhood Show* at their Rogers Park facility. This group show subsequently inaugurated the Randolph Street Gallery in the Chicago Cultural Center. In 1994, his work was presented at a group show entitled *Urbanity* in the John Hancock Signature Room on the 95th floor. In 1997 he received a Second Place award for his submission to the A.R.C. Gallery eight-state regional show juried by Ann Sass of the Whitney Museum of Art in New York.

Thorne has created illustrations for a book by the San Francisco poet Douglas Blazek. His drawings were published in the Spring 1994 issue of *Jubal*, a literary magazine published in New Orleans. Locally, he has done poster and graphic work for WXRT Radio and the Quiet Knight Nightclub, Independent Precinct Organization-Independent Voters of Illinois and many musical groups.

Thorne is one of 68 Chicago area artists featured in *The Chicago Art Scene* by Ivy Sundell (1998). Belloc Lowndes Fine Art held an exhibition for the book in the Spring of 1999 and continues to represent Thorne in his three-dimensional work.

Pala Townsend

"Initially inspired from a rain forest across the street from where I grew up in Portland, Oregon and subsequently from living beside Lake Michigan for the last fourteen years, my nature-related abstract paintings continue to explore themes of water, light and forest.

 Since 1996 I have been crafting new techniques that translate the magical quality of being in an atmosphere of verdant diffusing light. The new paintings have an illusionistic space that feels transparent, out-of-focus and holographic. The dreamlike, shimmering optical effects are build around the the ability of the eye to perceive focused and unfocused areas as distinct spatial planes. At times the out-of-focus markings speak the graphic language of photography and video pixelization but elude specific meaning."

181. *Yellow Diver II*
1999
Oil on Canvas
72" x 66"

182. *Station II*
 1998
 Oil on Canvas
 72" x 66"
 Collection of Microsoft Corporation,
 Seattle, Washington

183. *Obsidian Cave*
 1996
 Oil on Canvas
 72" x 66"

BIOGRAPHY

Townsend studied with Robert Colescott at Portland State University. She received her Bachelor of Fine Arts degree from University of New Mexico at Albuquerque and her Master of Fine Arts degree from Tufts University/School of Museum of Fine Arts in Boston, Massachusetts. She has taught at Massachusetts College of Art and the School of the Museum of Fine Arts, and has been teaching painting and drawing at The School of the Art Institute of Chicago since 1985.

Recent one-person exhibitions were held at Chicago Cultural Center, The University Club and Fassbender Gallery, all in Chicago as well as Laura Russo Gallery in Portland, Oregon. Other recent local group shows include Art 1998 Chicago at Navy Pier, Northern Illinois University Art Museum in Dekalb, Rockford College Art Gallery, Lake Forest College and Noyes Cultural Arts Center in Evanston.

Townsend is represented by Fassbender Gallery in Chicago.

Phillip J. Turner

"My work has primarily dealt with the figure and its environment. This body of mixed media work contains self-portraits, incorporated with found objects that literally and symbolically balance on the figure's head like 'Helmets and Crowns'.

These symbolic helmets and crowns began from an observation of women's hairstyles and other cultures' use of objects for head adornment and symbols of one's station in society. I also examine the plastic elements of the materials and enjoy the interaction of material surface. It is my intention for the viewer to become at once disconcerted by the balancing of objects on one's head and re-examine the discarded objects used for the collages."

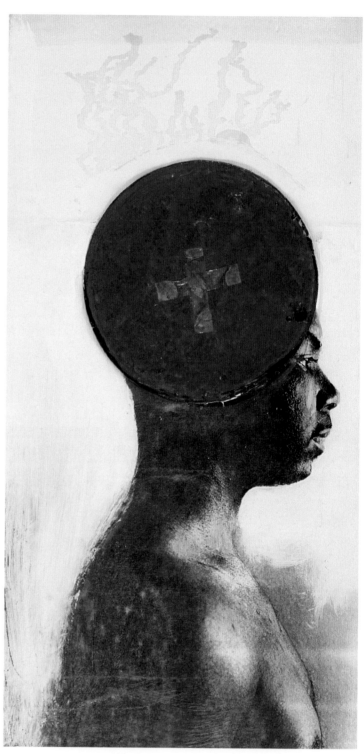

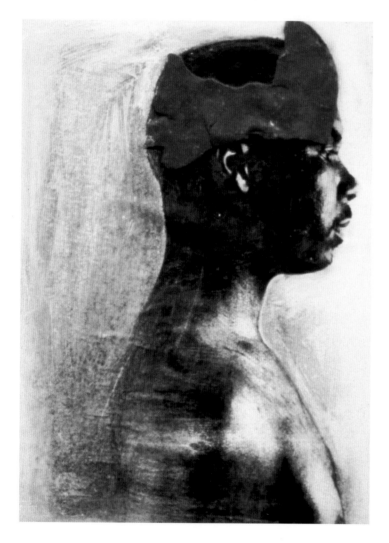

184. *Helmets and Crowns*
 1997
 Photo Transfer, Wax, Acrylic,
 Gesso, Found Objects on
 Drywall Plaster
 36" x 24"

185. *Helmets and Crowns: Top*
 Detail
 1996
 Photo Transfer, Wax, Acrylic,
 Gesso, Found Objects on Paper
 30" x 22"

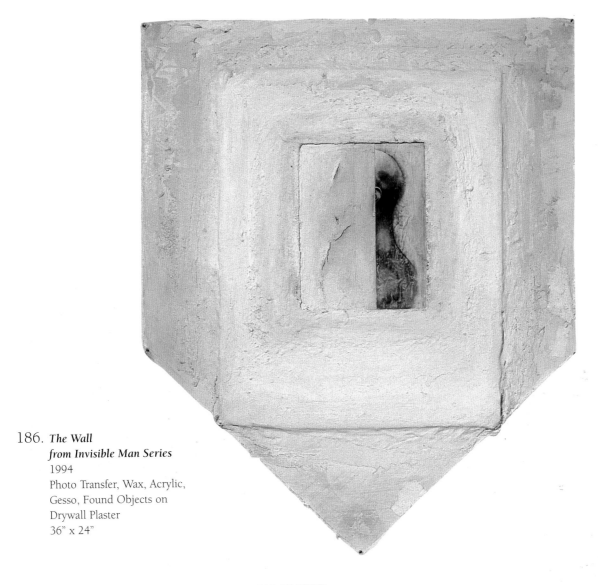

186. *The Wall*
from Invisible Man Series
1994
Photo Transfer, Wax, Acrylic,
Gesso, Found Objects on
Drywall Plaster
36" x 24"

BIOGRAPHY

Turner grew up in an artist family in Chicago. He studied Art History and Printmaking at Quincy University in Illinois and Illinois State University in Normal where he received his Bachelor of Fine Arts and Master of Fine Arts degrees, respectively. He is the Director of Curtis.Allen.Turner Fine Arts, his family's private gallery, which at one point mounted exhibits of young and international artists. It now only provides artists representation and consultation. Turner is also a co-founder and curator of PARKER Press which specializes in alternative prints. Since 1985 he has curated over 50 exhibitions of contemporary artists. In addition he works in the Visual and Performing Arts Department at the Harold Washington Library.

Turner's recent solo exhibitions were held at Indianapolis Arts Center in 1998 and Elmhurst Art Museum in 1999. He has also exhibited his work at the Museum of Science & Industry's Black Creativity Exhibitions in 1994, 1996 and 1997 and was awarded Best of Show in 1994. In 1997 his work was exhibited at Gallery 2 of The Art Institute of Chicago. Turner's work is in many private and public collections.

Annette Turow

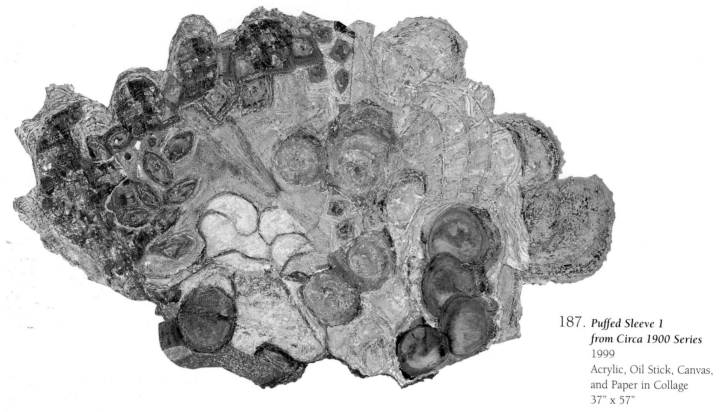

187. *Puffed Sleeve 1*
from Circa 1900 Series
1999
Acrylic, Oil Stick, Canvas,
and Paper in Collage
37" x 57"

HANNAH'S BEADS

"My mother had been dead for sixteen years. In 1998 I went to help her sister pack to move to a new apartment. I have always loved my Aunt Adele. She is an artist and she was my earliest mentor. As we finished our work, she came out of her bedroom with a small box and gave it to me.

'These belonged to your great-grandmother, Hannah Rachel, whom you are named for. I think you should have them because you are the oldest grandchild and you have her Jewish name.' Then she added, 'I've even discussed this with my children.' I was flooded with sensations. My aunt and I have exchanged few presents during my lifetime and this felt enormous. The sense of connection with the female descendants in my family had been denied to me for a very long time. I loved my grandmother, Nettie, very much and when she died a few years after my mother, that direct line was gone and I was alone. My mother was an expert seamstress and my grandmother had sewn patch quilts which are on the beds of the entire extended family. The images from these paintings came from that renewed sense of connection. The ideas for fabrics, sleeves, beads, buttons and brooches just poured forth as though I really knew what she might have worn.

My work is the result of elements of spirituality, the process of aging, connection to the past, and access to my own creative process through psychological awareness. I have focused on texture, color and pattern in this series of abstract compositions. Ultimately my work is always influenced by the collective awareness of my own ideas and the appreciation of other artists such as Marsden Hartley, Howard Hodgkins, Kandinsky and Gabriel Munter.

In memory of Hannah Rachel Kempler 1870-1936."

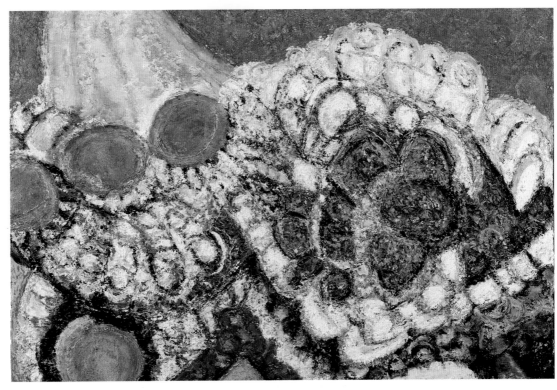

188. *Amber Beads and
Puffed Sleeve I
from Circa 1900 Series*
1999
Acrylic and Oil Stick
on Masonite
24" x 36"

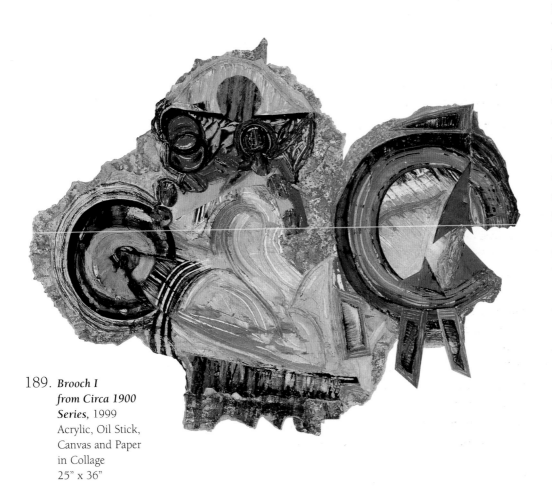

189. *Brooch I
from Circa 1900
Series,* 1999
Acrylic, Oil Stick,
Canvas and Paper
in Collage
25" x 36"

BIOGRAPHY

Turow received her Bachelor of Fine Arts degree from University of Illinois in Champaign and attended the Sarah Lawrence Summer Session in Paris. She went on and received her Master's degree in Education from Stanford University. In 1999 she taught at the State of Illinois' Integrating Arts into the General Curriculum program, was supervisor for Northwestern University School of Education and Social Policy, and was on the Committee for Gallery 37. In addition she was Chairman of the District 39 Educational Foundation.

In 1997 Turow had a one person show at I space, a Chicago gallery for the University of Illinois at Urbana-Champaign. She had three shows, including a one person show, at Gruen Galleries in 1998 and 1999. She was also part of an exhibit at Columbia College entitled *Painting in Chicago Now* in 1998.

Turow is currently represented by Rena Sternberg Gallery in Glencoe, Illinois and Walter Wickiser Gallery in New York City.

Alice R. Vrazo

"The imagery in my paintings is based on the Midwest landscape. Each day I drive past long, open fields and watch as the horizon divides the world into two parts: one solid and growing, one nebulous and shifting.

During evening walks in autumn, the sky has a way of closing in quickly. There is a certain dark beauty that fills the surrounding space as sight is shortened and the other senses piqued. This physical experience mirrors an internal state of vulnerability when understanding and confidence give way to uncertainty. Some of the darker pieces are an effort to reflect that moment when light slips away.

The landscape has always changed and been altered. I am drawn to the constant interaction of the earth and sky which signifies the meeting of humanity and the holy. I am interested in this view and the formal and interpretive challenges it presents.

The paintings are comprised of oil paint on an aluminum support and mounted in a basswood frame. The prints are oil on cover stock."

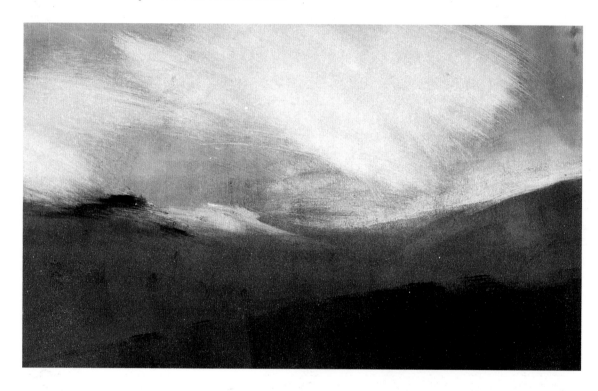

190. *Untitled*
1997
Monoprint
6" x 10"

BIOGRAPHY

Vrazo received a Graphic Arts degree from Macomb Community College, a Bachelor's degree in Fine Arts from Columbia College in 1993 and a Master of Fine Arts degree in Painting and Drawing from Northern Illinois University in 1997. She was a Visiting Professor at Northern Illinois University and has been a Visiting Professor at Judson College since 1997.

Vrazo has had solo exhibitions locally at Morton College in Cicero, Holy Covenant UMC Gallery and Wood Street Gallery in Chicago, and Evanston Art Center. She received Honorable Mention at the Norris Cultural Arts Center regional show in 1996 and a Third Place award at the International Juried Show at San Jacinto College in 1997. She was in the *Environments* exhibit at Kishwaukee College in Malta, Illinois in 2000.

Vrazo is currently represented by Wood Street Gallery.

191. (above)
Untitled
1998
Oil on Aluminum
12" x 18"

192. (right)
Untitled
1997
Oil on Aluminum
8" x 12"

Maureen Warren

"Travel is the source of ideas for me, from the cornfields of the Midwest to the rainforests of Tobago. I am interested in nature and the details in landscape, finding a grander idea in a small element and expanding on it.

I enjoy exploring the strange or unusual in the commonplace and combining the real and the imaginary. Birds have flown in and out of my paintings over the years and seem to be important residents in my work at the moment.

Though I prefer traditional materials, I often use ambiguous space in my work to give it a feeling of timelessness and modernity."

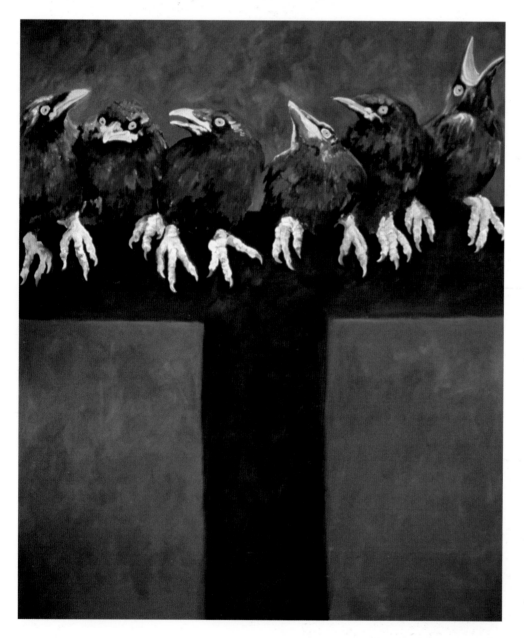

193. *Six Fledgling Crows*
1999
Oil on Canvas
60" x 50"

BIOGRAPHY

Warren received her Bachelor of Fine Arts degree from The School of the Art Institute. She then went on a Fulbright Fellowship to study at the Academy of Fine Art in Warsaw and Cracow, Poland. When she returned to Chicago, she continued her studies at University of Illinois at Chicago and received her Master of Fine Arts degree in 1984.

Warren's work was exhibited at many juried and invitational shows over the years. In recent years she has had solo exhibitions at the Riverside Art Center and the EMS Commons Gallery of Loyola University Medical Center in Chicago. She also had recent group exhibits at Gallery E.G.G., Artemisia Gallery, Joan Schenk Gallery, and Woman Made Gallery in Chicago as well as the Norris Cultural Center in St. Charles, Illinois. In 2000 she exhibited at University of Illinois at Chicago, Union Street Gallery in Chicago Heights, Contemporary Art Workshop and Northwestern University Settlement Association in Chicago.

Warren is represented by Gallery E.G.G. in Chicago and Ruth Morpeth Gallery in Pennington, New Jersey. She is also represented by Guild.com on the internet.

194. *Yellow Maize*
1998
Oil on Canvas
50" x 60"

195. *Fledgling Crow #5*
1999
Oil on Canvas
12" x 12"

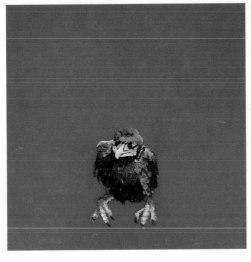

John Pitman Weber

"Starting in the summer of 1996, I worked for three years with tight gridded sequences of simple images: hand, mouth, ear, phone, ladder, box,…then bare feet, a head (asleep?), hands pointing to a camera, hands gripping a pair of pliers, a hatted man reading (or hiding behind a paper?), feet walking away…I liked the suggestion of obscure narratives with a touch of film noir, of 1940s-50s detective/spy stories. Some of the feet, hands and heads were drawn from photo details of homeless children and migrant workers. Other elements were invented in a quasi-cartoon style.

Gradually the format shrank and the color brightened. Then the grid loosened up; the treatment also became looser. I shifted to more explicitly autobiographical material, dealing with feelings about middle age, memories of childhood…Not, however, without attempting to implicate the larger history in which my life is embedded.

I believe my public collaborative work influenced and will continue to influence my studio work. Paradoxically I find the public work allows experimentation with new elements, colors and schemas. Since Spring 1998 I have been collaborating with my colleague and friend Nina Smoot Cain on broken tile mosaics with groups of teenagers in the Austin neighborhood. Our theme, especially in *Peace by Piece*, has centered on family, using images interpreted directly in cut paper from the family photos of the participants along with other symbolic elements evoking shared histories of migration, home-cooking, etc.

My sense of color has evolved through the intensive work with broken tile mosaic. I have also turned to themes in my own life which parallel our collaborative themes. Working in an African-American context, in partnership with my African-American colleague, has also provoked me to interrogate my own past.

My recent public work is influencing my studio work in powerful ways. Of course, my studio work has influenced my public work as well."

196. (above)
The Blue Box
1998
Acrylic on Canvas
50" x 35"

197. (left)
Pastoral
2000
Acrylic and Oil Pastel
36" x 48"

146

BIOGRAPHY

Weber grew up in Bronx, New York. He received his Bachelor's degree from Harvard University, then studied at École Nationale Superieure des Beaux Arts, and at Atelier 17 in Paris. When he returned to the U.S., he studied and received his Master of Fine Arts degree from The School of the Art Institute of Chicago. He is a full professor in the Art Department at Elmhurst College where he has taught for 32 years.

198. *Peace by Piece*
1998
Ceramic Tile Mosaic
at Beth Anne Center,
Chicago
A Collaboration with
Nina Smoot Cain
and Youth Team
9' x 13' Overall

In the 1960s Weber participated in the Civil Rights movement and the Anti-War movement. In 1969 he led his first outdoor mural at a church in Cabrini Green, a notorious housing project. The following year he met William Walker, a Black muralist. Together they created the program which became the Chicago Mural Group, an inter-racial artists group dedicated to community-based public art. He served as its Executive Director until 1981 and continues to serve as a Board member and Senior Artist of its continuation, the Chicago Public Art Group. Weber has led over thirty community public art projects in Chicago, Los Angeles, rural Georgia, New York City, Paris and LaRochelle, France and Managua, Nicaragua.

In the 1980s Weber showed his paintings and prints at alternative galleries in New York City, Toronto and Washington D.C. while also exhibiting in worship spaces in Chicago, Milwaukee and New York. In 1988 two of his prints were included in the major exhibit, *Committed to Print*, at the Museum of Modern Art in New York. In 1991 he was given a mid-career review by Valparaiso University in Indiana; and in 1998 Taller Mestizarte in Chicago hosted a retrospective of his prints. Other recent solo exhibits were held at Western Michigan University in Kalamazoo and Oakton Community College in Des Plaines, Illinois. In 1999-2000 his work was in a traveling exhibit, *Bridges and Boundaries*, curated by The Jewish Museum in New York City.

Shyvette Williams

"I believe we, all human kind regardless of our life circumstances, are born with a gift. I also believe this gift can be used in any expression to the benefit of mankind.

I have chosen to express this innermost knowing through painting. My medium varies depending on my mood and what I'm attempting to say. The images are born out of my life's experiences and a deep spiritual understanding. Through the process I've come many times face to face with other aspects of myself. The completed works offer the viewer an opportunity to get in touch with his or her inner feelings through the movement, color and texture."

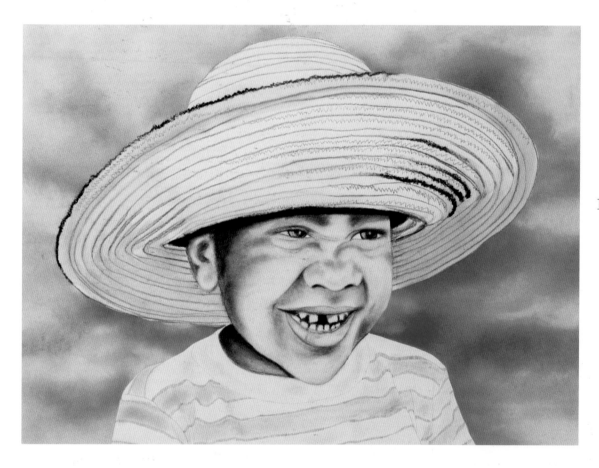

199. *Moyl*
1998
Pastel and Graphite
on Paper
20" x 30"

BIOGRAPHY

Williams is a ceramist, painter and book illustrator born in New Orleans, Louisiana. She went through the Chicago Public School System and received several scholarships to The School of the Art Institute where she studied Fashion Design.

In recent years Williams has been a juror for the *Eat Your Art Out* Art Fair sponsored by the Mayor's Office of Special Events, a panelist for Community Arts Assistance Program grants, and a panelist for the conference on African-Americans in Arts and Business held at Chicago State University. In 2000 she was a juror for *The Black Creativity Art Exhibition* at the Museum of Science & Industry.

Williams has had recent exhibitions at the Boulevard Arts Center, South Shore Cultural Center, and Northwestern University Settlement Association in Chicago and the Martin Luther King Center for the Performing Arts in Columbus, Ohio. Her work is in many private and public collections.

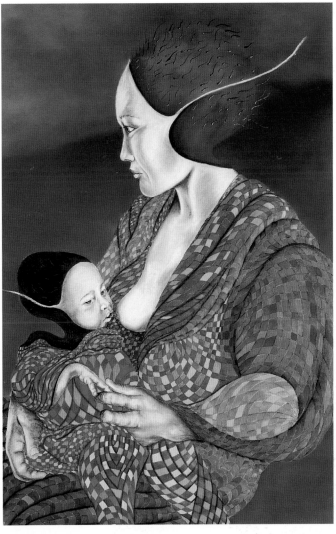

200. *Just for the Experience*
1996
Watercolor, Pastel
and Graphite on Paper
36" x 24"

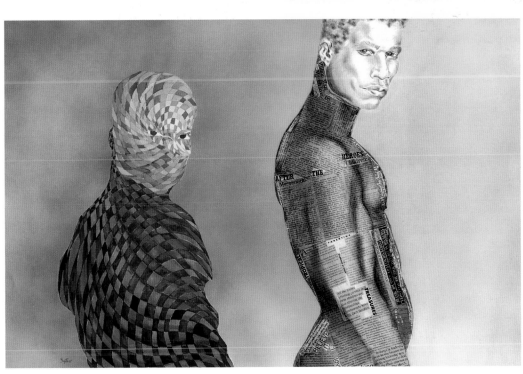

201. *Millionth Man*
1997
Watercolor, Pastel
and Graphite on Paper
24" x 36"

Laurie Wohl

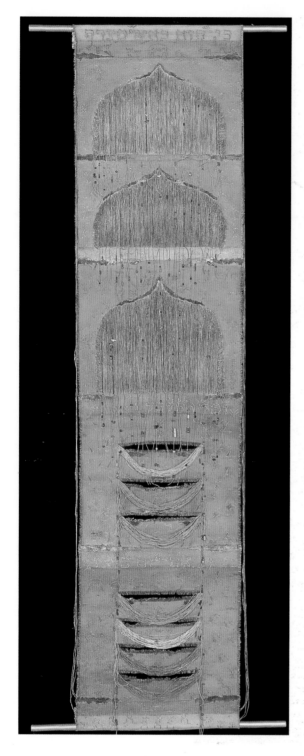

"The Unweavings® process I have developed is a unique method of working with canvas, evoking a spirit of mystery and celebration in the oldest tradition of intensely handcrafted textiles. Meditations on the themes of roots and memories are present, along with ritual narratives.

The hieroglyphic-like figures are my own iconography. Triumphant woman holds her arms aloft, the messenger brings news, the guardians dance, there is prayer and procession. The ritual narratives embodied in these figures are complemented in several places by Hebrew calligraphy using biblical and mystical texts.

The materials used in the unwoven tapestries are canvas, acrylic paints, modeling paste, South American, Japanese and Indonesian papers and beads from Africa, China, Japan, South America, Czechoslovakia and India. The beads form a rhythmic counterpoint to the unraveled strands and are prayers and marking points.

By unravelling the warp or weft threads then reconstituting the fabric through color and embellishment, I like to think that what is left is not a fragmentation of fabric or a veil which hides, but a tissue of light."

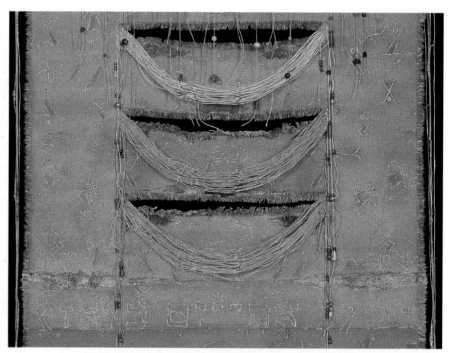

202. *Refiner's Fire*
1999
Unweaving® with Acrylic, Collaged
Papers, Modeling Paste and Beads
82" x 20"
Permanent Collection of
Beverly Art Center, Chicago, Illinois

203. *Refiner's Fire*
Detail

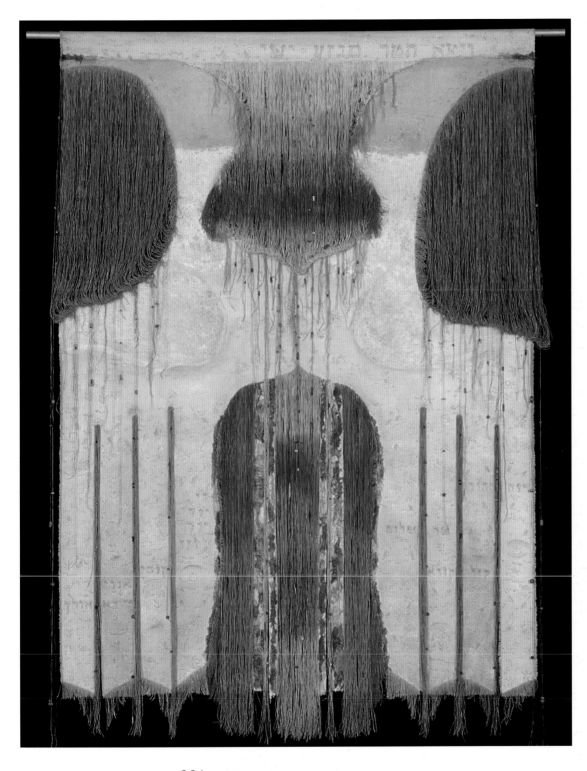

204. *Tree of Light: The Messiah Tree*
1998
Unweaving® with Acrylic, Collaged Papers,
Modeling Paste, Sand and Beads
68" x 47¼"

Takeshi Yamada

"The similarities and differences between cities always fascinated me. Therefore it was natural for me to produce artwork based on what I saw, photographed, researched, interviewed and felt about the unique characters of cities. They are the city's physical, social, material, architectural and cultural development and the people's origin, costumes, beliefs, folkways, etc. In this sense, I regard myself as a Visual Anthropologist.

RETOUCHING
I have been upgrading my old artwork that were produced since 1983 when I came to the United States. It is quite common for me to retouch or paint more on some of my paintings that were completed over 10 years ago. I believe artists have a right to keep working on their artworks to enhance the quality until they are purchased and taken from their hands."

205. *City Hall, fish eye, Chicago*
1994-1999
Oil and Acrylic on Canvas
24" x 32"

"This is one of the paintings that took me two to three years to complete. I filled out the corners in almost all the fish-eye style paintings to fit the rectangular canvas in 1998 and 1999."

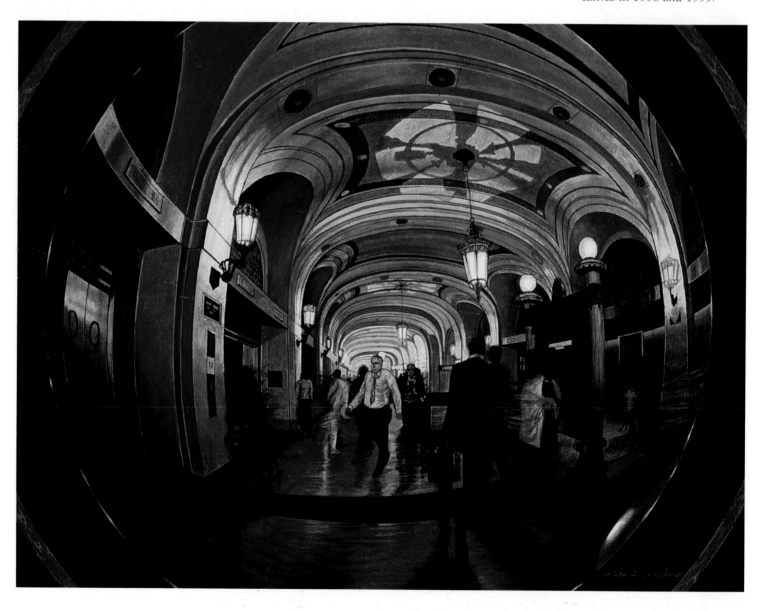

152

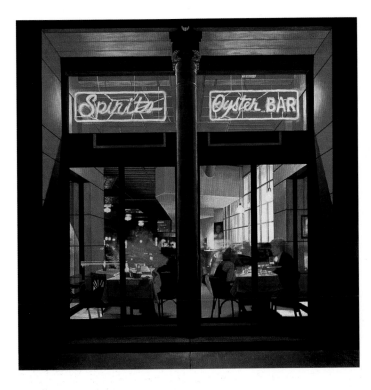

206. *Blue Point, Chicago,* 1991-1998
Oil and Acrylic on Canvas
24" x 24"

BIOGRAPHY

Yamada was born and raised in Osaka, Japan. He studied art at four schools in Japan including Osaka University of Arts. After moving to the United States in 1983, he studied at California College of Arts and Crafts in Oakland. He received his Bachelor of Fine Arts degree from the Maryland Institute College of Art in Baltimore and his Master of Fine Arts degree from University of Michigan School of Art in Ann Arbor. He has been teaching at Yamada Art Center since 1983.

In 1990, a series of his 48 New Orleans Mardi Gras paintings were exhibited at the Louisiana State Museum and he was granted Key to the City and Honorary Citizenship by the Mayor. In 1998 he received another Key to the City from the Mayor of Gary, Indiana recognizing him as an accomplished educator.

From 1996 to 1999 Yamada produced over 300 commissioned pen and ink illustrations for the *Strong Coffee* newspaper and *Chicago Shimpo*. He has published 19 fine arts books. His work was featured on the front cover of *The Chicago Art Scene* by Ivy Sundell (1998).

In the last two years Yamada has had solo exhibitions at Salem State College in Massachusetts and Collins Fine Art in Chicago. He also participated in group exhibitions at Japan Information Center and Hyde Park Art Center in Chicago; and Neville-Sargent Gallery in Libertyville, Illinois.

Yamada is represented by Collins Fine Art and Shinsen Gallery in Chicago; and Peltz Gallery in Milwaukee, Wisconsin.

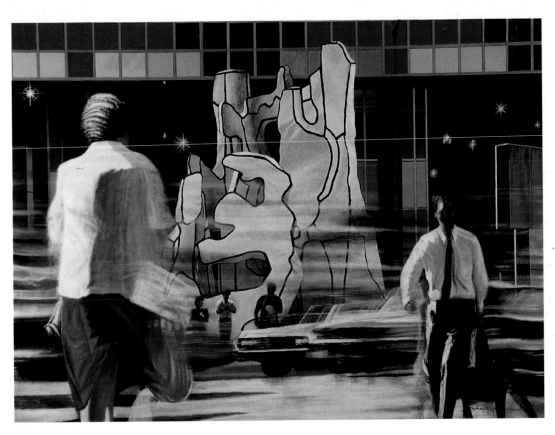

207. *James Thompson Center, Chicago*
1988-1998
Oil and Acrylic on Canvas
36" x 48"

"The shining lights of the office inside this building was made bigger and brighter in 1998. I also added more details to the lady's hair in the front, and more contrast to the man's face."

Victoria Yau

"My artwork is intended to capture some of the essence in nature and echo the inner voice of my soul. Over the years I have often picked up new artistic media or searched for new ways to express myself, but somehow there are never enough outlets for my creative process. Many projects are still waiting to be born.

My watercolor collage emphasizes the idea that forms and shapes are connected just as all events and elements in life are connected by an imaginary cord.

When I work feverishly and look beyond myself and my work, I become the artist, the critic and the work. When these three are in harmony, my work is complete. As in Buddhist meditation, when I reach a certain depth in producing my work, I have transcended myself."

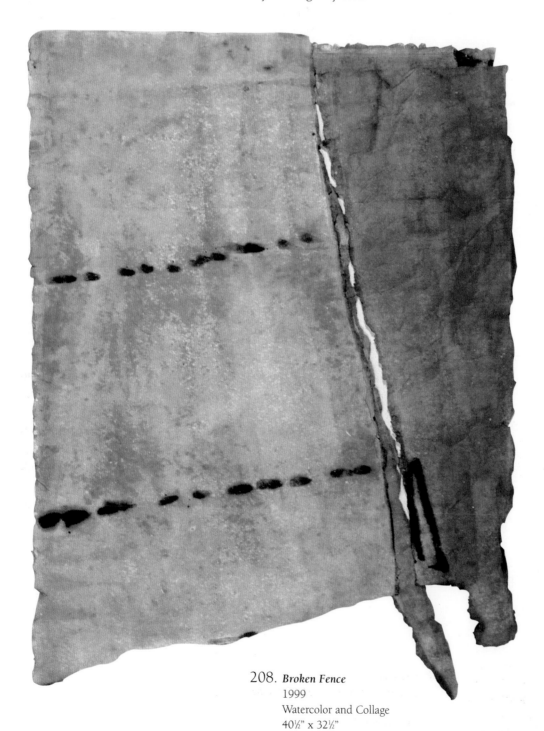

208. *Broken Fence*
1999
Watercolor and Collage
40½" x 32½"

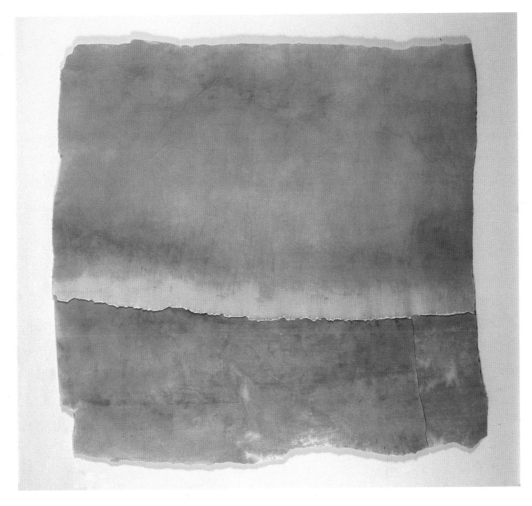

209. *April Snow*
1993
Watercolor and Collage
30½" x 29"

BIOGRAPHY

Yau was born in Shanghai, China. She studied Philosophy at National Taiwan University and Fine Arts at University of Puget Sound in Tacoma, Washington and University of California at Los Angeles.

In the 1980s Yau has had several solo exhibitions in Taiwan and Japan, including the National Taipei Museum of Art. Her *String and Misty Cloud* drawings were shown in Japan in 1986. She has also exhibited her work at U.S. Museums including the National Museum of American Art, Smithsonian Institution in Washington D.C., The Art Institute of Chicago, Portland Art Museum in Oregon, and Illinois State Museum in Springfield. In 1996 her work was shown at a solo exhibition at Color Field Art Center in Taipei, and in 1998 she showed her work at her New York studio, V.Y. Art Space.

Yau has recently published a book of her works.

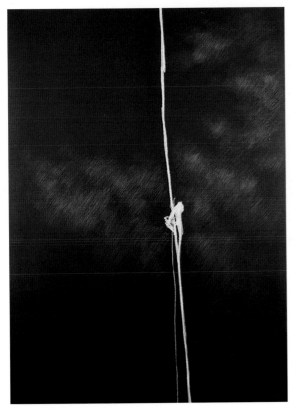

210. *Flashing*
from the String and Misty Cloud Series
1984
Oil and Acrylic on Canvas
50" x 39½"

Izumi Yoshitani

"Hidden underneath the lush green leaves and the fragrant flowers stands the 'real' tree. I see the vitality, resilience and dignity of the tree in its dark, weathered trunks and branches. In the nakedness I feel its character, strength and spirit.

After graduate school my life was filled with challenging work and obligations that kept me busy and satisfied with my family and business life. However I was isolated from the art world. As I made these prints of trees slowly and tediously in my spare time I realized that as an artist I was stuck as much as my trees were. The frequent use of a grid comes from *shoji*, Japanese sliding screens made of paper pasted on a wooden grid frame. One of my fond memories of growing up in Japan was waking up and seeing the soft sunlight coming through the white paper against the dark grid pattern. I felt comfortable and protected being inside shoji. But I realized later that it could also be a barrier or restriction. By placing my trees against a grid I hope to convey the contradictory feelings of tranquility and frustration.

211. *Mind of Her Own*
1991
Linocut on Woven Paper
24" x 37"

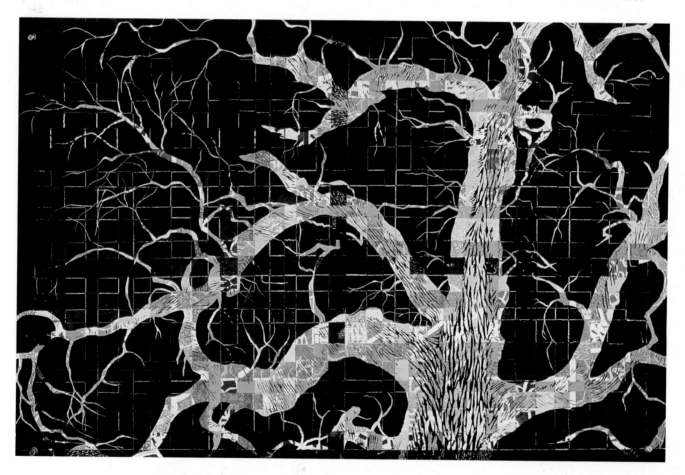

The drastic reduction of workload, the encouragement of a professor and the exuberance of young talented students in a seminar all helped to change the stagnant condition that I was in. In order to release myself from the shoji enclosure I decided to free my trees from their restrictive environment. I cut off my trees from their backgrounds and put them in new open spaces, like a sky or void, where they can move and float and fly leisurely to their next destination. Cutting out the images of trees from my prints and putting them in the new space was exciting; for the first time in many years I was enjoying my art again."

212. *Fly Away #2*
1997
Collage
32" x 22"

BIOGRAPHY

Yoshitani studied English literature in Tokyo and at University of California in Los Angeles before changing her focus to fine arts. She received her Bachelor's degree in Fine Arts from Elmhurst College and her Master of Fine Arts degree in Printmaking from University of Illinois at Chicago. She had taught printmaking, drawing and two-dimensional design at Elmhurst College from 1983 to 1995.

Yoshitani has had a number of solo and group exhibitions. In 1998 she had a one person exhibition at Expressions Graphics Gallery in Oak Park, Illinois. She is currently represented by Expressions Graphics Gallery.

213. *Fly Away #7*
1998
Etching, Watercolor, Colored
Pencil and Stitching
42" x 57"

Directory of Artists

Name	Gallery Representation*	Telephone Number	E-Mail Address and Web Site
Abajian, Alex.		(773) 989-8459	aabaj@yahoo.com; http://www.alexabajian.com
Buoscio, Christopher		(773) 728-7273	ctb@buoscio.com; http://www.buoscio.com
Callahan, Pamela		(773) 276-6481	callaloo@earthlink.net
Carrelli, Steven	Wood Street Gallery	(773) 227-3306 (g)	woodgall@aol.com
Cherry, M. Ivan		(708) 709-0579	
Ciurlionis, Rimas		(708) 749-8565	ciurlionis@msn.com
Cole, Grace	Byron Roche Gallery	(312) 362-9890	gvecole@aol.com; http://www.gracecole.com
Conklin, Andrew		(312) 654-0444	asconklin@mindspring.com
Detzner, Dick		(773) 525-3075	dick@detzner.com; http://www.detzner.com
Dzine	Eastwick Gallery**	(312) 440-2322 (g)	dzine@interaccess.com
Frankenstein, Curt		(847) 256-4764	
Gregor, Harold	Richard Gray Gallery**	(312) 642-8877	gregor@davesworld.net; http://www.hgregor.com
Hart, Pamela	Hartsart	(630) 637-1842 (a)	uwin2@earthlink.net; http://www.hartsart.com
Himmelfarb, Eleanor	Gallery 1756	(630) 668-0725	susanh@enteract.com
Hirsch, Jean		(847) 475-6766	
Hoffman, Ken	Animalia Gallery, MI	(309) 692-2653	khoffman@bradley.edu
Horan, Stephen		(312) 243-7355 (a)	sjhoran@aol.com; http://www.caconline.org
Igloria, Regin		(773) 975-7108	regin@mindspring.com
Irei-Gokce, Yumiko	KL Fine Arts**	(312) 829-5592	sekaijin@aol.com; http://www.klfinearts.com
Kapsalis, Thomas H.	Roy Boyd Gallery	(312) 642-1606 (g)	royboyd@worldnet.att.net
Katz, Donna June		(773) 525-3390	
King, Jill	Gwenda Jay/Addington	(773) 973-0708	artinfinite@aol.com; http://imageforum.net
King, Kathleen	**	(773) 227-3361	kking@artic.edu; http://uturn.org/king
Klopack, Ken		(773) 283-8791	gkklopack@ameritech.net
Koscielak, Gosia		(847) 920-1217	artmk2000@netscape.net
Kramer, Linda	Jean Albano Gallery**	(847) 446-1122	
Krauss, James	Gallery Ten, WI**	(630) 904-5259	krauss7@aol.com
Kryczka, Marion	Fine Arts Building Gallery**	(312) 334-5932	
Kulla, Roland	The Vedanta Gallery	(312) 432-0708 (g)	rkulla@midway.uchicago.edu
Kurtz, John		(773) 348-6845	
Lader, Deborah Maris	Belloc Lowndes Fine Art**	(773) 293-2070	Ink1101@aol.com; http://www.chicagoprintmakers.com
Lehrer, Riva	Lyons Wier & Packer Gallery**	(312) 654-0600 (g)	rivalehrer@earthlink.net
Luc, Carol		(773) 467-0767	luc@enteract.com
Maloney, Irene Ryan	Fine Arts Building Gallery	(312) 913-0537 (g)	maloneys4@aol.com
Matyjewicz, Heath		(773) 929-7616	
Menco, Bert	Anatomically Correct**	(847) 864-7210	bmenco@northwestern.edu; http://www.anatomicallycorrect.org
Mesple, James	Printworks Gallery	(773) 862-7297	
Miller, Dale		(847) 537-7571	daleart2@aol.com
Murrie, Herbert	Lydon Fine Art**	(312) 943-5995	hmurrie@herbertmurrie.com
Oehmke, Julia DelNagro	Griffin Graphics, Inc. Gallery**	(708) 672-3255	juliafineart@aol.com
Oh, Helen	Lyons Wier & Packer Gallery	(312) 654-0444	
Peldo, Chris	David Leonardis Gallery	(773) 278-3058 (g)	david@dlg-gallery.com; http://www.dlg-gallery.com

Name	Gallery Representation*	Telephone Number	E-Mail Address and Web Site
Pelnar, Mark	Fine Arts Building Gallery	(847) 540-6867	
Perz, Joyce Martin		(312) 642-9272	thinkart@aol.com
Piatek, Frank	Roy Boyd Gallery	(312) 642-1606 (g)	royboyd@worldnet.att.net
Plotkin, Nancy		(312) 255-1409	nplot9@aol.com
Principe, Sandra	Hildt Gallery**	(312) 664-4925	skprincipe@aol.com; http://www.sandraprincipe.com
Riseborough, Gay Griffin	Wood Street Gallery**	(773) 227-3306 (g)	woodgall@aol.com
Rolwing III, E. Charles		(773) 989-1859	ecr3@rolwing.com; http://www.rolwing.com
Roniss, Sallie Gilmore		(773) 764-4387	aroniss@aol.com
Semelroth, Eric		(630) 495-7907	esemelroth@hotmail.com
Skurkis, Barry		(630) 759-4821	baskurki@noctrl.edu
Sokolow, Deb		(773) 588-4398	debsokolow@yahoo.com
Spiess-Ferris, Eleanor	Sonia Zaks Gallery	(312) 943-8440 (g)	
Steinberg, Rubin		(773) 761-0981	
Stringfellow, Allen	Nicole Gallery**	(312) 787-7716 (g)	nicolgall@aol.com
Surdo, Bruno	Ann Nathan Gallery	(847) 673-6239	basurdoars23@aol.com; http://representational-art.com
Swartz, Shari		(773) 281-2647	dubear@attglobal.net
Tegeder, Dannielle		(773) 227-0176	DMTegeder@aol.com
Thorne, Charlie	**	(773) 486-0076	
Townsend, Pala	Fassbender Gallery	(312) 951-5979 (g)	ifassbender@msn.com; http://www.fassbendergallery.com
Turner, Phillip J.	Curtis.Allen.Turner Fine Arts	(773) 929-1824	np028@gateway.net
Turow, Annette	Rena Sternberg Gallery**	(847) 475-1564	artur1484@aol.com; http://www.annetteturow.com
Vrazo, Alice	Wood Street Gallery	(773) 227-3306 (g)	woodgall@aol.com
Warren, Maureen	Gallery E.G.G.**	(312) 326-0638	warrenmaureen@yahoo.com; http://www.guild.com
Weber, John Pitman		(708) 848-1586	johnw@elmhurst.edu
Williams, Shyvette		(773) 274-3622	
Wohl, Laurie	**	(773) 924-5597	
Yamada, Takeshi	Collins Fine Art**	(312) 243-0032	takeshiyamada@hotmail.com; http://www.nextmonet.com
Yau, Victoria		(847) 475-4519	
Yoshitani, Izumi	Expressions Graphics Gallery	(630) 960-0965	iyoshitani@sprynet.com

* Galleries listed are located in Chicago area unless otherwise noted. Local gallery addresses, telephone numbers and hours can be obtained by refering to *Chicago Gallery News,* (312) 649-0064, email: cgnchicago@aol.com. The inventory of work kept by the galleries varies. Those interested in seeing more of an artist's work are advised to first call the number or visit the gallery listed above.

** See additional galleries listed in the Biography section of the artist's feature pages.

(g) means the telephone number belongs to the gallery.

(a) means by appointment only.